DYNAMIC
SEASCAPES

DYNAMIC SEASCAPES

HOW TO PAINT SEAS AND SKIES WITH DRAMA AND ENERGY

Judith Yates

SEARCH PRESS

First published 2021

Search Press Limited
Wellwood, North Farm Road,
Tunbridge Wells, Kent TN2 3DR

Reprinted 2022

ISBN: 978-1-78221-823-4
ebook ISBN: 978-1-78126-790-5

PUBLISHER'S NOTE

All the step-by-step photographs in this
book feature the author, Judith Yates,
demonstrating watercolour painting.
No models have been used.

Readers are permitted to reproduce any of
the artwork in this book for their personal
use, or for the purpose of selling for
charity, free of charge and without the prior
permission of the Publishers. Any use of
the artwork for commercial purposes is not
permitted without the prior permission of
the Publishers.

SUPPLIERS

If you have any difficulty obtaining any of
the materials and equipment mentioned in
this book, visit the Search Press website for
details of suppliers:
www.searchpress.com

You are invited to visit the author's website
at: www.judithyates.com

Dedication

To Mum and Dad.
Who never said, 'Get a proper job!'

Acknowledgements

I would like to thank Roz Dace for seeing the potential in my work.

A huge thank you also to my editor Edward Ralph, for all his guidance and hard
work throughout the process. Not forgetting Mark Davison for his beautiful
photography and the designers for their creative input, along with all the team at
Search Press. A big thank you to my family for their support and enthusiasm and
especially my husband Colin, for his constant encouragement and kindness.

CONTENTS

INTRODUCTION — 6

MY INSPIRATION — 8

MATERIALS — 14

COLOUR — 24

UNDERSTANDING THE SEA — 32

MARK-MAKING — 40

EXPRESSION AND DYNAMISM — 50

WILD SEASCAPE — 70
 Step-by-step project

SHIMMERING MIST — 84
 Step-by-step project

COMPOSITION — 96
 Compositional basics — 98
 Viewpoint — 100
 Creating drama — 104
 Skies and light — 110
 Foreground: added elements — 116
 Texture, tricks and illusions — 122

CREATING MOOD AND ATMOSPHERE — 128
 Elements of atmosphere — 128
 Stormy raging seas — 130
 Misty, ethereal atmosphere — 132
 Calm, shimmering waters — 134
 Dreamy atmosphere — 136
 Brooding mystery — 138
 Dreamy nostalgia — 140

AFTERWORD — 142

INDEX — 144

INTRODUCTION

The lure of the ocean and beauty of the coastline have moved
me from an early age, and I am thrilled to be able to share my
joy of seascape painting with you in these pages. The deep-
seated passion for the sea has continued into my adult life, so
it's no surprise that my artistic practice has been dominated by
the theme.

I aim to capture the raw experience of nature in my work, to
create a personal interpretation of the mood and atmosphere
of the coast, to encapsulate the fresh breeze, the sound of the
crashing surf, and the taste of salty air. It's a challenging subject,
but I always feel the challenge is part of the fun.

Over the following pages I will demonstrate how you too
can paint the sea and coastline, using a mix of traditional and
contemporary painting methods. I will show you how to combine
a variety of media and materials with my favourite experimental
techniques; enabling you to create visually stunning artwork with
some unexpected results.

I hope you enjoy experimenting alongside me, learning new
tricks to add to your painting repertoire that you will be able
to return to time and time again. By the end of the book, you
will have developed the confidence to tackle any seascape
and experiment with your own ideas and techniques, resulting
in exciting, dynamic paintings full of drama and light.

Opposite
SEA SURGE
40 x 25cm (15¾ x 20½in)
This painting was about the power and translucent
quality of a breaking wave. To capture both the energy
and beauty in one painting, I used a combination of
watercolour, acrylics and acrylic inks with granulation
medium. The reference photograph was used with the
kind permission of Roz Dace.

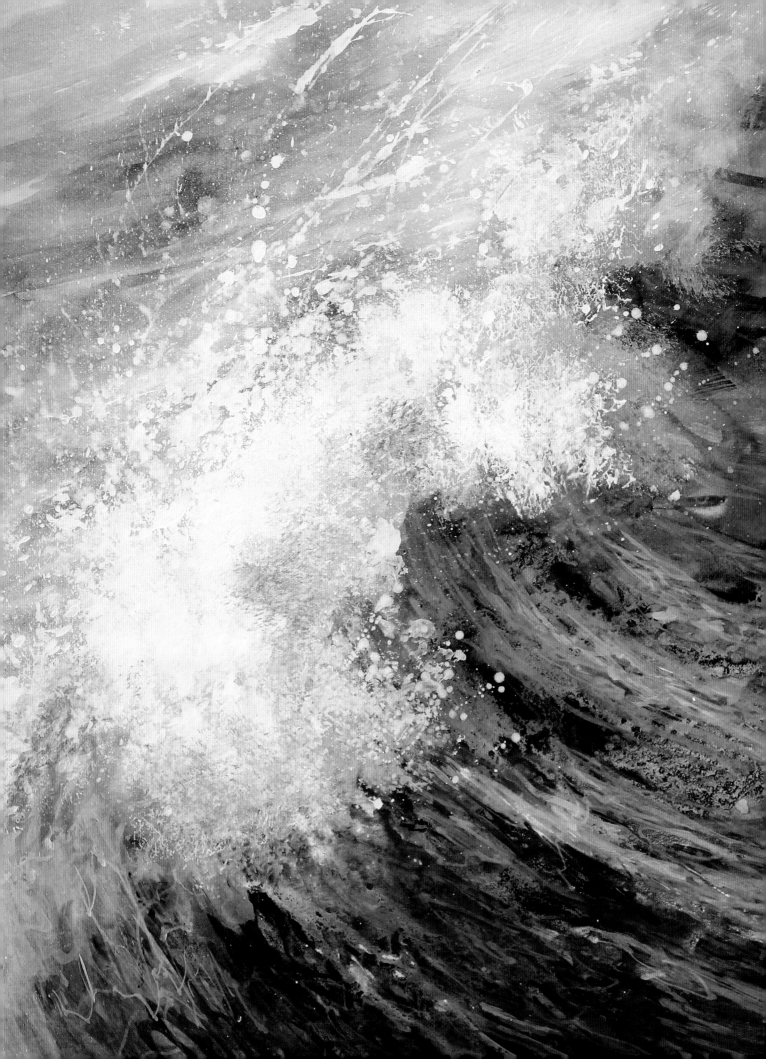

MY INSPIRATION

I always create my best work when I have just visited the coast and the memory is still fresh in my mind. Inspired by my visual and sensory experience, I am keen to capture the scene in paint.

I enjoy so many aspects of the UK's varied coastline, from the stark drama of winter to the calmer shores of summer. However, like many lovers of all things coastal, I am not lucky enough to live close to the sea, therefore I rely on *aides-mémoire* to keep the inspiration fresh in my mind until the next visit.

TAKING AND USING PHOTOGRAPHS

I always pack a camera on my trips to the coast in order to record features that catch my eye, such as waves, light effects and atmospheric details. I constantly scan around for new viewpoints and interesting compositions.

On my return to the studio I am not a slave to the photographs. I use them as a visual aid or prompt rather than copying them directly. My aim, particularly in my expressive works, is to capture the essence and atmosphere of the location more than to create a perfect representation of a particular place.

If, like me, you are lucky enough to have family or friends living by the coast who kindly allow you to use their photographs, this can be an invaluable source of visual reference. Such photographs are especially useful when you are already familiar with the location and can also bring your own experiences and memories to the artwork.

I encourage you to use your reference shots to create areas of convincing detail, but you should feel free to move away from the photograph. You can emphasize areas, increase and decrease vibrancy and of course move things around or leave them out altogether! You can happily incorporate details from several photographs in order to create your own interpretation of the scene, too. Such approaches will enable you to create your own personal interpretation of the location.

It is easy to end up with hundreds of photographs, so it pays to be organized. Keep your reference shots and digital files together under headings. I suggest that you keep the best photographs and discarding the rest: that way they will always be readily on hand and easy to find when you are searching for inspiration. This saves you a huge amount of time when you are looking for a specific shot or subject matter. Experience tells me that if I don't do this, I end up scouring through thousands of shots to find the perfect wave, an ideal pattern of sand or a particularly atmospheric sky.

I use a compact digital camera for taking my reference photographs.

SKETCHING

Sketching *en plein air* is useful for quickly capturing your main areas of interest. A small sketchbook, a couple of brushes and a basic set of watercolours is all you need; you can pack them in a backpack and be ready to go.

By their very nature, sketches are often created quickly, resulting in an immediate, loose interpretation of the visual scene. Once you are back in the studio, you can use your sketches as a reference for your paintings. Translating the characteristics of the sketch helps to maintain a freshness and immediacy in the final work.

Use a sketchbook as a kind of painting scrapbook or art journal, and you will find it is of great benefit to your practice. Keep written notes alongside small snippets of work and you will soon build up a marvellous resource, especially when you require inspiration for work.

Tip

We have all created paintings that didn't work out as expected, and that we have ultimately discarded. Here's an alternative: rather than throw the whole painting away, cut out sections or areas of the painting that do work and keep them for future ideas and inspiration through collage.

Look for colour combinations you enjoy or a particularly pleasing layering of paint. Small experiments and snippets of techniques can be added and the results can act as a starting point for a new piece of work.

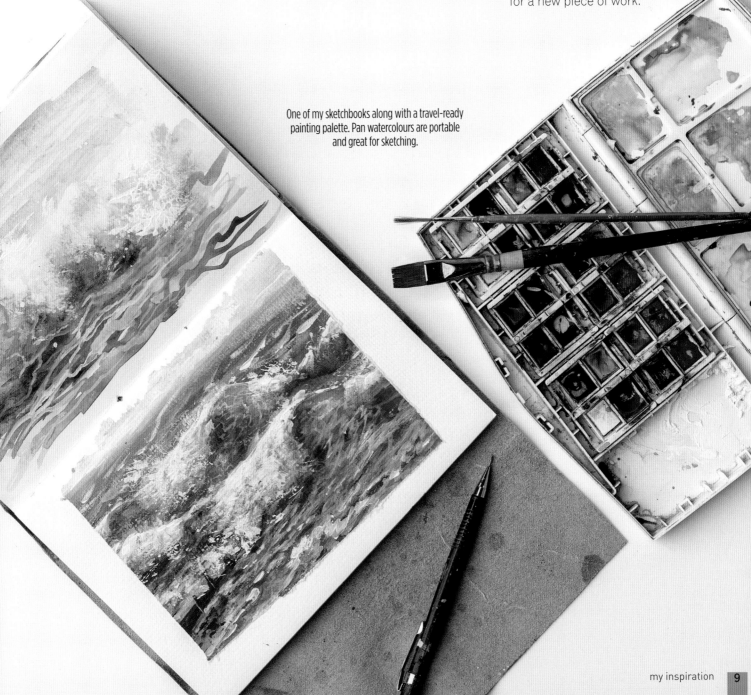

One of my sketchbooks along with a travel-ready painting palette. Pan watercolours are portable and great for sketching.

OTHER REFERENCE MATERIAL

To support my photographs and sketches, I also collect samples and small natural treasures from the coast. My home is scattered with an assortment of driftwood, bowls of shells, pebbles and secret finds, all of which operate as reminders of the texture and atmosphere of the coast. Once I am back working in the studio, my sketchbooks and artefacts act as a perfect memory-jogger to rekindle the experience.

Along with photographic images, it's useful to have a reminder of the swell and movement of the sea, and that's where video can come in handy. You can make your own reference footage of the sea using your camera or phone, or refer to existing footage on the internet or film libraries.

I watch films of crashing surf or waves lapping onto the shore when I need a reminder of the constant change and movement of the water. These provide a marvellous way of studying the movement of waves and watching how they break. It also allows you to observe the varying colours and light effects in different conditions. The footage will take you straight back to your initial experience, to the sound of the surf, to the energy of the location. These elements are part of the whole experience, and far more evocative than studying a small static image.

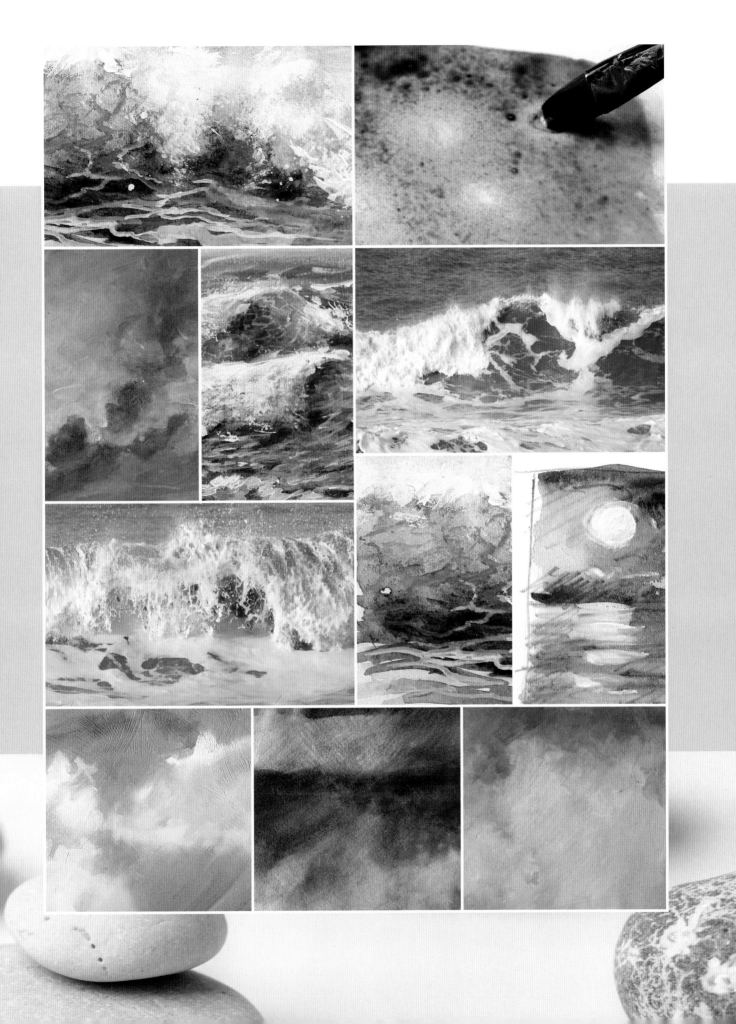

OBSERVATION AND EXPERIENCE

When I visit the coast, I am often guilty of viewing my favourite locations through the lens of a camera. I'm sure we have all done the same – being so keen to capture the perfect image, we snap away for hours without really absorbing the experience.

It is so important to take the time just to experience the location. This way you can take note of your emotional response. You will then later be able to remind yourself of the atmosphere that you want to capture in your work.

Observe the place with an analytical eye: decide on the details that attract your attention the most. This might be the light falling on the water, the patterns in the sand or perhaps the energy of the waves. Analysing exactly what your work will be about will help distil your final intentions in your mind. Once you start your painting, this will be the element that you emphasize, so that the viewer understands what you are expressing in your work.

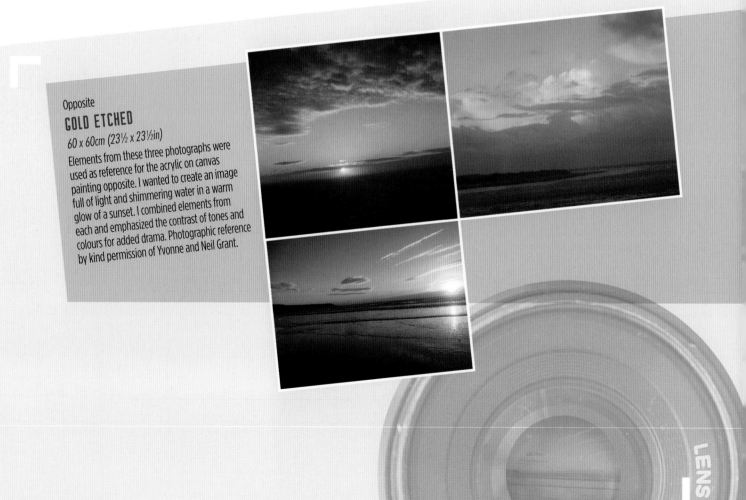

Opposite
GOLD ETCHED
60 x 60cm (23½ x 23½in)
Elements from these three photographs were used as reference for the acrylic on canvas painting opposite. I wanted to create an image full of light and shimmering water in a warm glow of a sunset. I combined elements from each and emphasized the contrast of tones and colours for added drama. Photographic reference by kind permission of Yvonne and Neil Grant.

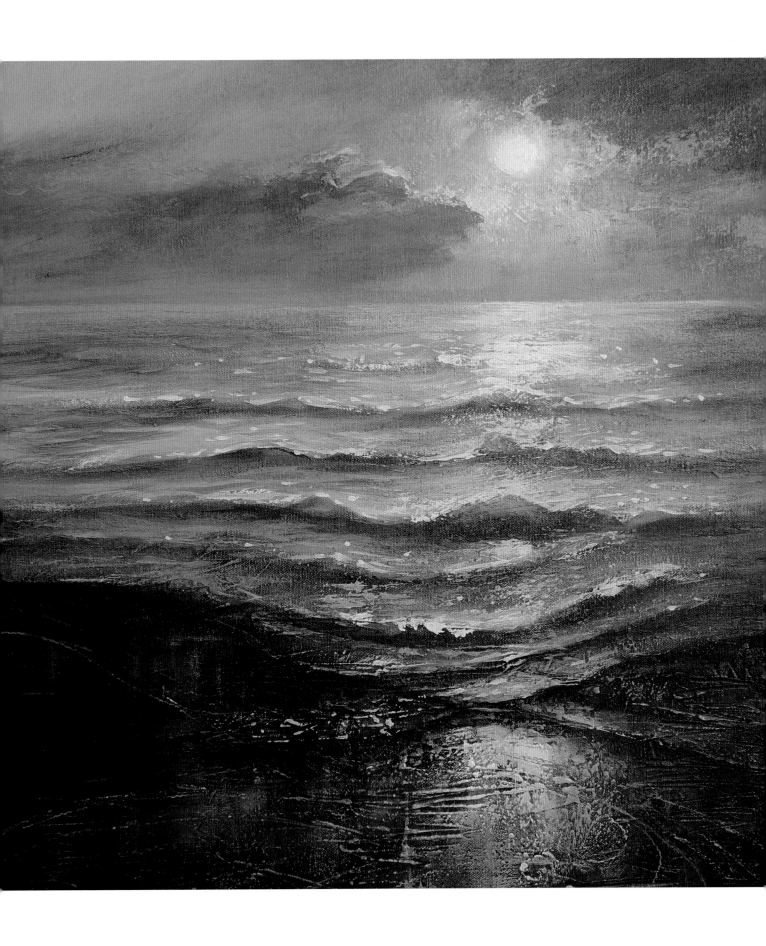

MATERIALS

I find browsing the aisles of art suppliers so enticing – there are always so many exciting new products. There is nothing so thrilling as finding a wonderful new surface to work on or discovering a new paint you have never tried before. Alongside my suggestions here, I would always encourage you to try out different art materials of your own choice – that way you will find new possibilities with which to experiment, resulting in original, intriguing results.

After years of painting and trying out different materials, I have developed firm favourites. There is such a variety of brushes, paints and surfaces from which to choose that the possibilities can be bewildering as well as exciting. To simplify things as you start, I have listed my favourite materials on the following pages. All are tried and tested, and will give you good results.

PAINTS AND **WATER MEDIA**

Water media is a catch-all term for media that can be diluted with water (as opposed to oil paints or pastels, for example). I use acrylics, watercolours and acrylic inks – either on their own or all together, depending on the effects for which I am aiming. It is also possible to mix water media with painting additives, something that we will look at on pages 20–21.

There is a wide variety of both watercolour and acrylic paint brands from which to choose. Manufacturers create different ranges to suit different needs. Most manufacturers produce cheaper Students' ranges and more expensive Artists' or Professional ranges; and the quality is reflected in the price. Although the professional ranges are more expensive, in my opinion the depth of pigment makes it well worth the extra cost.

I do use mid-ranged acrylic paints, including tubes of System 3 from Daler-Rowney and Galeria from Winsor & Newton among other well-known brands. These are good options, but my favourites are Winsor & Newton Professional Acrylics in 60ml tubes and Professional Watercolour in 5ml tubes.

I use Daler-Rowney FW artists' acrylic inks. Acrylic ink is waterproof when dry, and can be used on its own or with other additives to achieve interesting effects. Ink can be used directly from the bottle, by means of a dropper included in the lid, or mixed with water and other water media and applied with a brush.

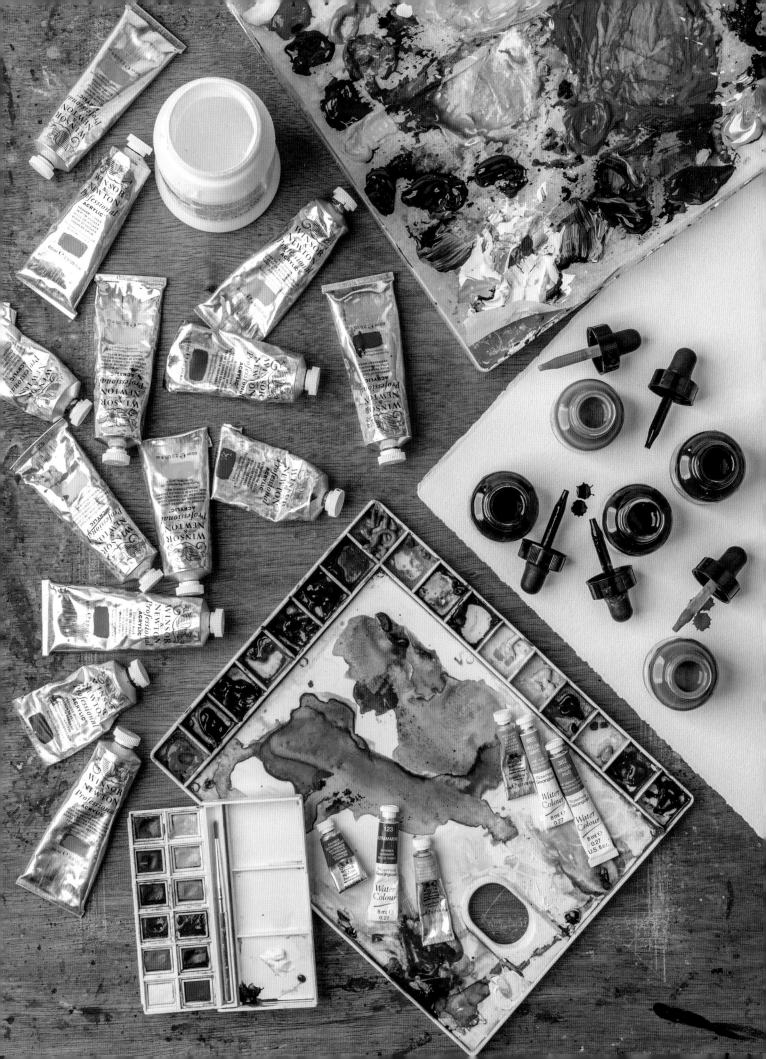

BRUSHES, KNIVES AND OTHER APPLICATORS

It is only by practising with a range of brushes that you will discover what suits you best. Your favourite brushes will always be the ones that are compatible with you and your style of painting, and this will be different for everyone.

Over time you will become familiar with your brushes, so much so that they become an extension of you and your personality. Through practice, you will become familiar with the different marks that you can make and the characteristics of each individual brush – how it feels; how much paint it holds; how to move it to make a specific mark, and so on.

My brushes work hard. I use them quite vigorously, especially on rough and textured surfaces, and after a few weeks the bristles become splayed and lose their spring. This means they are no longer useful for painting fine detail. Consequently, my old brushes are relegated to a large pot of tatty, dry, bristled specimens perfect for achieving a range of rough and rugged marks.

Because they are more resilient than natural hair brushes, I usually favour working with a range of synthetic brushes from a variety of manufacturers. The spring in synthetic brushes makes them a perfect fit for both acrylic and watercolour paint.

- **Flat brushes** So called because of their wide, flat bristles, these look a little like a small household brush. I favour short, synthetic flat brushes. Available in lots of different sizes, just three – 25mm (1in), 12mm (½in) and 5mm (¼in) – will allow you to use most of the techniques in this book.

- **Round brushes** Round brushes come to a point, and so are very useful for detailed work. I have two or three soft, round, synthetic watercolour brushes, in sizes 4, 6 and 12. These hold plenty of water, so are perfect for watercolour washes. I also use smaller synthetic round brushes in sizes 1 and 2 for fine detail.

- **Fan brushes** I have several fan brushes too; their splayed shape makes them ideal for softening and blending hard marks.

- **Rigger brushes** Designed to paint fine rigging on paintings of ships, rigger brushes have very long, fine hairs that carry a lot of paint and allow them to draw clean, fine lines. I always have a couple of rigger brushes in various sizes to create thin, expressive marks.

- **Decorating brushes** For work on large canvases, I keep a number of large, stiff, bristled decorating brushes, in sizes ranging from 60mm (2½in) to 75mm (3in). These are perfect for fast coverage and to create huge sweeps of colour. They are also brilliant at producing soft washes and blends over a large surface area.

- **Palette knives** I regularly use these metal trowel-like tools to apply paint, as they produce looser, more expressive and less definite marks than brushes. They also provide a wonderfully loose textured layer of paint. I use three sizes of palette knife: 1, 3 and 6.

- **Speckling brushes** Along with a number of old toothbrushes, I own a wonderful speckling brush that looks a little like a wire bottle brush, with a metal rod to insert that adds tension to the bristles as you turn it. I use both to create sea spray. They both create marvellous and very different effects in seconds.

- **Other applicators** It is enjoyable to find and use a variety of paint applicators. The fun is in finding new objects and materials to create interesting marks and effects that differ from brushes and knives. Right in front of you are your fingers – perfect for blending. Try sticks; combs; sponges; cotton thread; old credit cards; cardboard strips; and anything else you find that will make intriguing marks. My favourite at the moment is an old Victorian pastry cutter. When dipped in paint it creates fascinating marks across a surface. Pipettes are useful for applying liquid media. I'm sure rifling through the kitchen drawers would throw up more options, and there will be no end of possibilities in the garage.

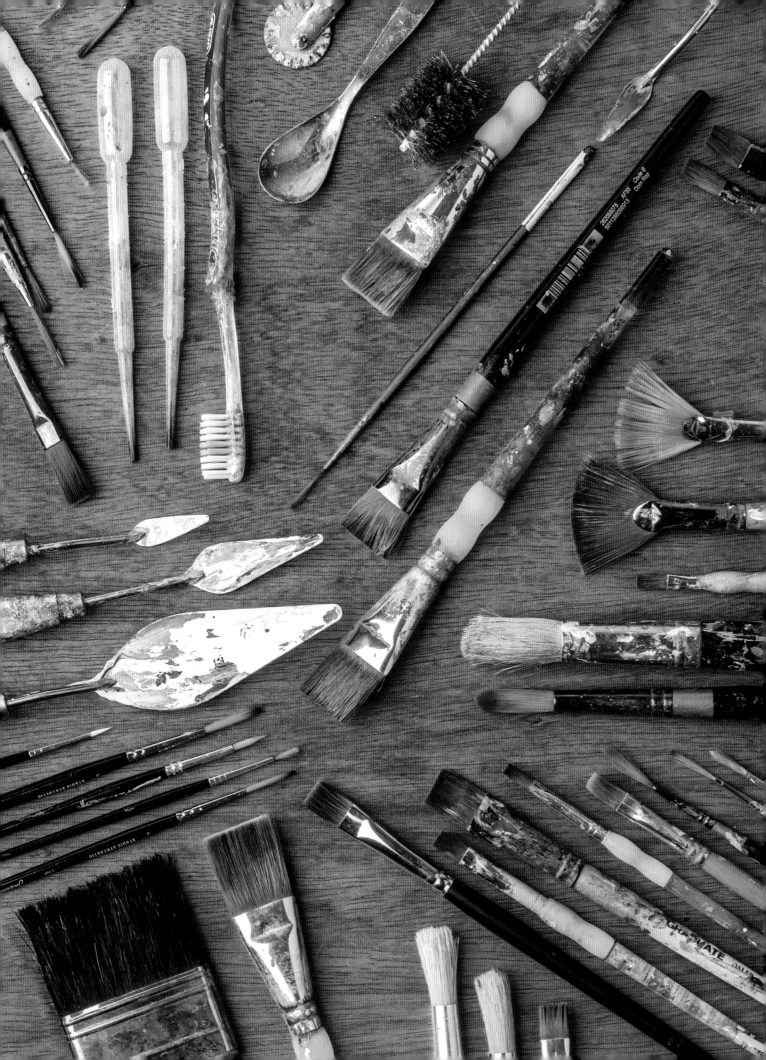

PAINTING SURFACES

The choice of a painting surface is important as it will enhance the subject matter. The results will depend on the absorbency and textures of each surface. For more detailed work, I suggest using a smoother texture; while a thicker, textured surface works well for more expressive work.

As a guide I have included my main choices of painting surfaces below. You will find many more options to explore, so spend some time trying out both familiar and unfamiliar surfaces, and experimenting with different approaches of applying paint to each.

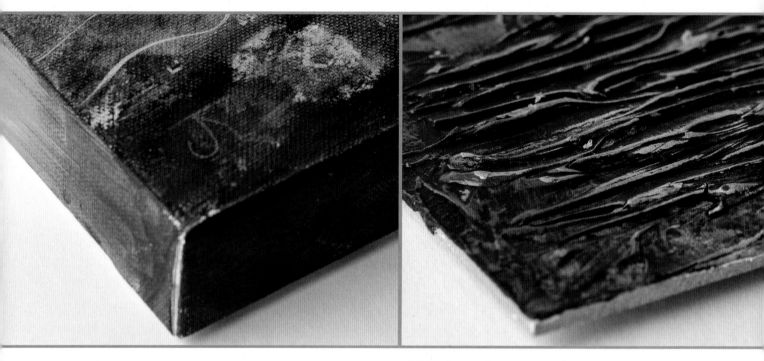

Canvas

I use a variety of ready-made, pre-prepared canvases in a range of sizes for my acrylic painting. I love the spring in the surface of a box canvas (as pictured above), especially when used with vigorous painterly techniques.

Canvas can be purchased in various textures, some finer, some rougher. There is no right or wrong; your choice should come down to personal taste.

Watercolour paint can be applied onto canvas too. You need to use a specific primer medium called watercolour ground for this purpose. The ground enables watercolour paint to adhere to a variety of surfaces, not just canvas.

MDF board

I regularly use 4–6mm (³⁄₁₆–¹⁄₄in) MDF board, which I cover with one or two layers of gesso primer. I normally purchase a 122 x 183cm (4 x 6ft) panel from my local DIY store, taking advantage of the cutting service to obtain a range of panel sizes.

The rigidity of the surface is very enjoyable to work with and very different from canvas. Using identical painting methods on each surface will create subtly different effects. MDF is not only inexpensive, it's also an incredibly resilient surface to work on. Any amount of layering, scratching – even sanding – does not affect its ability to carry paint. You can build up the surface and scrape back as many times as you wish without fear of damaging the board.

As with canvas, you can work on board with watercolour after applying watercolour ground over the entire surface.

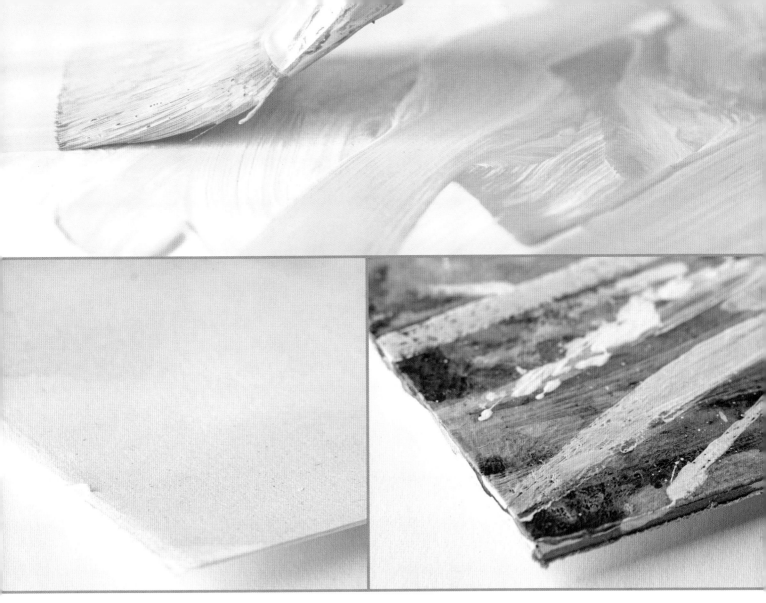

Watercolour paper

Although intended for watercolour paint, this surface works brilliantly with acrylics or mixed media. The absorbency of the paper results in wonderful, soft, hazy effects that are hard to achieve on other surfaces.

You can select from a range of textures, from smooth Hot-pressed (HP) to heavily-textured Rough surfaces. Not surfaces, short for 'not hot-pressed', and also called cold-pressed (CP), are halfway between the two in terms of surface 'tooth'. Your choice will depend on the image you are creating and your own personal preference.

I usually choose the heaviest weight paper I can find, at least 300gsm (140lb). This means that I do not have to stretch the paper to prevent cockling, which can happen with thinner, lighter papers. Another handy option is watercolour board: sheets of watercolour paper that have been mounted onto a rigid, acid-free and archival card.

Try exploring several options to see how they react. A very textured paper will accommodate vigorous dramatic effects, while Hot-pressed paper is impressive for detailed work, enabling subtle details and light delicate areas to show up without becoming lost in the texture.

Mount board

One of my favourite surfaces to work on is mount board. It is compatible with both acrylic and watercolour paints.

Mount board combines several of the qualities associated with watercolour paper and MDF. It has a very resilient surface, but also absorbs paint in the outer surface, allowing soft, atmospheric effects to be achieved. Mount board is tough and resilient, and therefore works well with scratching and layering techniques, with little risk of breaking down the surface. Because of the absorbency of the board, the artwork does need framing with glass.

MEDIUMS AND ADDITIVES

Working in an experimental fashion with paint and combining different acrylic and watercolour mediums and additives will produce many unexpected outcomes that could not easily be achieved through traditional paint application alone. I am constantly on the look-out for new methods of painting and enjoy days of experimentation without worrying about the outcome. Here are the additives that create the best results for me.

- **Gesso (A)** Along with the traditional use of gesso to prime surfaces, this opaque acrylic substance can also be used to create textures on the surface before starting a painting. Marks can be painted into it with brushes or created with a palette knife. Different materials can be pressed into the surface to create an impression of various natural forms.

- **Textured pastes (B)** Textured pastes can be used like gesso but they are thicker and hold their shape better, resulting in a more obvious mark. They are available in different finishes: fine, for a smoother finish; and coarse, with a sand-like texture. They are available in gel or paste form. They take a few hours to dry when applied very thickly and must be totally dry before you apply any paint. When texture is added to the surface, suggested detail can be created: a dry brush dragged at an angle over the textured ground will pick up the raised surface and highlight the detail, implying light interacting with the landscape.

- **Granulation medium (C)** Drops of this colourless liquid can be added to a wet wash using a pipette. The medium splits the pigment in the wash, resulting in flecks and speckles as the particles separate. It can be used with watercolours and acrylics to create subtle and interesting effects, but it works best with acrylic inks where it will create dramatic results.

- **Methylated spirits (D)** A favourite additive of mine, I buy methylated spirits in a large bottle and decant the liquid into smaller screw-top pots for ease of use and for safety. You can add drops of meths onto wet watercolour or acrylics with a pipette, or apply it with a brush. It repels the pigment, leaving round patches reminiscent of lichen or patches of light; creating fascinating organic-looking results that suggest natural forms.

- **PVA glue (E)** This is particularly interesting medium. It will start to soften under the application of watercolour or acrylic paint, after which it can be manipulated, or the surface can be scraped away. This results in interesting marks in areas where the PVA has softened.

- **Bleach (F)** Bleach creates a lightening effect when added to watercolours. The results are subtle and slightly random; producing uncontrolled blending from dark into light.

- **Salt (G)** Salt is very effective when added to a wet watercolour wash. The crystals absorb the water, drawing paint towards them. Once dry, it creates subtle suggestions of natural forms. You can use sea or rock salt to cultivate large star-shaped markings. Table salt creates a more understated sparkling effect.

- **Masking fluid (H)** This latex-based liquid is used extensively with watercolours. It can be applied using a variety of tools and implements, reserving small areas of the work that you need to remain white. Remember to use old brushes, as the fluid is tricky to remove from brushes and bristles. Once dry, the fluid will enable you to apply broad, loose washes without the need to carefully paint round intricate edges. When the painting is totally dry, the masking fluid can be removed by rubbing it, either with a putty eraser or your finger.

- **Watercolour ground (I)** This acrylic-based primer is available in either white or clear. It can be applied to a variety of surfaces using a brush. Once dry, it creates a slightly absorbent layer which makes it possible to use watercolours on surfaces which would be otherwise incompatible with the medium, such as wood, canvas and hardboard.

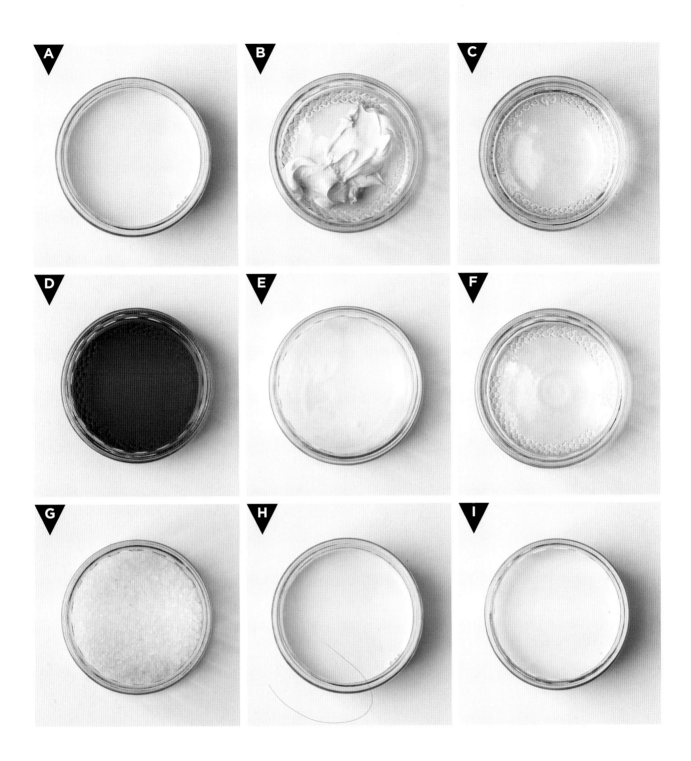

SETTING UP YOUR WORKSPACE

It is necessary to have a space where you are able to work on your artwork both flat and upright, and with all of your paints and materials within easy reach. It is perfectly possible to work in a fairly small, contained space, so do not be put off because you do not possess the large, airy artist's studio of your dreams. Many of the most talented, creative artists I know work from their kitchen table, or in small spaces put aside for the purpose elsewhere in the house.

I find it handy to be able to swap and change my methods in a moment, so decisions can be made quickly and my working position changed without effort. To this end, I usually use a flat 2m (6ft) table top with a table easel so that I can either stand or sit. This gives me a horizontal surface for wet techniques, where the materials need to be applied to a flat surface then allowed to dry. I sometimes supplement this with a stand-up easel next to the table for larger work.

Be prepared

It may sound obvious. but it's a good idea to have all your tools and materials out before starting work, even those you think you may not need. As the work evolves, creative decisions happen quickly. Many techniques rely on the paint still being wet, and having everything in easy reach means your creative flow is not interrupted by having to search for what you need mid-painting.

I recommend using a stay-wet palette for acrylics (as shown in the picture opposite) to keep the paint moist. The clean central area will fill up quickly as you mix colours, so I supplement this with a large sheet of MDF, mount board or toughened glass beneath my easel, on which I mix my paints. This provides a much larger clean mixing surface that is handy to drag the pigment onto, especially when mixing with a palette knife or large brush.

For watercolours, ceramic palettes with mixing wells are perfect; there are many options available on the market.

Water becomes dirty very quickly, so it is a good idea to use large pots of water for washing your brushes and smaller pots of clean water for painting. This will prevent the need to change the water every few minutes, and it also helps to avoid sludgy colours in your work.

COLOUR

The coast, with its ever-changing weather and light conditions, presents a vast array of colours. Before deciding upon the colour palette for your seascape, you need to examine your reference material, studying the range of different hues. Colours in nature are often rather subdued; the drama often emanates as much from the mix of light and dark tones and combination of warm and cooler colours as from the hues themselves.

COLOURS AND MIXING

To understand the varying qualities of colour, experimenting with and mixing colours together and examining the results, really, really helps. If you are starting out with painting, I urge you to keep practising your colour-mixing and explore the combinations of alternative colour mixes. Over time this will pay dividends, as you will be able to mix any chosen colour and at a glance recognize small subtleties of tone, the process eventually becomes instinctive.

The same pigment can be called by an alternative name by different manufacturers. Watercolour paints can be called by different names to your preferred acrylics, too. A way of checking that you are obtaining the same colour is to look at the pigment code on the label, e.g. PY Pigment Yellow. To begin with, looking at the colour swatch provided beneath the tubes, also online and in art shops, is a good enough guide. Over time you will become familiar and an expert with your own personal favourites.

Basic palette of colours

The majority of colours you will require can be mixed using the following basic palette. Of course, like myself, you can add more colours as you progress, experimenting and trying out new options. For ease of use, all colours listed are from the Winsor & Newton's Professional Acrylics range, with notes on watercolour equivalents with very different names. Feel free to find your own alternatives as described above.

Titanium white This is very opaque, so it is great for mixing with all other colours – adding even a small amount brings out the colour in all hues. I use so much of this I buy it in large 500ml tubs for better value.

Ivory black I never use this in isolation, but mixed with other dark colours it produces a rich dark shadow for small deep recesses. I also add tiny amounts to dull down colours.

Cadmium yellow light Has a great opacity and mixes fabulously with all colours. It makes wonderful greens with either ultramarine blue or phthalo blue and a touch of titanium white. Cadmium yellow pale is the watercolour equivalent.

Yellow ochre Excellent for mixing with various blues to create subtle-toned greens, and useful very watered down as a warm glaze. I mix a tiny amount to titanium white to add a glow to sea foam.

Raw umber This is an earthy, subtle colour that mixes well with other colours to both tone them down whilst simultaneously warming them up. It is not a very

saturated pigment so it can be used as a glaze over an entire painting to add a subtle glow.

Burnt umber This dark colour is perfect to use for shadows, especially when mixed with other deep colours, also for adding in very tiny quantities to tone colours down. Sepia is a good watercolour alternative.

Ultramarine blue When mixed with titanium white, this creates a clear summer blue sky. With the addition of a tiny touch of burnt umber, it forms a subtle base for a realistic sky which will sink into the background. The equivalent watercolour is called French ultramarine.

Phthalo blue (green shade) This is a strong colour which makes incredibly bright turquoise blues. It can be used alone, thinned down, or mixed with white. It combines well with other colours and creates wonderful greens with all tones of yellow and ochre hues, but beware of using too much, as it is so saturated that it will dominate everything. Winsor blue is a close watercolour alternative.

Permanent alizarin crimson A very translucent, glossy, deep colour until mixed with white, when it forms a wonderful bright pink.

Cadmium red medium A very bright red. Very useful to mix with greens to create a rich brown. When mixed with cadmium yellow light it creates a rich, deep-toned orange hue which is effective in creating a warm glow to sunsets. It is simply called 'cadmium red' in Winsor & Newton's Professional Watercolour range.

CHOOSING YOUR OWN COLOURS

Having started with a basic colour palette (see opposite), my palette has increased over many years of painting to include a collection of additional colours that I find useful. Shown to the right are my own preferred colours. They include paints from the basic palette along with a few additions and substitutions that I have found to be useful, although not crucial.

When I start a new painting, I include all of these colours on my palette, even if the hues in a seascape are very subdued blues and greys. In order to help avoid waste, I use a stay-wet palette that means they remain usable for weeks.

Along with larger amounts of the main hues, I tend to squeeze out tiny amounts of the brighter colours in case I need them for changing a specific colour. I would rather have them there ready, even if they remain untouched, than have to stop mid-flow.

These bright, saturated colours are infrequently used, but very useful. Pink and purple hues are very useful for foreground flowers and glazes, for example. Turquoises are so easy to use as a base for bright, Mediterranean scenes (and so very beautiful) that although they are unnecessary, I tend to use them for ease and speed of colour-mixing. With the addition of cadmium yellow and white, turquoise is ideal to represent clear bright water. Similarly, I use dioxazine purple as a quick method to deepen and dull down all colours, adding it to burnt umber to create a warm dark tone.

I have on occasion purchased colours purely because I was attracted to them visually, only to leave them on the palette unused. Conversely, I work with colours I thought that I would never use on a regular basis, using them to add subtlety to other colours or to provide a warm, sun-infused glaze. Raw sienna is a perfect example.

Colours to suit the scene

In my examples on the following pages, you can see that the ocean can take on a variety of colours from the clear, bright greens and blues of the Mediterranean to icy cool greys, to the pinks and yellows of a reflected sunset. In an evening seascape, the colours will be very muted, approaching black in the darkest areas, with the occasional sharp highlights here and there. Once you have decided upon the main colours of your seascape, these hues will establish the feel and mood of your painting.

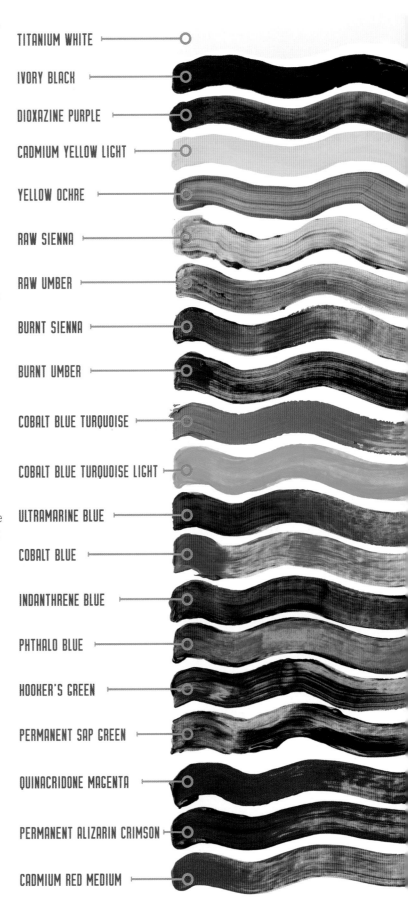

TITANIUM WHITE

IVORY BLACK

DIOXAZINE PURPLE

CADMIUM YELLOW LIGHT

YELLOW OCHRE

RAW SIENNA

RAW UMBER

BURNT SIENNA

BURNT UMBER

COBALT BLUE TURQUOISE

COBALT BLUE TURQUOISE LIGHT

ULTRAMARINE BLUE

COBALT BLUE

INDANTHRENE BLUE

PHTHALO BLUE

HOOKER'S GREEN

PERMANENT SAP GREEN

QUINACRIDONE MAGENTA

PERMANENT ALIZARIN CRIMSON

CADMIUM RED MEDIUM

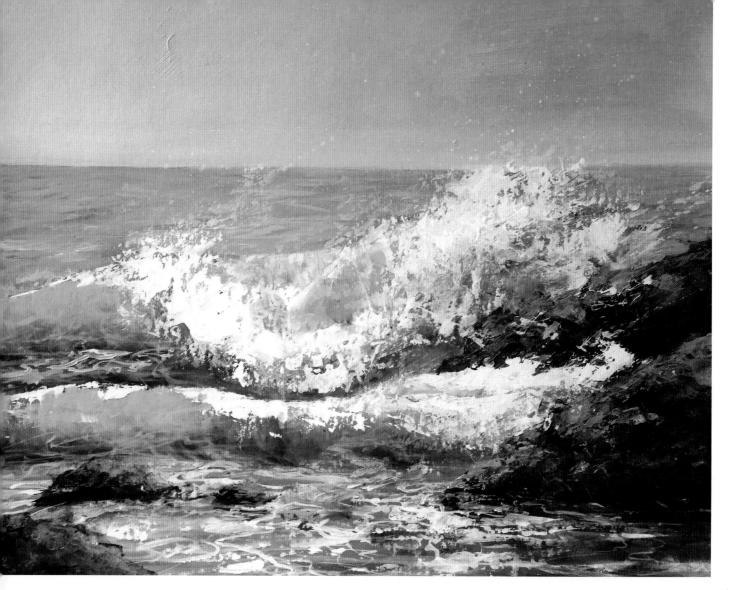

MEDITERRANEAN PALETTE

A fresh and clean palette is needed for the water in this painting. To create the illusion of the transparent sea, lit by the sunlight of the Mediterranean, I used pure watercolour in cobalt turquoise, Winsor green, French ultramarine and manganese blue hue for the base layers. I added the tiniest amount of burnt umber to the darker tones to take the searing brightness off them. The white foam was painted in acrylics and has a small amount of cadmium yellow added to create a warm glow.

The water moves from dark turquoise in the shadows to a clear bright green in order to depict the light shining through the top of the wave. The burnt umber, mixed with black for the rocks, creates a strong contrast against the bright clean areas of colour, making them appear even brighter.

The sky is a mix of ultramarine blue and titanium white. A mix with both more white and more lemon yellow was added to the ultramarine mix for a gentle tonal change, creating directional light moving towards the left of the painting.

TURQUOISE COAST
Acrylics and watercolour.

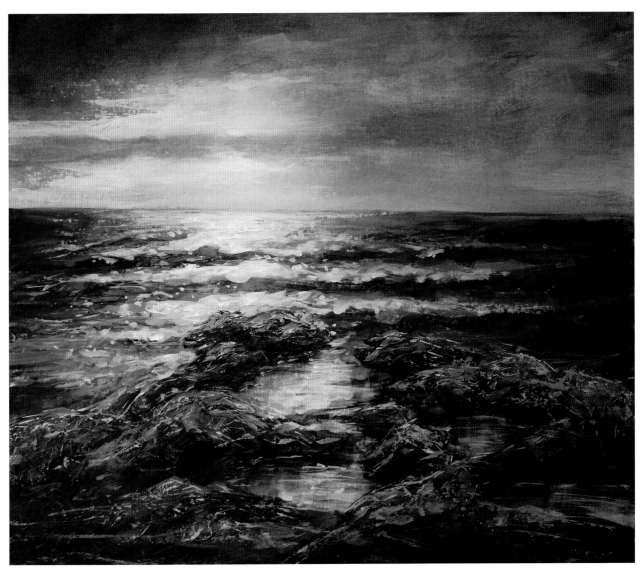

EVENING PALETTE

For this painting I wanted to suggest a watery
sun going down behind brooding dark clouds.
I used subdued colours throughout to achieve the
effect: the very deep shadows on the rocks are a
mix of black and burnt umber; the rich deep blue
shadows on the water are a mix of indanthrene
blue and black with the tiniest tip of white to bring
out the colour; and the mid-tones of the water
were created using a mix of indanthrene blue and
phthalo blue, titanium white and a tiny touch of
raw umber. All the colours have been muted to
suggest evening light. Even the lightest highlight
is a creamy beige, but this appears brighter
against all the darker tones.

NIGHT SHEEN
Acrylics and watercolour.

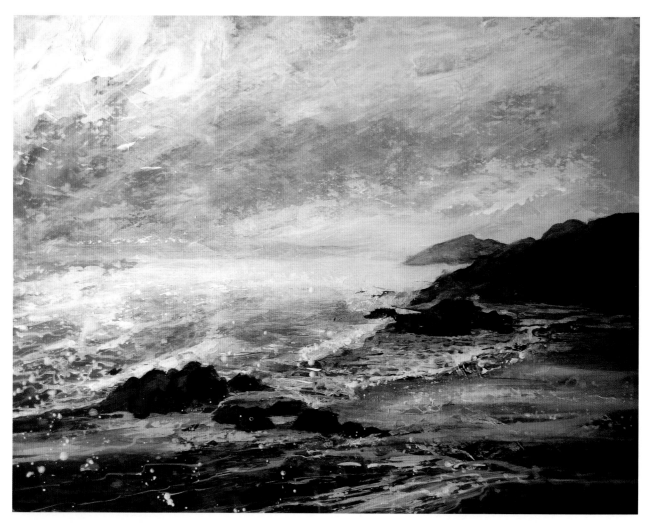

WINTER PALETTE

The use of cooler colours in a restricted colour palette helped to create an icy, wintery feel to this painting. The cool greys and blues of the sky were painted with ultramarine, with the addition of a tiny touch of raw umber to warm up a few areas.

A blue-green was used for the mid tones of the water; this was mixed from indanthrene blue, Hooker's green and titanium white with a tiny amount of ivory black to tone it down. The rocks are a mix of indanthrene blue and black to create a cold dark tone. All the colours were mixed with plenty of titanium white for a hazy, misty effect.

SUNWASHED, WINDSWEPT
Acrylics.

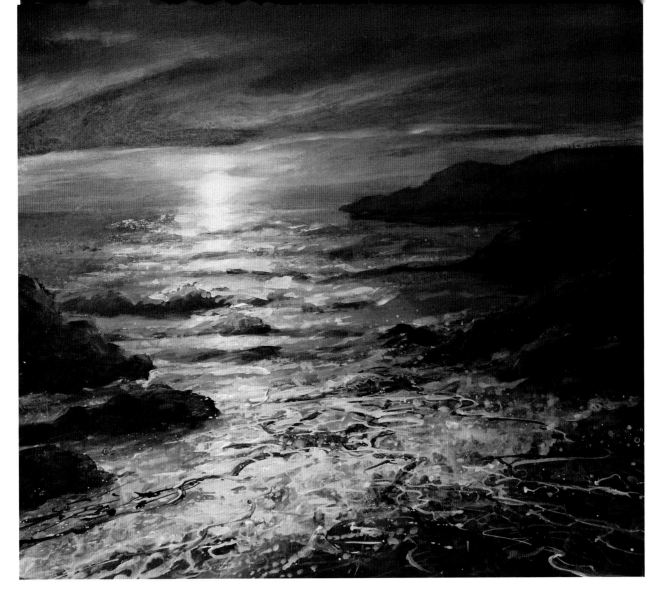

SUNSET PALETTE

To create a subtle, subdued glow in this painting, I used muted, warm colours to contrast with the deep, dark tones of the shadows.

The brightest area of sunlight was created using titanium white mixed with cadmium yellow and a touch of raw sienna. For the subtle orange glow, I mixed cadmium red with cadmium yellow and a touch of burnt sienna. I added glazes of dark purple to the sky and brighter flashes of mid purple – mixed from dioxazine purple, raw umber and white – to the shadows on the water. These purples contrast with the oranges, and the effect enlivens and invigorates the painting.

BURNISHED SHORES
Acrylics.

BALANCING COLOURS

It is essential to balance out tones throughout a painting to avoid a boring monotone effect. Using a combination of bright, mid and dark tones will ensure that a painting sings.

Placement of the areas of colour is also important. For example, painting neutrals next to bright colours will immediately emphasize the bright colours – far more than if they are surrounded by other equally saturated hues. This works especially well in a seascape, where you can reserve those final clean brights for tiny glints of bright light and for small areas such as the very top of a wave where the sun shines through.

Complementary colours

Complementary colours are those opposite one another on the colour wheel: for example yellow and purple; blue and orange; or red and green. When mixed, complementaries neutralize each other to make grey, but when simply placed side by side, they make each other appear more vibrant.

Complementary colours can be used to great effect in a painting, by balancing the dominant colour with its complementary. For instance, a rich deep blue can be used with a sandy ochre as a contrast. It has a very pleasing result that makes both areas shine.

Be sparing with white

It is tempting to use white paint straight out of the tube when creating highlights, foam and sea spray, but too much searing pure white can sit unnaturally on the surface and look unconvincing. Avoid this by adding a tiny amount of colour to the titanium white to create a subtle and delicate tint. Try using cadmium yellow light, yellow ochre or ultramarine blue: it will still read as a white highlight whilst looking much more natural.

Colour and perspective

Warm colours attract the eye, while cool colours appear to recede. You can use this to create a sense of depth and distance in your paintings using colour.

Use warmer, cleaner colours at the front with a stronger tonal contrast; this creates the appearance of it being in the foreground. Use colours which are closer in tone towards the horizon; in cooler, more muted, blueish-purple tones. This will help to make the background sink away.

MIXING COLOURS

I enjoy using colours in both a traditional and a more experimental way. Many colours in nature are very understated and I find the interaction between these muted colours to be one of the most beautiful aspect of a painting.

With that said, I often give nature a helping hand by emphasizing certain hues for a more dramatic final result in an otherwise naturalistic artwork. However, avoid using too much bright, saturated colour straight out of the tube. It can result in a very jarring, lurid piece of work that is uncomfortable to look at. Using a more subtle, subdued version of the pure colour will give you a more natural, convincing option.

Subtle colour mixing requires practice. Subdued tones work beautifully alongside a more individual approach to colour. When mixing muted tones, my tip is to remember to add the tiniest amount of colour, a 2mm (¹⁄₁₆in) square dot of paint makes a big difference: it can be enough to take the searing brightness off the pure colour. Remember that you can always add more, so build up tiny amounts until the desired effect is acquired. It's much easier to add colour than to take it away.

Methods to mix subtle tones

These swatches demonstrate how the addition of small amounts of different paints can dramatically tone down a clean bright hue. The base colour used each time is an equal mix of phthalo blue and titanium white. The surrounding swatches were mixed using various added colours to tone down the original blue.

- **Warming** A mix of burnt umber, raw umber and sepia is marvellous for this purpose. This is a reliable way of dulling down brights with a slightly warming effect and one that I personally use all the time.

- **Dulling** Adding black will make a colour darker but it will also make the colour duller, however it is useful in small quantities to add depth, especially to blues and reds.

- **Cooling** Combining purple with your bright hue will create a cooler, more muted effect than adding sepia.

- **Muting** Adding a complementary colour – yellow to purple; red to green; or orange to blue – will give a muted neutral hue. The smallest amount of paint makes a huge difference – if you add too much of a colour's complementary, the result will be a neutral grey.

- **Tinting** Adding white will lighten the hue, but also make it more pastel, reducing the vibrancy.

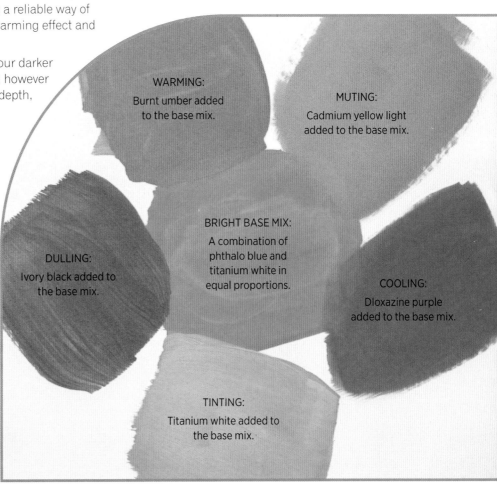

WARMING:
Burnt umber added
to the base mix.

MUTING:
Cadmium yellow light
added to the base mix.

BRIGHT BASE MIX:
A combination of
phthalo blue and
titanium white in
equal proportions.

DULLING:
Ivory black added to
the base mix.

COOLING:
Dioxazine purple
added to the base mix.

TINTING:
Titanium white added to
the base mix.

UNDERSTANDING THE SEA

The sea is both an exciting and challenging subject to paint. From clear tropical waters to dark, churned-up stormy seas, with all their changing moods and raw energy, the different aspects of the ocean are all fascinating. I think this explains why it remains an eternally appealing subject and source of inspiration for artists.

When trying to recreate the constant movement and translucent, reflective qualities that we find so beguiling, it can be confusing knowing where to start – there seems to be a huge amount of visual information to absorb.

The ocean is endlessly changed by the weather and the light conditions. Each element affects the appearance of the sea, causing it to display totally different colours and reflective qualities by the hour. This is part of the delight and appeal of the sea – and also a source of frustration when trying to capture it in paint.

When I am trying to decide which details to include in a painting, I find it advantageous to break down the different elements of the sea into layers. This helps me to make sense of all the information in front of me, and also enables me to decide which details to include in the painting and which to leave out.

Opposite
CRASHING SURF
50 x 60cm (19¾ x 23½in)

My main aim in this acrylic on canvas painting was twofold: I wanted to show the translucent quality of the water, along with the patterns made by churning foam and crashing waves. The main body of water was built up in thin layers, using a watery mix of ultramarine blue, Hooker's green and a tiny touch of sepia acrylic paint to add subtlety. I used loose, directional brush strokes, to retain the energy in the painting and to describe the movement and shape of the waves. When glazes of thin watery paint are loosely worked over each other, some of the underlying marks remain visible, which creates an interesting multi-layered effect. This technique suits the subject of seascapes, by suggesting the translucent layers of changing colour and light through the water.

Titanium white was added to the sea towards the horizon to create both a sense of perspective and the reflections of the sunlight on the surface of the sea. To suggest the watery sun shining through the wave from behind, the colour was lightened towards the top of the wave, where the water would be thinner. To the dark blue-green base colour of the water, I added increasingly more titanium white and cadmium yellow pale, gradually building up the colour to make it appear brighter towards the thinnest part of the the wave.

In the foreground, I used a rigger to describe the foam tendrils on the surface of the churning water, using loose brush strokes and a wet wash of titanium white. To suggest the sand showing through the shallow water in the foreground, I used a thin ochre wash of colour over the previous marks. The sea spray was added using a toothbrush and dry brush technique to suggest the various types of water droplets. I used a mix of titanium white, ultramarine and sepia for the areas in shadow; then changed to pure titanium white in a single cream consistency for the flicks of spray for the final highlights.

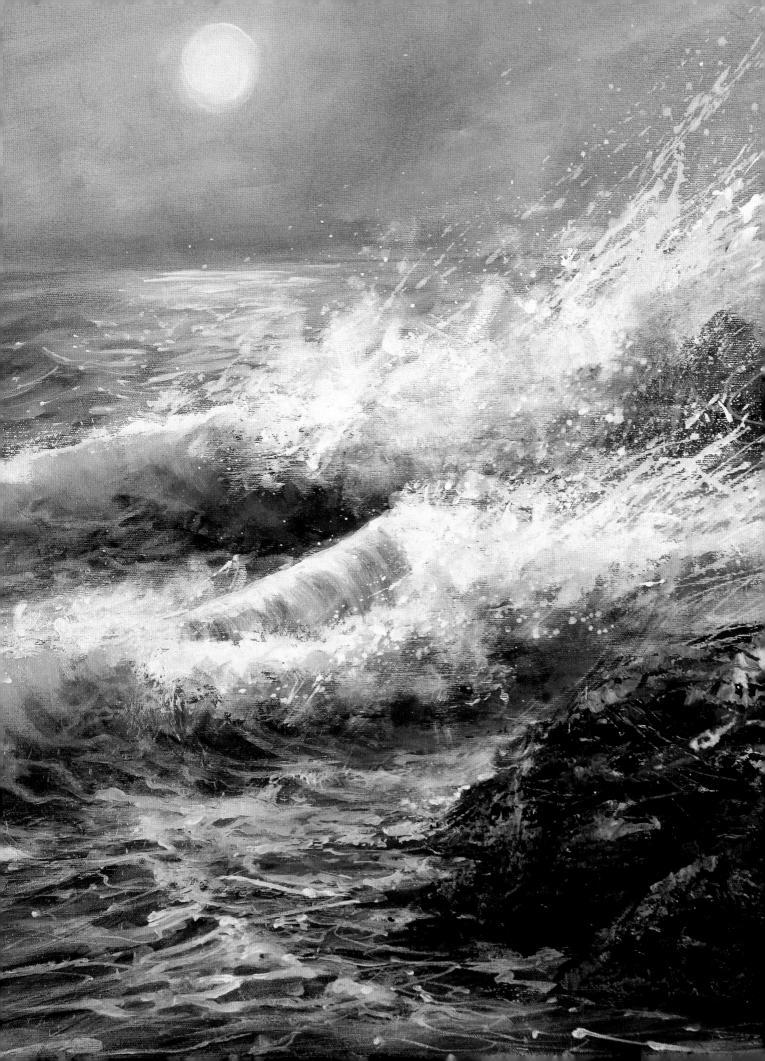

SURFACE REFLECTION The sea possesses a mirrored surface that reflects the sky. Painting the sky on top of the base colour of the sea immediately creates the illusion of the surface of the water. A mix of ultramarine blue and titanium white can be used for a clear blue. For a wintery sky, a soft blueish-grey tone mixed from titanium white, burnt umber and phthalo blue works well. Here, a mix of titanium white and ultramarine blue with a touch of burnt umber was used for a subdued tone. I used delicate, slightly arched brush strokes to suggest light hitting the curved surface of the waves.

WAVE INTERIOR As a wave rears up and breaks, it allows you to see into the depths of the sea beneath the surface. I have heard this described as a 'window into the sea', which is so appropriate. This is especially visible when the sun shines from behind the wave and cuts through the water, creating brighter patches within its depths. To suggest the light cutting through the top of the wave, I added more titanium white and cadmium yellow to the base colour of the sea and painted slightly brighter tones towards the top of the wave.

FOAM A breaking wave creates white foam, which is aerated water. This always contains its own shadow, and it also creates a shadow on the sea below. The white reflects colours around it and so will never be pure white. Instead of using pure titanium white, try mixing in a little blue and purple. There will also be areas showing warmer reflected light, which can be made with a mix of titanium white and yellow ochre. Creating slightly different colours within the foam will create a more convincing result.

The shape and form of foam will vary depending on the size and height of the breaking wave. Try not to create too many hard edges within the foam; instead use lost and found edges to suggest an airy quality. To keep the edges soft I used a very dry brush containing different mixes of titanium white, ultramarine blue and burnt umber, and used a scrubbing motion to create a soft misty effect to sit beneath the sea spray.

DEMYSTIFYING A COMPLEX SEA

Here is a breakdown of the sea showing all the various elements that would be visible in perfect conditions.

WAVES Waves are made up of troughs and peaks, which can be described with highlights and shadows. Waves are affected by the weather conditions and each wave is different in size and shape. Each large wave is also made up of smaller waves.

To create the shadow on the water in this example, I used a thin wash of indanthrene blue mixed with burnt umber at the base of the wave. I also used this beneath the foam where the light would not reach. Using glazes of colour in this way subdues and unifies the base colours. You can then paint highlights on top which will glow against the more subtle tones.

SEA SPRAY A powerful wave creates sea spray, which flies off the top of the breaking wave. This creates tiny sparkling particles. Sometimes larger water droplets or foam splash off into the air, too, creating dynamism and drama. The water droplets are never all the same size and it looks much more realistic if you create different types of spray with different methods. I used a variety of techniques to create the spray here, including stippling with a brush, splattering with a toothbrush and, for large water droplets, splashing with wetter paint from a distance.

REFRACTION Moving, rippled water acts as a lens bending the light. Wavy broken patterns of light can therefore be seen cutting through deeper water. In shallow, clear water, the light can be seen shimmering onto the sea bed in bright undulating forms. The light showing through the depth of the water in is often brighter and more saturated than the main body of water. Here I mixed the greenish sea colour from Hooker's green, indanthrene blue and burnt umber with a small amount of titanium white. I added extra green and cadmium yellow to create this refracted light effect.

SEA FOAM TENDRILS The foam moves over the surface of the sea and is pulled up the face of breaking waves, drawing the foam in elongated strips. It moves over and around small waves and sea swells and consequently it describes the shape of the swell. This can be a useful device for emphasizing the churning of the water. In the shadow it will show as a darker purple–blue tone than the lighter foam in sunlight. To keep the feeling of energy on this example, I used fast, very loose brush strokes, with wet white paint and the edge of a flat brush.

SEA BED The colour of the sea depends not only on the reflected light and clarity of the sea but also the surface of the sea bed, which will show through the water up to a certain depth. In the shallow water near the beach, the ochre colour of the sand shows through, resulting in a light green/yellow tone. Layers of seaweed-covered rocks in amongst the clean bright turquoise sea can make the surface appear very dark grey in patches.

ROLLERS
40 x 40cm (15¾ x 15¾in)
Acrylic on canvas.

LIGHT THROUGH WAVES

The top area of a wave always appears brighter and lighter than the deeper, main body of water below, as the sunlight shines though the thinner part of the wave. The translucency of water in a choppy sea can be suggested using lighter, more saturated colours towards the top of the wave.

Adding yellow and white to the base colour along with a subtle gradation of tone will create a believable glow. The yellow used can be cadmium yellow light, cadmium yellow, lemon yellow or ochre; each will produce a different result. This method will work with any colour of sea, from dark greys to bright turquoises.

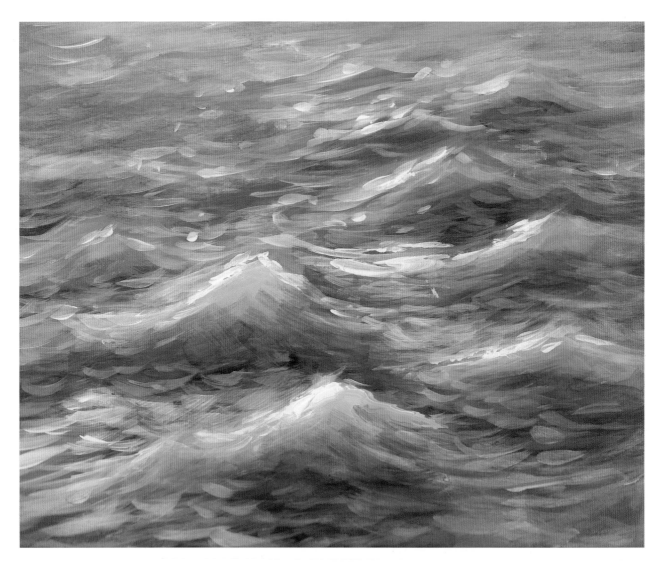

In this painting the sea changes colour slightly from one side to the other, as it often does in nature. I used more subdued, natural tones than in the step-by-step demonstration opposite. The highlight at the top of the wave is a mix of the base colour of each wave with added cadmium yellow and white, resulting in the same suggestion of thin translucent water, whatever the colour. Extra details can be added to this basic painting of a wave for a subtler, more convincing effect as explained on the previous page.

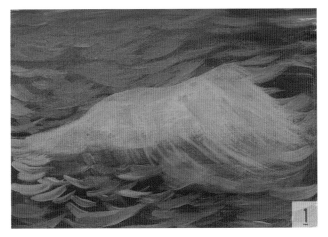
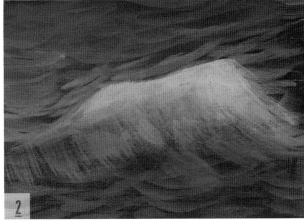
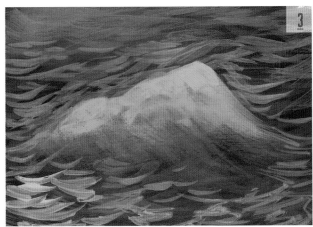
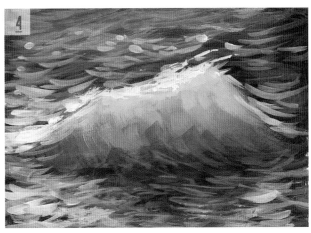

Building up a sunlit wave

1 Start by painting a deep blue background, using a mix of ultramarine blue, phthalo blue and indanthrene blue with a small amount of titanium white. Next, fill in a large simplified wave shape using a mid-tone of this background colour, plus cadmium yellow light and more titanium white. Use angled down-strokes in the direction of the wave to describe the curve. Use a mix of ultramarine blue and titanium white to paint the small blue waves with brisk marks of the edge of a flat brush. Build up a pattern of irregular, repeated, wide U-shapes to suggest the sky reflecting on the surface of the choppy sea.

2 Add cadmium yellow light and titanium white to the original wave colour (ultramarine blue, phthalo blue, indanthrene blue) and build up brighter, lighter colour at the top of each wave to suggest sunlight showing through the translucent water from behind. This can be repeated until the correct tone is achieved, slowly getting brighter and lighter towards the top. It is only by trial and error – through dabbing small amounts of the colour on the surface – that you will know when you have achieved the correct brightness for a believable result.

3 Paint an even brighter colour at the top of the wave, to increase the appearance of translucency. Add more titanium white and more cadmium yellow light to the mix, and gently blend the brushmarks in with a clean finger to merge one colour into the next. Once this is done, emphasize the light on the choppy water a little more using very watery white paint.

4 Add still more highlights to the very top of the wave to create a more subtle gradation of tone. Water is never one flat colour, so add a few subtle brush strokes of a warm mid-toned hue halfway down the face of the wave – add phthalo blue to the original mix to create this more saturated turquoise hue. To suggest the choppy surface reflecting the sky, quickly paint light blue sky reflections on the surface of the water, using ultramarine blue and white. Next, add dashes of whiter highlights in thick paint, at the high points where the sun would hit the wave. Finally, paint a glaze of indanthrene blue in front of the wave where the water would be in shadow, to unify and darken all the tones beneath. The addition of the final highlights and shadows always brings the painting to life and gives a more believable three-dimensional feel.

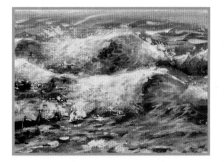

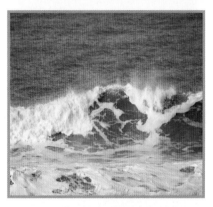

PAINTING *SWELL*

Brooding skies and extreme weather conditions have always inspired me. On trips to the North Wales coast, I have on many occasions encountered moody dark clouds with flashes of glinting sunlight. For this painting, I referred to sketches and photographic reference as a starting point – you can see them to the left – but built drama through more intense tonal changes and added dynamic marks for a sense of movement.

To emphasize the stormy skies in this painting I exaggerated the contrasts, using a mix of burnt umber and indanthrene blue to create the deepest tonal value. Following this, I slowly lightened the hues by adding yellow ochre to the mix. Finally, I created a contrasting patch of bright sunlight towards the centre using a mix of titanium white and yellow ochre.

For a soft gradation of tones, I blended the cloud forms together with the tip of a finger, while also keeping the area wet with an occasional spray of water from a water spray. The latter is one of my favourite pieces of equipment, as it helps to keep acrylics wet and malleable for easy blending.

I wanted to create as much churning movement as possible in the sea. For the background area of seawater, I used a very dilute mix of Hooker's green, indanthrene blue and cerulean blue, and a 15mm (¾in) short flat brush to apply the paint in wet, slightly curving strokes describing the direction of the waves.

To represent the light gleaming through the water and catching the churning movement of the waves, I used a rigger brush held lightly to paint a variety of vigorous expressive marks. This helped to create the lively, free-flowing effect. For the different tones, I used a fluid mix of phthalo blue and lemon yellow. A few finer marks were created by dipping cotton in thin paint before laying it onto the surface in curvy lines.

To create energy in the splashing foam, I loaded a size 15 palette knife with titanium white, then wiped some of the paint off again so only a thin surface layer remained. I then briskly scraped the semi-dry knife across the surface in an upward motion. This caught on the slightly textured surface of the canvas to create a broken misty effect. I also bounced a loaded knife off the surface in a sideways direction, leaving several interesting splashes behind. This adds to the feel of sea spray. Once this was dry, I then applied a very thin wash of yellow ochre over all this white, both to tone the whole area down a little and to add a suggested glow from the sun.

For the finishing touches, I used a single-cream consistency of pure titanium white paint and splashed it off a fully loaded brush with a whip-cracking motion, at a distance of approximately 40cm (16in) away from the surface, keeping a wet rag handy to wipe off any unwanted marks. The resulting splashes evoke the foam breaking away and flying into the air with force.

SWELL
60 x 60cm (23½ x 23½in)
Acrylic on canvas.

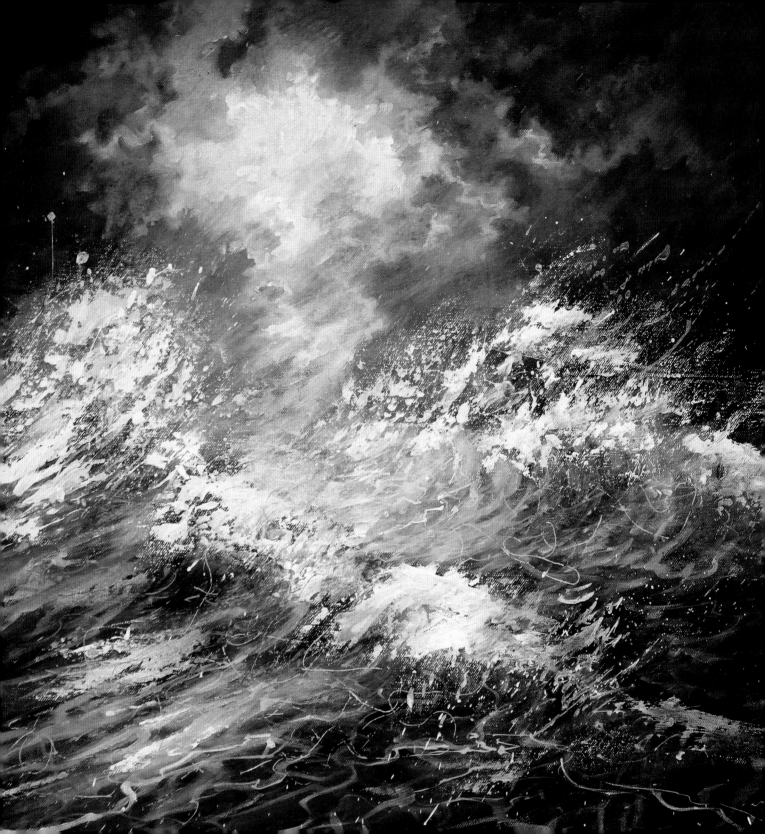

MARK-MAKING

Using a variety of marks within a painting adds considerable life and energy to the work. Conversely, using the same marks or brush strokes across the entire surface results in a dull, uninspiring image.

The previous pages have shown and explained some examples of how I paint my seascapes; now it's time for you to experiment. The following pages provide guidance and encouragement for a few of my favourite approaches, but be creative: try different methods of your own to apply paint and create interesting marks.

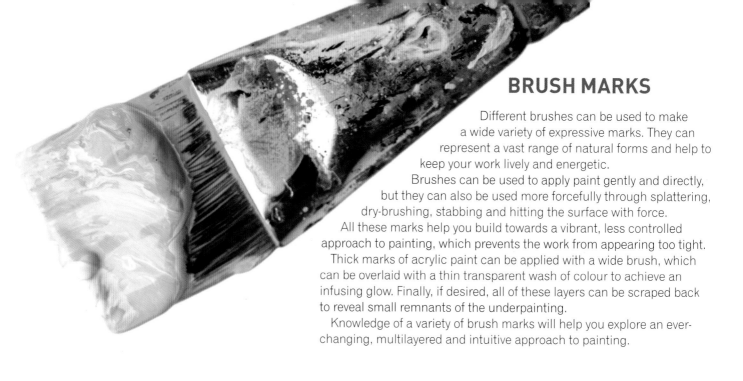

BRUSH MARKS

Different brushes can be used to make a wide variety of expressive marks. They can represent a vast range of natural forms and help to keep your work lively and energetic.

Brushes can be used to apply paint gently and directly, but they can also be used more forcefully through splattering, dry-brushing, stabbing and hitting the surface with force.

All these marks help you build towards a vibrant, less controlled approach to painting, which prevents the work from appearing too tight.

Thick marks of acrylic paint can be applied with a wide brush, which can be overlaid with a thin transparent wash of colour to achieve an infusing glow. Finally, if desired, all of these layers can be scraped back to reveal small remnants of the underpainting.

Knowledge of a variety of brush marks will help you explore an ever-changing, multilayered and intuitive approach to painting.

Using a flat brush

I mostly use flat brushes (see detail A), as these allow a great variety of marks to be made without swapping brushes. This allows for smooth, instinctive painting, and allows you to create everything from crisp, obvious marks that can describe the direction and shape of the subject to more effusive and fluid broken marks. Alternating bold, broad marks with smaller, more detailed lines helps to break up the surface, preventing the work from having the same 'pace' throughout.

Flatten the brush in the paint as you load it (see detail B), to give it a crisp 'blade' at the tip of the brush. Details C–E show the marks you can make with different parts of a brush loaded in this way. C shows the flat 'face' of the brush being used for clean, smooth strokes; D shows the blade of the brush being used to draw fine lines; and E shows the corner of the brush being used for tiny details.

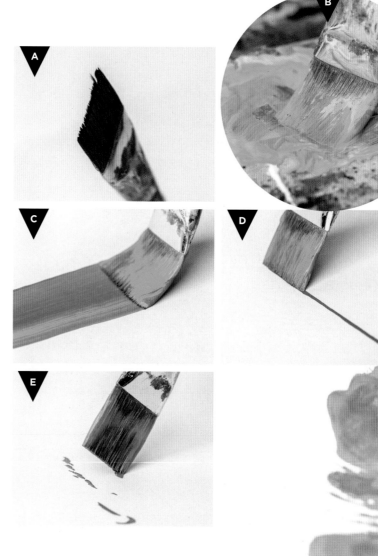

Expressive marks

The flat brush can be used a little like a pen, flowing from thick to thin lines. If you keep the blade held at a consistent angle, you can make wonderful calligraphic marks, as shown in detail A. Twisting the brush mid-stroke will change both the weight and quality of the line, introducing more fluidity to the quality (see detail B).

Twisting and applying pressure as you move will create more expressive marks. As more paint comes off the brush, the line will start to break up as the hairs are put under pressure and released. The speed at which you work and the consistency of the paint will also affect this. Details C and D show how the same thick paint can be induced to break up with speed and motion. This effect is great for picking up the texture of the surface and creating complexity and interest.

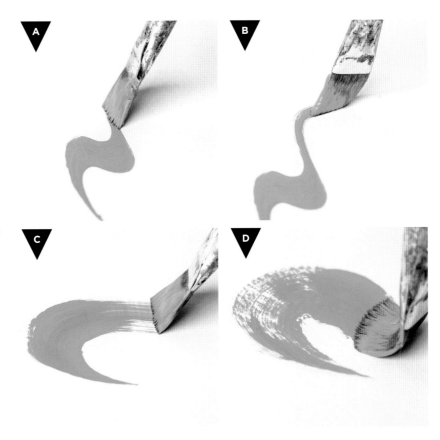

Loose gestural marks

In order to create large sweeping marks like that shown below, practise using the whole arm and body in the movement, together with a loose, drifting wrist. You can also try sweeping the brush lightly across the canvas in fast arching shapes – I can best describe this as being like the movement of a dance.

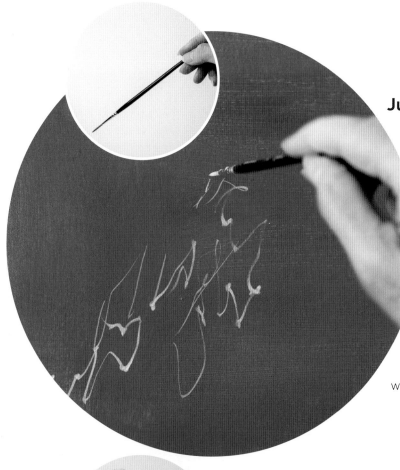

Juddering

Another totally different way of holding a brush is with tension in the hand and wrist. A frenetic, 'juddering' and partially uncontrolled movement creates a jolting tremor in the line when moved back and forth across a small area.

A rigger brush loaded with wet paint is perfect for this technique. Hold the rigger at the very end of the handle throughout, as shown in the detail.

Hold the brush perpendicular to the surface, almost upright, and put tension into your wrist. Use a juddering, jerking motion to scribble and draw. Keeping it in a loosely horizontal direction will suggest foam tendrils.

The marks made with this technique are suitable for a plethora of subjects; from foam and light on water, to organic textures and plant forms.

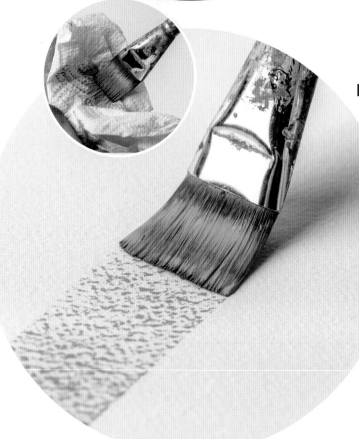

Dry brush

This technique creates beautiful broken strokes, which makes it a perfect technique to use anywhere when you require a soft gradation of tone. You can use any brush for this technique, but it works particularly well with flat brushes.

Load the brush as normal and wipe off most of the paint on kitchen paper or a rag, leaving a small amount of semi-dry paint amongst the bristles, as shown in the detail.

Use a light pressure to drift the brush lightly over the surface. This will pick up the texture of the surface and any high points of the painting. Test the result on a spare piece of paper – the stroke should break up, and just catch the surface of the paper.

Wet-on-wet marks

Allowing wet paint colours to merge together in a
loose, uncontrolled way works well for both watercolour
and acrylics, creating soft, atmospheric effects as the
colours blend.

It is an effective technique to use very thin washes of
colour, enabling the paint to find its own path across
a painting by tipping and tilting the wet surface at
different angles.

1 Thoroughly wet the surface, using a water spray for speed,
and spread it out with a brush.

2 Apply the colour either mixed with large amounts of
water or quite dry, in order to see the different effects that can
be achieved.

3 Tilt the work in different directions, allowing the paint to run
across the paper before bringing it back under control.

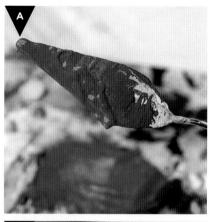

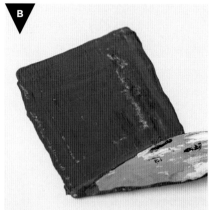

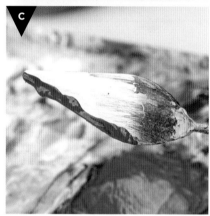

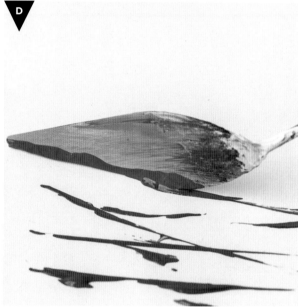

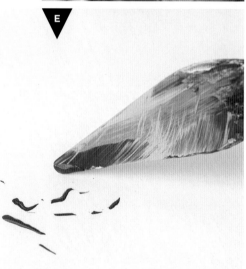

USING A PALETTE KNIFE

Marks created with a loaded palette knife can emulate so many natural textures. Try bouncing paint across the surface of the canvas using a palette knife to create smears and splashes with directional movement.

The face You can load the face of the palette knife, as shown in detail A, by running it through a well of paint in your palette. This can be used almost like a butter knife to create the smooth, clean marks shown in detail B.

Edge and tip Just like a flat brush, palette knives are versatile: you can use the edge for making linear marks, as shown in detail D, and the tip for applying fine detail as shown in detail E. It's not so precise as a brush, but the marks you make have a pleasing and distinctive appearance. When loading the brush to use the edge or tip (see detail C), run the side of the knife through the paint, rather than covering the face.

A semi-dry palette knife smeared across the surface of
a painting at a shallow angle will rub along, creating a
broken effect that emulates natural textures.

Palette knife smearing

Because palette knives are hard-surfaced, they
don't work into the recesses as a brush will,
allowing you to quickly build up large areas of
texture. As the paint runs out, the mark breaks up,
further enhancing the effect.

With practice this is a fast, effective way to
indicate light falling onto broken rock surfaces, or
textures like sand and earth. The top layer can also
be scraped into (see below) to create additional
texture. You can paint over the result once dry, and
repeat to steadily build up the tones.

Palette knife scraping

Palette knives can be used to remove
as well as apply colour, which allows for
dramatic colour layering and produces
intriguing results. The marks you reveal
will be affected by the consistency of the
overlaid paint, the part of the palette knife
you use, and the texture of the surface.

Here, a yellow underpainting was allowed to dry
before blue was painted over the top. While wet, part
of this second colour was scraped away with the tip and side
of the palette knife, revealing the underpainting.

PAINTING
SURF AND SWELL

This interpretation of churning waters on a shoreline was painted entirely in acrylics. It's a great example of how variety in the marks you make will allow you to build up a convincing sea surface. A lot of the basic mark-making techniques on the previous pages were combined here, together with some of the more unusual techniques that we are about to explore in the following chapter.

The base coat was painted whilst the canvas was flat on the table. I covered the entire surface with a very watered-down wash of process cyan, Hooker's green and indanthrene blue. Whilst the paint was still wet, I added a few drops of methylated spirits to create interest. The resulting organic circular marks are still visible in the base layers, suggesting seaweed, fauna and rock formations. For this technique to work, the paint needs to be damp but not too wet.

To suggest the foam and light hitting the surface of the water, I used brisk brushwork, applying the paint with a thick round brush loaded with dilute titanium white. The small wavering highlights were created in titanium white using very wet paint on a fine rigger brush. This was held gently by the tip of the handle to obtain a loose wriggly, slightly uncontrolled line (see page 44). The aim was to keep a feeling of vigorous motion in the work by using brisk movements. To suggest foam bubbles in the surf, methylated spirit was applied in drops onto a very wet mix of titanium white at the bottom of the image.

Splashes of paint were added by loading a wet rigger brush with wet titanium white then using a 'whip crack' motion from around 60cm (2ft) away to apply the paint. As ever, a wet rag was at hand to wipe away stray, unwanted splashes.

SURF AND SWELL
76 x 50cm (30 x 19¾in)
Acrylic on canvas.

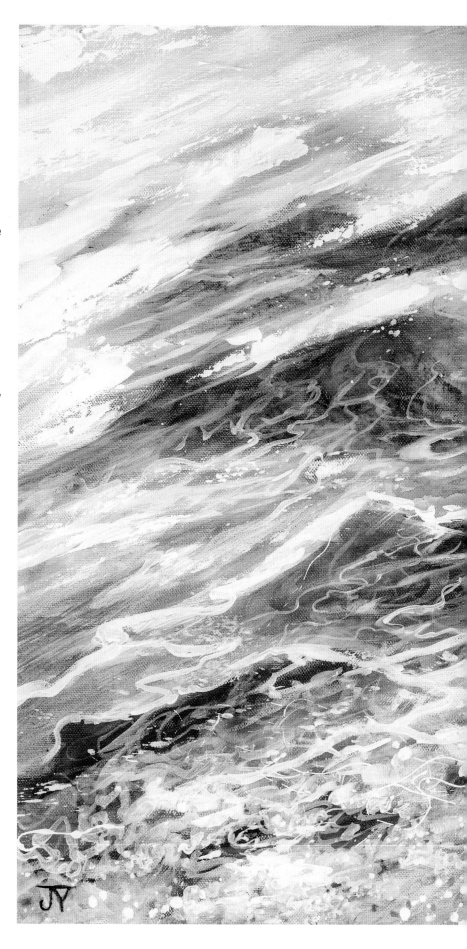

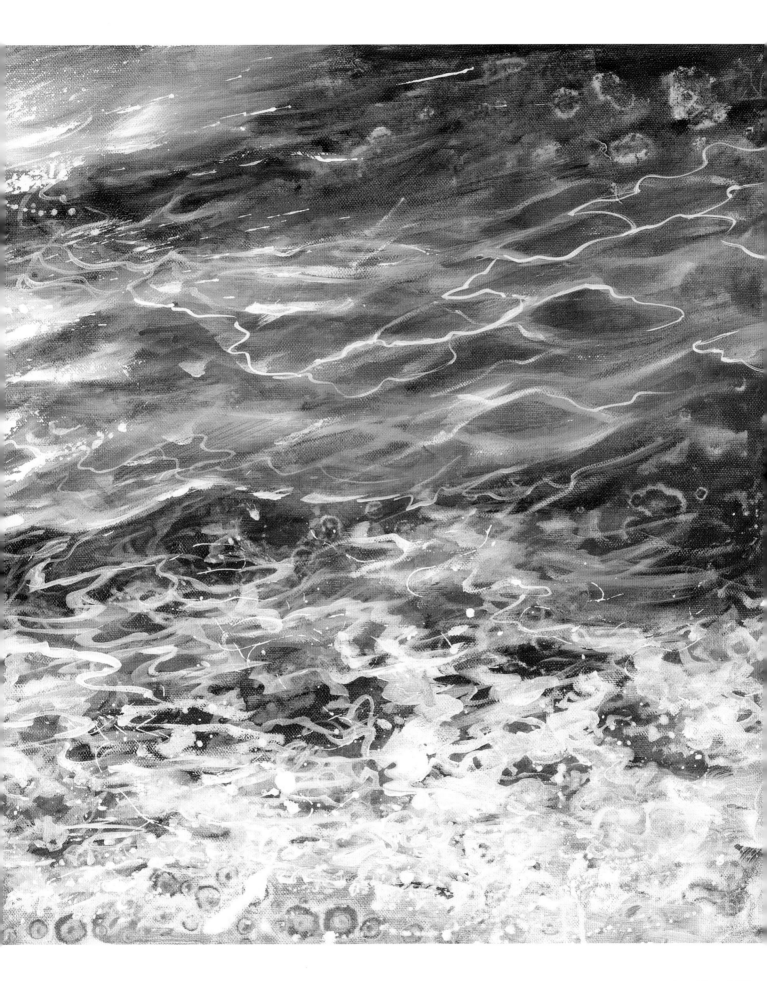

Wet acrylic drips over watercolour.
Detail from *Tide Tracks*, on page 69.

PVA glue overpainted with acrylic, then scraped with a palette knife.
Detail from *Island Bay*, on page 56.

Granulation medium over acrylic .
Detail from *Sea Surge*, on page 7.

Table salt on watercolour.
Detail from *Echoed Gold*, on page 63.

Salt crystals on watercolour.
Detail from *Evening Fell*, on page 125.

Salt crystals on watercolour, allowed to dry upright.
Detail from *Echoed Gold*, on page 63.

Textured Paste with acrylic colour wash.
Detail from *Barmouth Light*, on page 135.

Gesso with multi-directional texture.
Detail from *Sea Spray*, on page 131.

EXPRESSION AND
DYNAMISM

Having worked naturalistically for many years, I began to realize that I needed to bring added interest to my work. Once I started experimenting with a variety of new techniques and different, looser methods of applying paint, I found myself inspired and excited by the results. I was fascinated by the underlying, half-exposed details that began to show through the surface of my paintings. I found it liberating to realize that there were no rules with this way of working, giving rise to new horizons and fresh possibilities.

Gesso texture with acrylic drips.
Detail from *Soft Sand Shimmer*, on page 142.

PVA glue with dry-brush acrylic.
Detail from *Tide Tracks*, on page 69.

Granulation medium with watercolour.
Detail from *Tide Tracks*, on page 69.

Methylated spirits on acrylic wash.
Detail from *Echoed Gold*, on page 63.

Granulation medium added to acrylic
and allowed to run.
Detail from *Tide Tracks*, on page 69.

Gesso texture overlaid with
dry brush acrylic.
Detail from *Indigo Seas*, on page 139.

Methylated spirits on white acrylic.
Detail from *Surf and Swell*, on page 48.

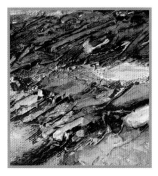

Heavy textured paste and acrylic.
Detail from *Sand Rivers*, on page 122.

EXPERIMENT WITHOUT PRESSURE

I would like to encourage you to experiment with your paintings. The following pages explain some of my favourite techniques, but there are many more effects to discover with acrylics and watercolours. Finding your favourites and trying out new methods will help you to create your own interpretation of your subject.

This loose, intuitive way of working is both enjoyable and exciting. Through it, I know you will discover new possibilities in your paintings, making you feel reinvigorated and inspired. By combining a range of different media and experimental approaches, you will discover many intriguing effects and interesting textures that would be difficult or impossible to achieve with traditional painting techniques alone. The resulting textures suggest many aspects of the coast, from natural forms to atmospheric skies, with dramatic and often unpredictable results.

All the softness of the underlying techniques contrast with the more definite, vigorous brush marks on the surface layers, particularly useful when describing waves and cloud forms. The combination of these loose, experimental effects, along with more disciplined brushwork, will help to create a believable image. The results will be a happy mix of the traditional and the experimental.

I find it is rewarding to spend time experimenting without the pressure of creating a finished piece of work, and I suggest you give it a try too. This will enable you to try new looser techniques without feeling restricted by the need to create a perfect result. Consequently you are really 'playing' with paint and trying out a diverse range of options. Forget the rules and let the paint flow, drip and blend as it pleases, without attempting to bring the paint under control.

MY FAVOURITE TECHNIQUES

Demonstrated here are several of the techniques that I use on a regular basis. You can pick and mix from these processes to suit the needs of your subject and also use them alongside looser, less controlled applications of paint. I suggest that you explore and practise these on spare paper or board before moving on to trying them in a painting.

Prepare to make a mess. I do on a regular basis, and thoroughly enjoy being unconcerned with the results. By allowing the paint to 'do its own thing' and taking risks with a variety of techniques, you will move your work in an exciting new direction, be enthused by the creative process and create something surprising and beautiful too!

Many of my experiments end up being discarded or stored and worked into at a later date. Others feel like a breakthrough, and lead to a new technique or effect that I come to love.

I hope you also discover that the less controlled experiments often reveal the most beautiful results. Remember that being in control is not everything and that 'happy accidents' are inevitable. I suggest that you welcome them and make them work for you.

Working in layers

When I'm practising the techniques outlined here, I invariably incorporate several layers. I rarely leave a technique standing alone as it can appear too obvious. Instead, I layer the paint, either with additional techniques over the top, or simply overlay with a thin glaze of transparent colour.

Using glazes

I am a great fan of glazes and use them throughout the painting to build up soft, translucent layers. These can be applied with a very wet mix of acrylics over a base layer of acrylics or watercolour.

The use of thin glazes of colour unifies the underpainting, resulting in the techniques becoming less distinct and allowing a subtle suggestion of previous marks to show through. Highlights and lowlights can then be painted on top of this muted layering, allowing the colours to stand out.

These fragments of half-suggested detail add a little mystery to the work, encouraging the viewer to focus into the painting and search for partly-exposed, underlying detail. I feel that returning to a painting and discovering something new on each occasion is compelling and retains the viewer's interest – this technique helps you, the artist, to deliver that.

Glazes are semi-transparent layers of diluted paint that are painted over existing areas. They allow some of what is already there to show through, and create the impression of depth.

Salt

The application of salt to a watercolour wash results in a variety of natural effects. The salt absorbs the water, drawing the pigment towards it. As the water dries, it leaves subtle marks. The paint needs to be quite wet for the best result, and the technique works best on a dark colour.

The results change depending on the wetness of paint, the amount of pigment used and whether you use crystals or table salt: the latter leaves a more subtle and scattered effect than salt crystal. The results are most effective when left to dry completely. The salt can then be brushed off the surface to reveal the full effect.

1 Apply a wash of watercolour and drop salt crystals on the wash at intervals. Straight away you will see the salt start to absorb the paint.

2 Leave the work to dry completely before brushing the salt away. Star-shaped or snowflake markings are left where the salt has absorbed some colour along with the water.

Granulation medium

Granulation medium is a clear liquid that can be added to a wash of watercolour paint or acrylics. It separates the pigment, creating an intriguing granular texture within the paint.

1 Apply your watercolour paint, acrylics or acrylic ink (as used here).

2 Use a pipette to drip the granulation medium into the wet ink (or paint).

3 Use a brush or tip the surface to help the granulation medium move and run into the paint and create patterns.

Tip
More medium can be added until the desired result is achieved. Try using a dry rag to lift off areas – it will leave interesting granulated textures.

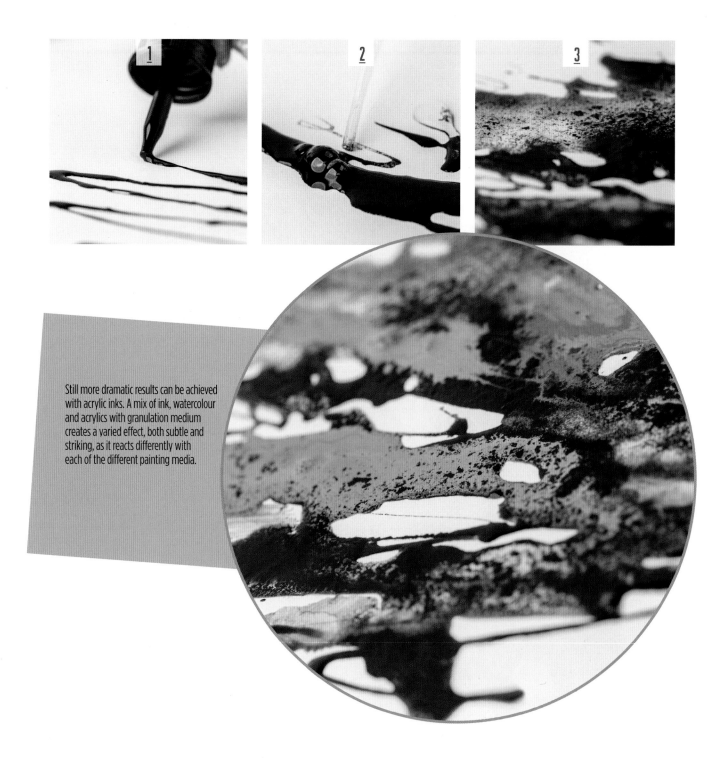

Still more dramatic results can be achieved with acrylic inks. A mix of ink, watercolour and acrylics with granulation medium creates a varied effect, both subtle and striking, as it reacts differently with each of the different painting media.

Textures with PVA glue

The beauty of using PVA glue to create texture is that, unlike textured pastes, it can be dampened once dry and made sticky again by applying water or paint over the surface. When the top layer is then scraped away, it leaves behind intriguing remnants of colour and texture.

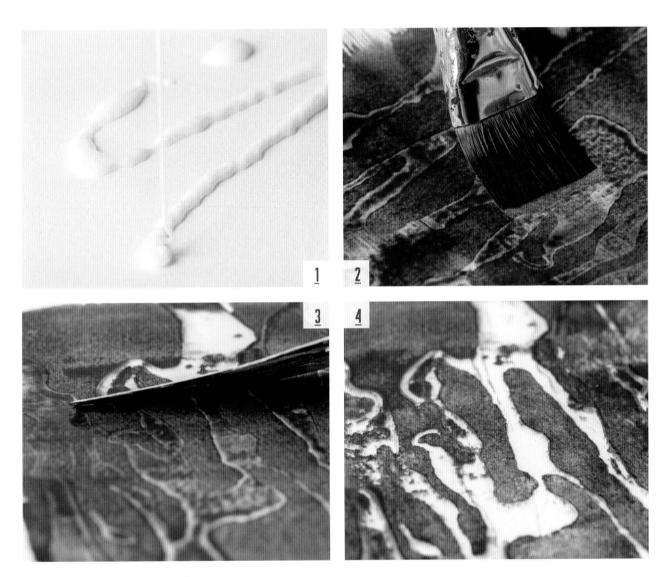

1 Apply glue from the nozzle onto the paper in various shapes and allow it to dry completely. This may take a few hours.

2 Cover the area with a layer of watercolour or acrylic paint in a single cream consistency.

3 After about thirty seconds – time to allow the glue to soften on the surface, but before the paint starts to dry – scrape over the surface with a palette knife.

4 The surface of the glue will be scraped away, leaving pale marks beneath. Allow everything to dry completely, and you can later glaze over the marks for subtlety.

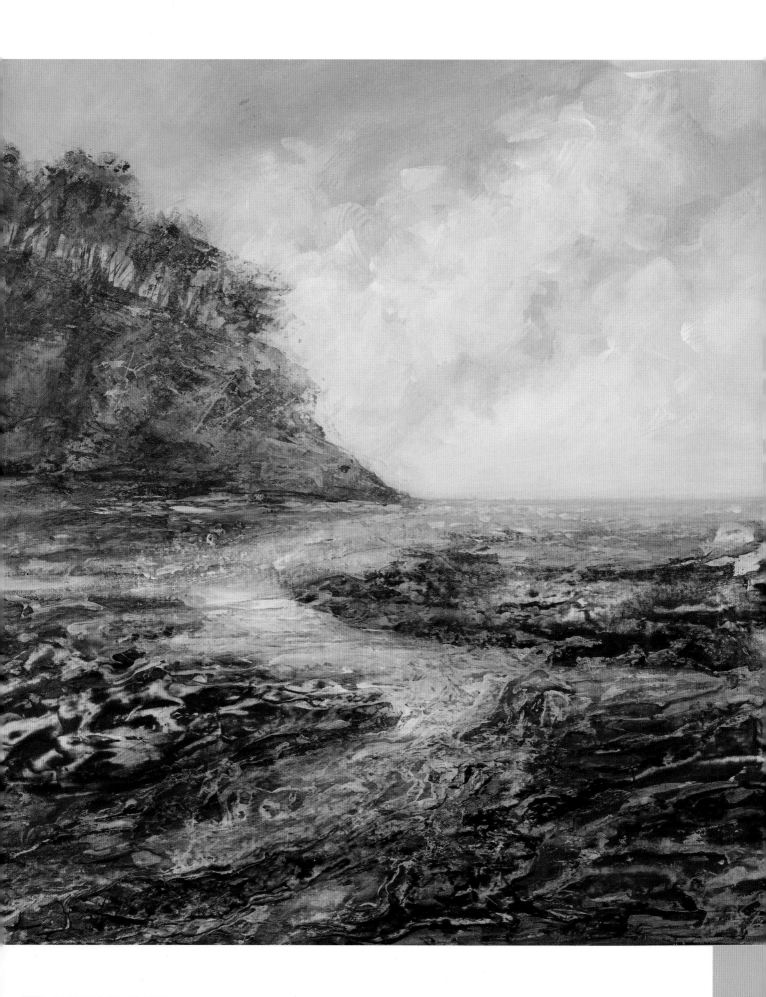

PAINTING *ISLAND BAY*

Seaweed-covered rocks in small hidden bays and pools of water – from which the unmistakable smell of seaweed emanates on hot summer days – are full of varied and interesting textures. To capture the fascinating tangle of textures in these areas without being too literal, I used a multi-layered approach in this painting.

Working over a loose wash of yellow ochre, burnt sienna and Hooker's green paint, I created the foreground texture for this painting using the technique on page 55, dribbling PVA glue from the tube in shapes that suggested the areas of rock and seaweed. After allowing the glue to dry completely, I covered the textured area with a thick layer of Hooker's green and burnt umber acrylics. Once the glue had started become sticky again, I scraped away the top layer of thick paint and glue using the edge of a palette knife, revealing a subtle patina and leaving remnants of colour around the edges of the shapes made previously. As you can see in detail A, the base layer and the underlying marks made by the glue are still visible. The effect is never totally controllable and always a surprise.

Working at an angle, I later dragged a layer of very pale green over the central area with a dry brush, held horizontally. This picked out the areas of texture and gave the impression of seawater running between the rocks and picking up light. The result is a loose, multi-layered suggestion of natural forms and textures. After paint and glue had dried, I glazed a very thin wash of gold ochre over the whole foreground (see detail B) to merge the techniques and colours together. The rocky coastline and trees in the background were painted over a slightly textured ground. This was created using a thick layer of acrylic paint, applied with a palette knife in the grey base colour (see detail C). Further dark grey areas were loosely painted with a palette knife.

ISLAND BAY
41 x 45cm (16¼ x 17¾in)
Acrylics on mount board.

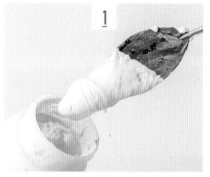

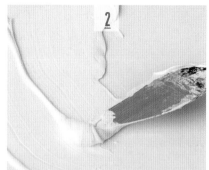

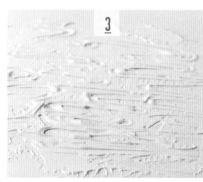

Using texture paste

Texture pastes, also called modelling pastes, can be smooth or coarse with a gritty texture. Both smooth and coarse pastes work well on all surfaces. Which you choose depends on your own preference. They are an effective way of implying detail while keeping the work impressionistic and not too literal.

By adding your own textures into the paste with various implements, a range of natural elements can be suggested. Objects can be pressed into the wet surface to create intriguing structures.

In smaller areas, the use of more definite marks and thicker texture works particularly well to suggest rough uneven ground, rock surfaces, seaweed and many other natural forms.

1 Apply textured paste from the pot onto your chosen surface using a palette knife.

2 Use the knife to smooth the paste to cover the area you require.

3 Marks can be made into the paste to suggest natural textures using the end of a knife or an assortment of implements.

4 A thick base layer of paint can be applied over the dry texture for a flat colour.

5 Once the paint has dried, a flat brush containing fairly dry paint can be dragged at an angle over the textured ground to pick up the raised surface and highlight the detail, implying light interacting with the subject.

6 A semi-dry palette knife can also be used to apply the top layer.

Tip
Rather than painting the whole areas after the paste has dried (as in step 4), you can skip to step 5 and applied paint over just the raised surface with the dry brush technique on page 44. This will emphasize the marks in the paste.

Various colours applied over the texture will run together creating subtle interesting effects.

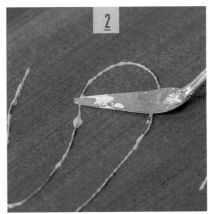

Printing with cotton

This is best done on a pre-painted base. A variety of objects can be used in the same fashion; covering them with paint, then pressing them onto the surface to create an unusual print of the texture. Cotton thread is ideal for creating linear, semi-random effects that are perfect for representing streaks of sunlight on water or refracted light through waves.

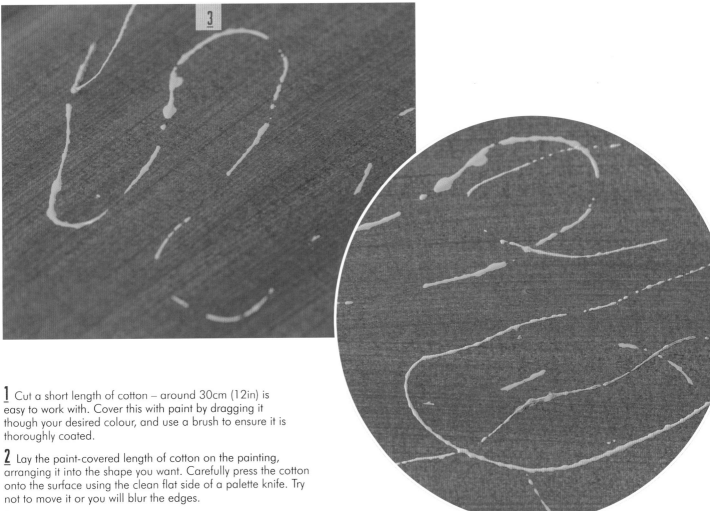

1 Cut a short length of cotton – around 30cm (12in) is easy to work with. Cover this with paint by dragging it though your desired colour, and use a brush to ensure it is thoroughly coated.

2 Lay the paint-covered length of cotton on the painting, arranging it into the shape you want. Carefully press the cotton onto the surface using the clean flat side of a palette knife. Try not to move it or you will blur the edges.

3 Carefully remove the cotton whilst still wet to reveal the marks.

Multiple layers, made in different colours, quickly build up into complex patterns.

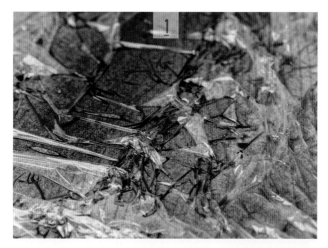

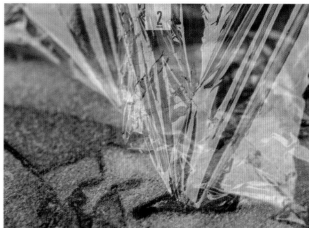

Plastic food wrap

Subtle textures can be suggested using plastic food wrap over wet paint. It works best on transparent watercolour washes and acrylic washes. This technique can also be used over thicker, more opaque, paint and removed just before it dries. It provides a perfect base, suggestive of natural forms, to work into further using other techniques. You can use more traditional painting methods to emphasize areas of the semi-random result that you particularly like, too.

Less absorbent surfaces such as mount board and gessoed hardboard create the most dramatic results. The technique also works on watercolour paper, albeit in a more subtle way.

1 Paint a wash over your chosen surface. While wet, crumple a piece of plastic food wrap and place it over the wet wash. Do not allow the wash to dry or it will not be effective.

2 Create abstract shapes by moving and pulling the plastic food wrap in different directions, then leave it to dry naturally. Once it is totally dry, pull the food wrap away to reveal the resulting textures.

3 The texture of the surface will show up and the results will be suggestive of natural texture and organic forms, in a non-literal, semi-abstract way. The marks will be darker where the plastic food wrap has touched the surface and drawn the wet paint to it through surface tension. Where the plastic food wrap has stood away from the surface, the areas will be lighter.

Methylated spirits

It is easy to achieve intriguing marks using drops of methylated spirits. This gives subtle results on watercolour, but the most dramatic results are achieved with watery washes of translucent acrylic paint without any white added.

You need to work fairly fast to make sure the paint does not start drying or getting absorbed by the surface; otherwise the technique will not show up. If the paint is too wet and flooding, it will look as though the technique is working well but the paint will then flow back into the area and ruin the effect. As with the plastic food wrap technique opposite, less absorbent surfaces such as canvas or gessoed board give the most dramatic results.

Start by applying a thin wash of acrylic colour to the surface. Aim for a glossy wetness with a good amount of pigment for the best results. While the wash is still glossy wet, but not flooding, use a brush to apply drops of methylated spirits to the wet surface, either by splashing from a height or by lightly touching the loaded brush onto the surface, as shown in the detail.

A glaze can be applied over the marks once they have dried, creating a subtle glow. Different colour washes can be applied for a variety of moods and effects.

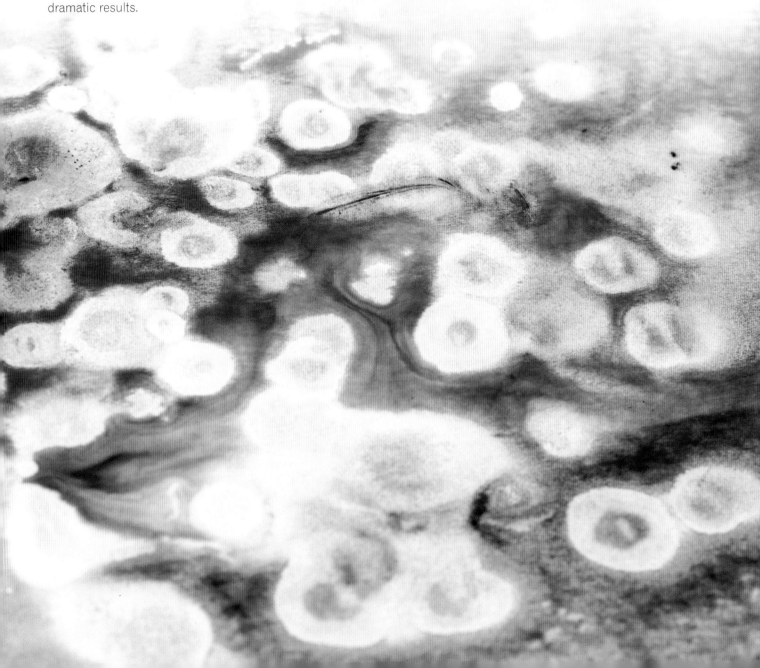

PAINTING *ECHOED GOLD*

Early evening by the coast is my favourite time of the day. In order to capture the colours of the fading sun across this still bay, I ignored the majority of the detail and decided to simply use colour and techniques to suggest reflections and light.

I made only a vague impression of the skyline and distant land to help it fade into the background. The sky was created with watercolour, applying wet indanthrene blue, yellow ochre and burnt sienna after I had thoroughly wetted the area with a spray bottle. While it was wet, I developed the sky by tilting the surface in different directions, encouraging the paint to flow across the surface. I drizzled table salt over the wet paint and once again tipped the paper in a sideways direction to create cloud forms (see detail A).

The results of using salt are random, unpredictable and different on each occasion but create appealing results. I also added a few salt crystals to the right-hand side of the orange glow of the sunset to create the larger, star sparkles in the sky you can see in detail B.

The sea was painted with acrylic washes in varied tones. A few drops of methylated spirits were applied to the wet paint to create large circular areas in the sea (see detail C) to suggest refracted light. Finally I glazed over the right-hand side of the sea with a wash of burnt sienna to reflect the colour in the sky above.

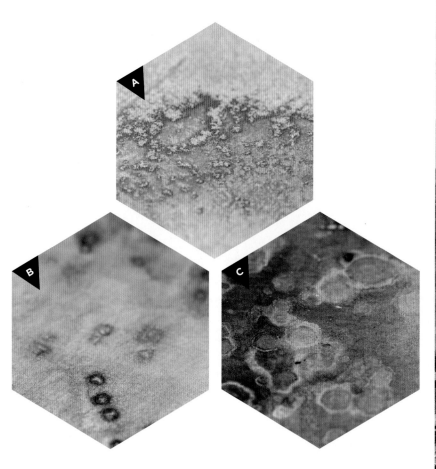

ECHOED GOLD
46 x 37cm (18 x 14½in)
Watercolour on 300gsm (140lb) Bockingford
Rough surface watercolour paper.

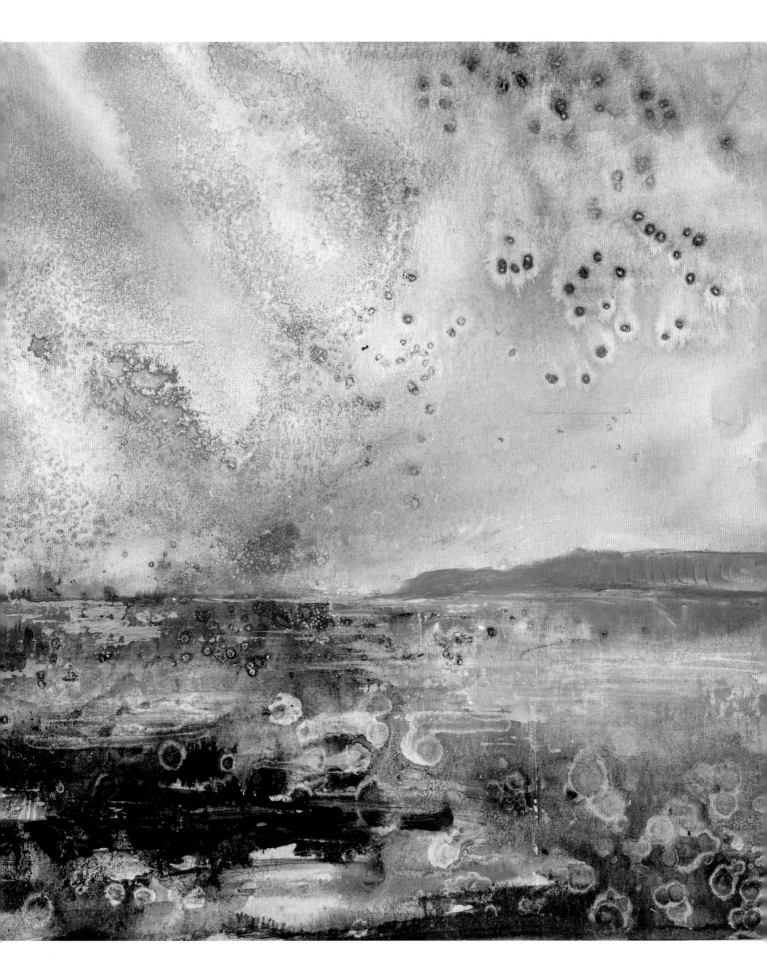

Dripping

Paint needs to be diluted until it flows readily for this technique. This is part of the reason for using high-quality paints, as these contain enough pigment to remain vibrant even when heavily watered-down.

Prop the artwork up, then use the tip of a round brush to deposit the wet paint at the top and allow gravity to take over: the fluid drops of paint will slowly make their journey down the surface, as shown in detail A. The more you can deposit with the brush, the further it will flow, so use a large brush for the most dramatic effects.

Acrylic inks are naturally fluid and work well with this technique. Being high in pigment, they form opaque marks, as shown in detail B.

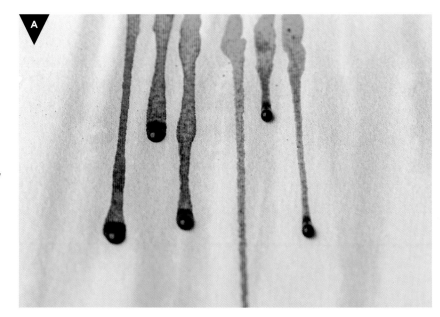

When wet paint or ink is allowed to drip through textures, it creates many wonderful unplanned effects, as the paint finds its own journey through the surface and picks out the detail. You might also try spraying the wet surface with water and allowing the paint to drip and merge.

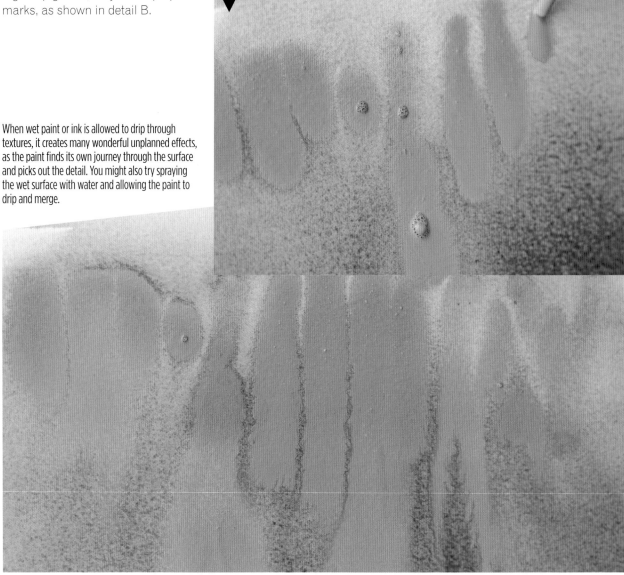

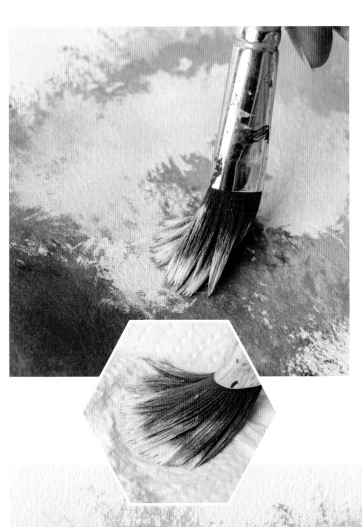

Scumbling

Scumbling is a handy way to add a sense of depth and colour variation to an area of a painting. A layer of broken, speckled or dry colour is added over the previous colours, enabling small areas of the underpainting to show through. It creates a soft, atmospheric build-up of tone.

Make sure that the underlayer is dry before you begin scumbling. Use an older brush, as this technique is tough on the bristles. I tend to use relatively large brushes for this technique.

Load the brush lightly and remove the excess on kitchen paper or a rag, as shown in the detail. You're not creating a dry-brush effect, but you want to avoid lots of fluid paint.

Holding the brush upright, make small, vigorous motions – as though drawing tiny stars – to encourage the brush to make loose marks with no obvious edges or strokes. As you work, twist and turn the brush to vary the angle; this helps to avoid edges and create a soft finish that will merge different areas together.

Scumbling is wonderful for atmospheric effects, like cloud, mist or spray. Because it interacts with, rather than covers, the underlying paint, it helps to 'knock back' the area. This makes it useful for building depth later on in a painting.

Speckling

I have owned a speckling brush for only a short while, but it has quickly become a favourite implement of mine. I love the effects that it can achieve. You can create a variety of marks from fine spray to huge blobs of paint. The size of the splashes depends on the thickness of the paint and the amount held within the bristles. Another factor will be how far you hold the brush from the surface.

Always keep a wet rag handy to wipe off mistakes and unwanted stray splashes. There will be many with this method of working, but the end result is well worth the effort spent cleaning up.

Tip

A good seascape painting requires a multitude of splashing and splattering effects to mimic nature. Sea spray and splashes are never uniform. The greater the variety of methods you use in an artwork, the more believable the resulting painting will become.

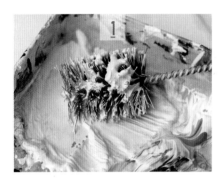 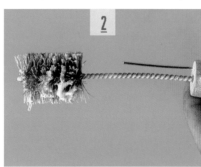 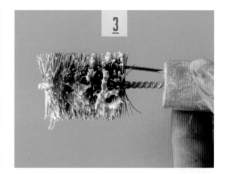

1 Load the brush with wet paint by rolling it in the paint. Make sure you cover all the bristles thoroughly.

2 Hold the brush over the surface.

3 Move the metal bar into the bristles.

4 Carefully turn the brush in the right direction to splash the surface – and not your face!

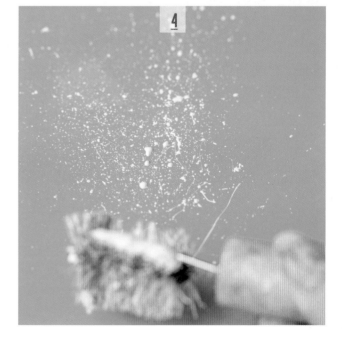

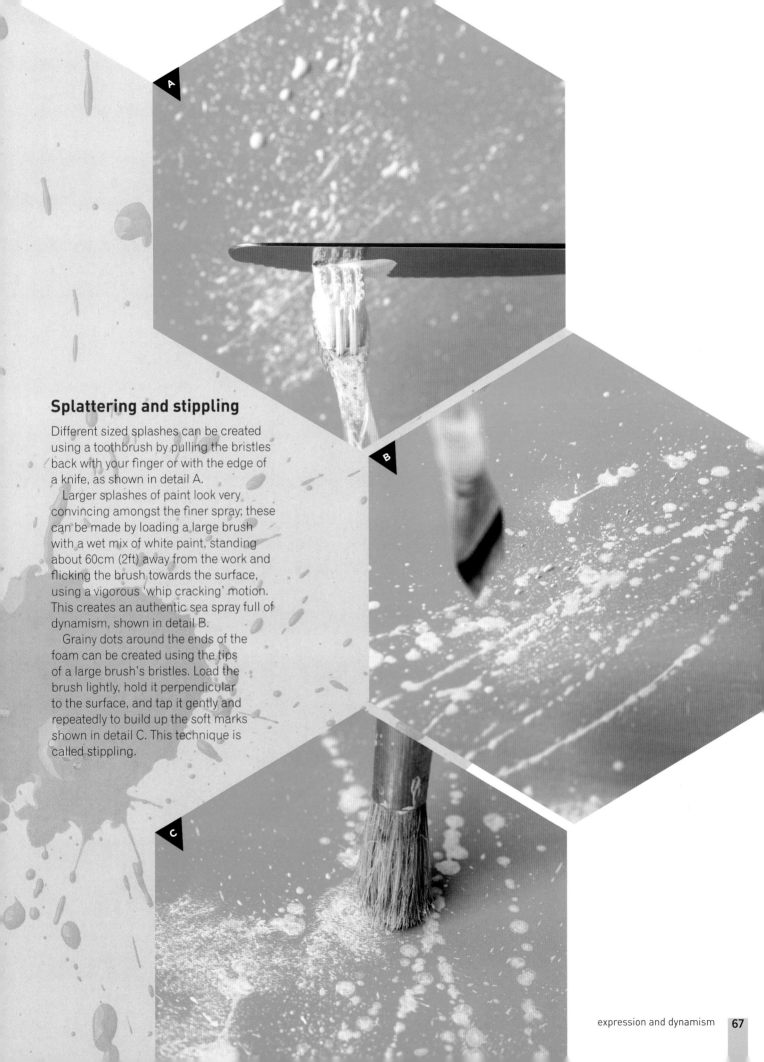

Splattering and stippling

Different sized splashes can be created using a toothbrush by pulling the bristles back with your finger or with the edge of a knife, as shown in detail A.

Larger splashes of paint look very convincing amongst the finer spray; these can be made by loading a large brush with a wet mix of white paint, standing about 60cm (2ft) away from the work and flicking the brush towards the surface, using a vigorous 'whip cracking' motion. This creates an authentic sea spray full of dynamism, shown in detail B.

Grainy dots around the ends of the foam can be created using the tips of a large brush's bristles. Load the brush lightly, hold it perpendicular to the surface, and tap it gently and repeatedly to build up the soft marks shown in detail C. This technique is called stippling.

PAINTING *TIDE TRACKS*

This painting used a wide range of the techniques detailed in this chapter, and just goes to show that using them in combination will really help you to achieve new effects.

I painted a soft sky using washes of watercolour on dampened paper, allowing the colours to blend into each other. I added a few salt crystals to the left-hand side for added texture and to suggest broken light.

For the marks in the sand, I used both acrylic and watercolour paint, along with acrylic inks. Within the darker areas, I allowed dribbles of paler, thicker paint to blend and flow into the wet transparent wash to create interesting textures.

I added random drops of granulation medium to the wet areas to break up the surface, tipping the paper to create rivulets and speckles of granular texture.

The marks made in the foreground were fast and fluid to attract the eye to them and add dynamic movement, leading the eye into the painting. I applied dark indigo acrylic inks with a sweeping arm movement, using the dropper in the lid. I then dripped an opaque, wet mix of titanium white acrylic on the central area with a plastic pipette, using similar loose marks.

Once dry, I glazed the foreground a number of times to unify the painting, using very thin washes of yellow ochre, indanthrene blue and burnt sienna until I achieved the depth of tone that I desired.

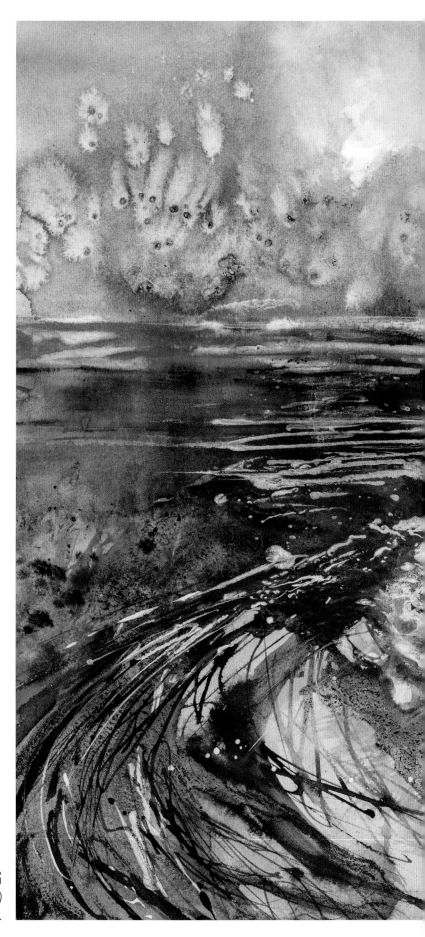

TIDE TRACKS
56 x 43cm (22 x 17in)
Mixed media on Hot-pressed watercolour paper.

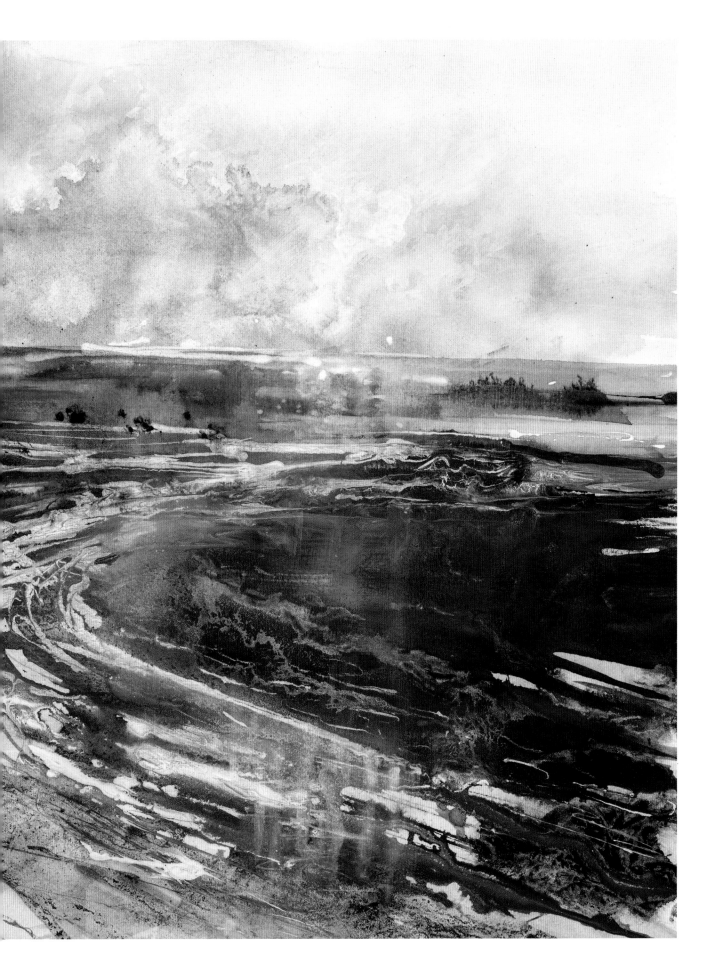

WILD SEASCAPE

I love the challenge of painting bright patches of translucent sea and surging waves. I invariably aim to suggest the water in a realistic, convincing fashion, whilst keeping the work lively and full of energy. However, it is so easy, in the desire for a realistic interpretation, to stifle the life out of the work by allowing the painting to become too tight and rigid.

In this *Wild Seascape* painting, I wanted to demonstrate how to build up a translucent patch of water from the ocean floor upwards. You will see that you can suggest the depths of the sea by creating an interesting base layer with a simple and effective technique, then subsequently overlaying the underpainting with a variety of marks and glazes.

In this painting I would like you to use a collection of vigorous brush marks and unrestrained splashes to suggest movement and energy. In this way you can add dynamism to the work, whilst also suggesting the shape of the waves. Remember that the more unrestrained energy you use to make your final splashes, the more it will translate into your work. If you are removing splashes from the walls and ceiling afterwards, then you have certainly been dynamic!

You will need

BRUSHES: 37mm (1½in) flat, size 6 round, 12mm (½in) flat, 17mm (¾in) flat, 5mm (¼in) flat, and size 2 rigger

ACRYLIC PAINTS: Titanium white, ivory black, dioxazine purple, cadmium yellow light, yellow ochre, raw umber, burnt umber, ultramarine blue, cobalt blue, indanthrene blue, phthalo blue, and Hooker's green

SURFACE: MDF board, 60 x 60cm (23½ x 23½in)

Gesso

HB pencil

Water spray

Methylated spirits

Palette knife

Toothbrush and spoon

Speckling brush

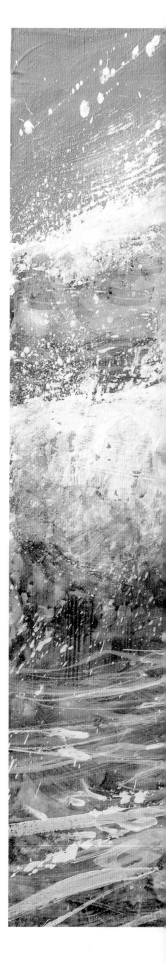

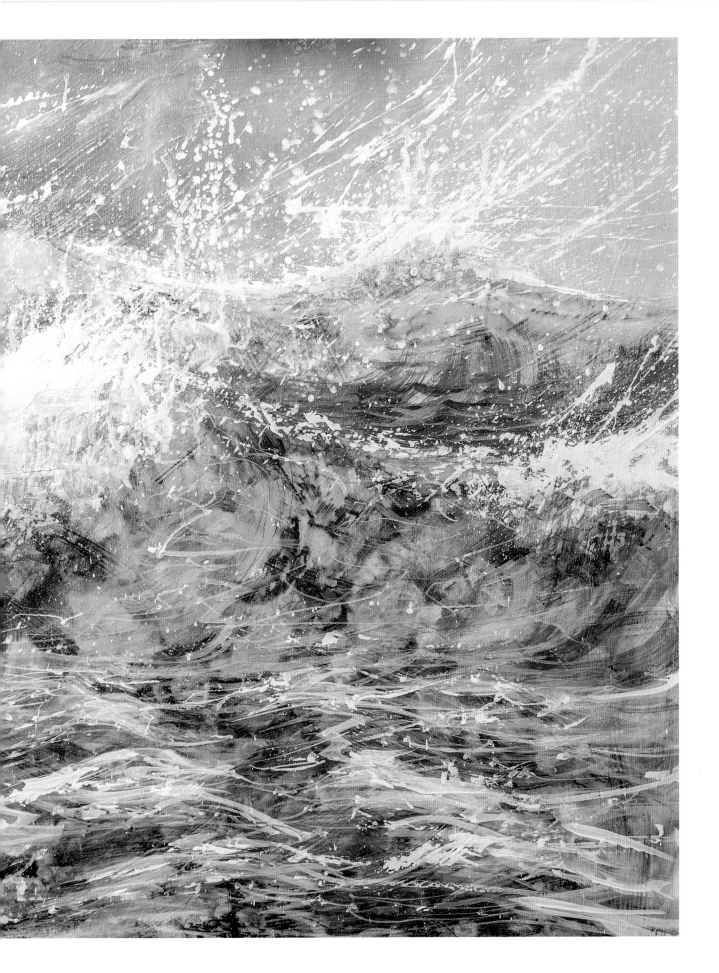

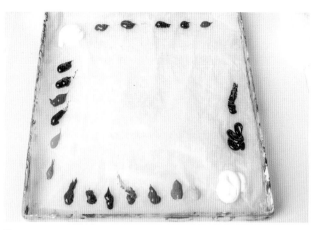

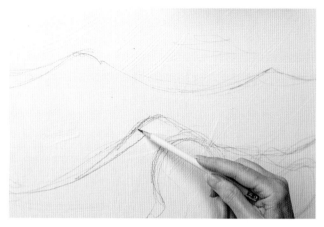

1 Prime the board by applying gesso and allowing it to dry. Lay out your paints around the edges of the stay-wet palette. Make two separate areas of titanium white – one for mixing, and one for pure whites.

2 Use an HB pencil to plot out the peaks and troughs of the main waves. To avoid getting over-detailed, try holding the pencil at the tip, like a brush. This will enable you to make clean, sweeping strokes. Add a few starting marks to suggest the curling marks of the water. These may change later, but it will give you a starting point.

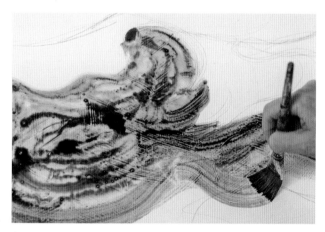

3 Take the board off the easel and lay it flat. Lightly wet the surface with a water spray, then wet the 37mm (1½in) flat brush and pick up Hooker's green and indanthrene blue. Use the brush to paint the foreground waves (roughly the lower half of the painting) with long sweeping strokes. The paint should be glossy and wet, but not so fluid that it runs when you pick up the painting.

4 Use the size 6 round to apply methylated spirits to the surface. The additional detail here will make this area seem to advance.

5 Change back to the 37mm (1½in) flat brush to paint the distant sea and sky with more dilute washes of the same colours.

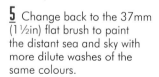

6 Leave the painting flat, and allow it to dry thoroughly before continuing. Use the 37mm (1½in) flat brush to mix indanthrene blue with titanium white. Add a hint of dioxazine purple and raw umber – these will mute the colour slightly, helping the colour to recede into the distance. Use choppy strokes to apply this to the sky. Add more hints of white and yellow ochre towards the right, to suggest sunlight.

7 Use your finger to smooth the colour into the surface.

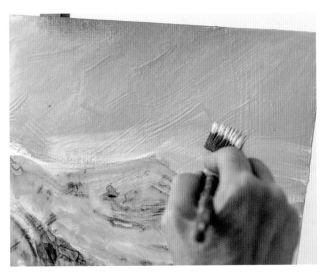

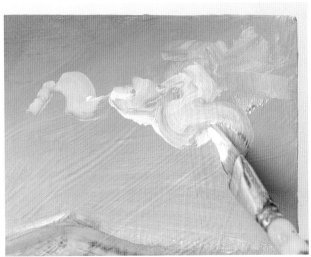

8 While the paint remains wet, add more white to the mix and work back into the sky, moving it backwards and forwards to create a soft blend, with no obvious visible marks.

9 Use twisting marks to suggest clouds.

10 Soften the marks into the surface with your finger, being careful not to obliterate them entirely.

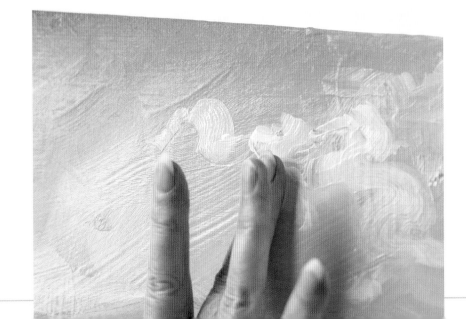

11 Mix indanthrene blue with a little Hooker's green, and hints of burnt umber, ultramarine blue and dioxazine purple to create a dull, greyish cold blue. Use this to paint the transition between foreground and background sea, pulling the strokes upwards to suggest the curvature of the distant waves.

12 Create a strong, clean bright green from titanium white, phthalo blue and a hint of cadmium yellow light. Pick it up on a 12mm (½in) brush and wipe off the excess paint before applying it to the tips of the distant waves. This allows you to create a semi-dry-brush effect.

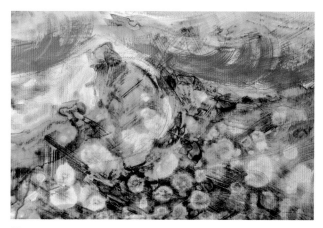

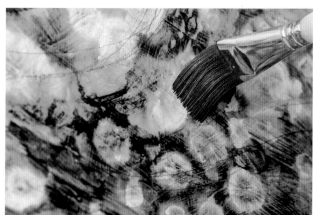

13 Glaze the upper part of the foreground with yellow ochre, using loose sweeping marks. This very thin wash brings out the subtlety of the underpainting.

14 While it remains wet, glaze the lower part with indanthrene blue – be careful not to make this powerful colour too dark: dilute it heavily to knock back the surface impact.

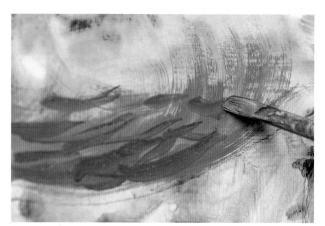

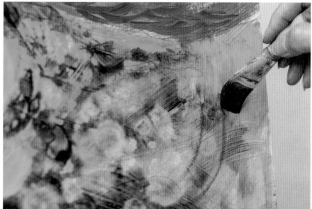

15 Switch back to the 12mm (½in) flat brush and build up some shorter marks on the surface of the sea with the cold blue mix (see step 11).

16 Still using the 12mm (½in) flat brush, mix titanium white, cadmium yellow and phthalo blue. Use the dry brush technique to apply the paint, suggesting the light coming through the wave crests on the main waves. As you're applying the paint, use the pencil marks to guide the curve and curl of your brush strokes.

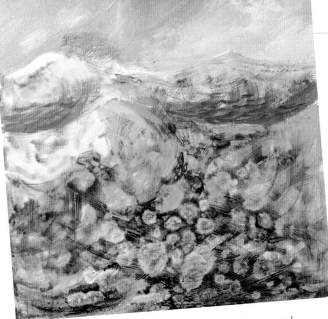

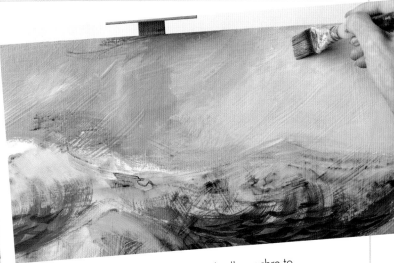

17 Use the 37mm (1½in) flat brush to suggest the waves' shadows and uplift into the light with a watery mix of indanthrene blue and a tiny touch of ivory black. This adds important contrast.

18 Use a bright mix of titanium white and yellow ochre to overlay the sky, emphasizing the right-hand side to build the sense of light.

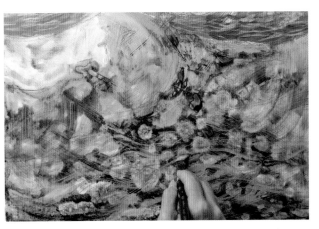

19 For the highlights of the sky reflected in the sea, pick up a selection of brushes: I'm using a 17mm (¾in) flat, a 5mm (¼in) flat, and a size 2 rigger. Swap between these to build up the highlights with the sky mixes on your palette, creating small, flicked U-shaped marks. Start subtlely, and build up.

20 For the foreground sea, vary the mixes with hints of cobalt blue and indanthrene blue. Use similar sweeping marks as in the background, but make them larger. Use the blade of the brush to help create irregularity. Avoid putting these marks in areas of shadow cast by the waves themselves.

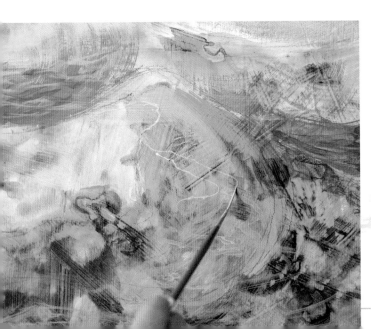

21 Swap to the 5mm (¼in) flat to begin to extend these marks up the surface of the wave, using wavering, longer marks as shown.

Tip
Keep scrap paper in front of you to allow you to wipe excess paint from the brush, away from the wet palette.

22 Add more titanium white to create a just off-white blue, and swap to the rigger. Holding it by the very end of the handle, enjoy applying both long wavering marks and light flicks.

23 Use the 12mm (½in) flat to make bigger marks with the off-white blue. Apply the paint with the blade of the brush, keeping it almost horizontal, so the marks are kept along a common plane.

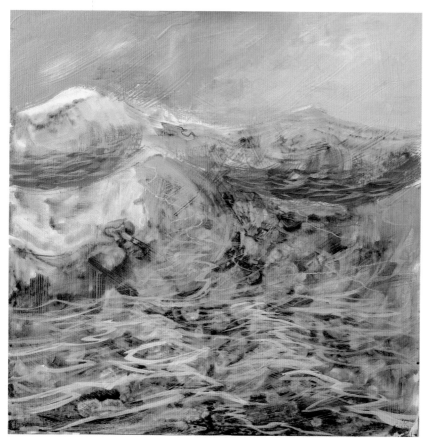

24 Swap between the brushes, gradually brightening the mix with more titanium white, building up the directional marks on the foreground sea.

25 Add a little Hooker's green to dilute indanthrene blue, and use this to glaze areas of the foreground. This knocks back some of the reflections and adds depth to the effect.

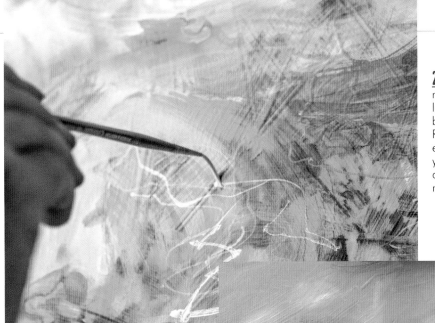

26 Return to the rigger to build up more reflections. Alternating these layers of glazing and highlight helps build up depth, interest and movement. Remember to hold your brush at the very end of the handle, to reduce the control you have: you want to add movement and a sense of freedom, not rigidly apply marks in a fixed, planned way.

27 Apply the marks to the foreground using the original pencil marks as your guide, largely ignoring what is on the surface. In this way, you prevent yourself overemphasizing already-strong marks, and ensure that the painting as a whole looks like it belongs together. Swap to the 12mm (½in) flat brush for bolder marks at the front.

28 Pick up titanium white on the edge of the palette knife. Wipe off the excess and ever so lightly draw it across the top of the main wave, aiming to catch the texture of the gesso surface.

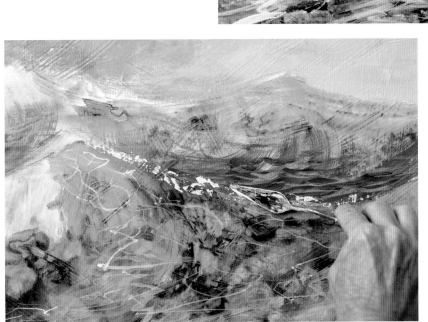

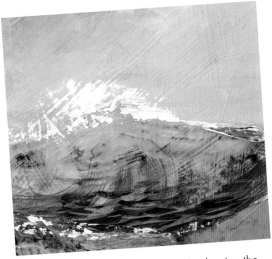

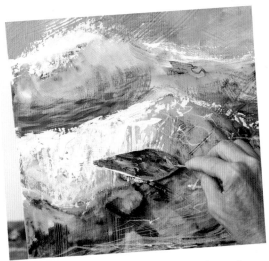

29 Create a splash in the distance by drawing the loaded palette knife across the surface; and use the edge as a drawing tool to create very fine marks on the crest of the distant wave.

30 Build a base of thick white paint on the centre left, using a vigorous curved motion.

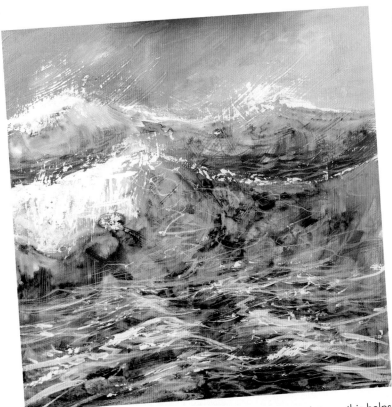

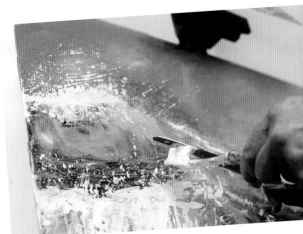

32 Prepare a dilute area of titanium white in your palette and thoroughly cover the toothbrush bristles. Hold the toothbrush up near the areas of foam. Draw the spoon handle over the toothbrush to spatter fine foam around the areas.

31 Apply a few hints with the palette knife in the foreground, too – this helps to prevent the painting feeling like it's made of unrelated sections.

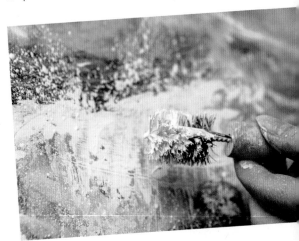

33 Load the speckling brush in the same way, and build up the fine mist and foam.

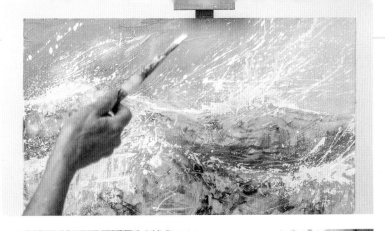

34 Pick up dilute titanium white on the 37mm (1½in) flat and make large spatters with sharp flicks of the wrist. Keep the angle roughly consistent, and aim to have the paint spraying upwards, out of the painting, to add motion.

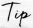

Tip

Turning the painting upside-down can help you place the spatters where you want them. Be bold, and don't be afraid of putting too much on; you can always wipe away errant marks with a wet cloth.

35 Once the spatters have dried, use the 17mm (¾in) flat to glaze the foam, adding shadow and form to the mass with small dabbing marks. Use a translucent blue-purple mix of ultramarine blue and dioxazine purple. Vary the hue with a spot of burnt umber, to grey it a little.

36 While the paint is still wet, add some glazing hints of an indanthrene blue and ivory black mix. These dark tones help to create contrast and impact.

THE FINISHED PAINTING
A larger picture can be seen on pages 70–71.

PAINTING *RAGING SEAS*

My intention with this painting – a similar composition and subject to the previous step-by-step project – was to capture elements of the exhilaration and awe I feel when close to forceful waves. Instead of a highly realistic interpretation, my main interest was to suggest the energy and surging power of a stormy sea.

To start, I loosely painted the main shapes and tones, using dilute washes of acrylic colour in Hooker's green, indanthrene blue and phthalo blue. To produce the organic forms towards the bottom right of the canvas, I added a few drops of methylated spirits onto a dark wash of indanthrene blue. These would show through subsequent layers.

Using a mid-sized flat brush, I started to form the shape of the waves by painting with a mix of titanium white, cadmium yellow, Hooker's green and phthalo blue at a thicker consistency; akin to single cream. I followed the curve down from the top of the water to suggest light shining through the thinnest area of the wave.

To indicate the reflected sky on the surface of the water, I painted very loose arching marks within the shadow of the wave. This was completed in a sideways motion, using a small 17mm (¾in) flat brush, loaded with a wet mix of titanium white and ultramarine. I then moved on to add fast swaying marks over the darker areas to suggest movement. I used a mix of phthalo blue, sap green and titanium white for this. Subtle hints of these marks show through the subsequent glazes and suggest the layers of light seen through translucent water.

I also added tendrils of sea foam drifting down the face of the wave. For this process I used a rigger brush loaded with a wet mix of titanium white paint, and applied the paint with a loose sweeping motion of the whole arm. This drew the paint into thin loose shapes, which I painted to flow and overlap. For this

technique, the paint must be fluid enough to drift off the end of the brush, and you must reload it at regular intervals.

To suggest the foam bouncing off the surface, I loaded a size 15 palette knife with titanium white and briskly scraped it across the canvas in an upward motion. I also bounced it off the surface in a sideways direction, leaving several interesting splashes behind, which adds to the feel of sea spray. I then applied a thin glaze of ultramarine blue and deep violet over the underside of the foam for shadow.

I also created vigorous white splashes in the key areas for the bright white spray. These marks were made at a distance of around 60cm (2ft) using a rigger brush loaded with a wet mix of paint. They are the final marks that give the feeling of dynamism as the wind blows foam off the top of the wave. Until these are applied the painting looked too static – these ultimate additions make a huge difference to the energy in the work. Once I was happy with the marks, I unified areas with a large, flat brush by glazing across the whole surface using elongated, sweeping marks. A wet mix of raw umber and yellow ochre was employed to give a warm glow, while a very watery indanthrene blue helped to produce the deeper shadows.

To suggest light refracting through the water, I added brighter surface marks with a bright mix of white, yellow, green and primary yellow. These stand out from the subtler background and form tracks throughout the painting that direct the eye across the artwork.

For the sky, I built up contrasting tones of the clouds using cobalt blue, indanthrene blue and burnt umber, which were mixed with a very small touch of titanium white. I blended the whole area together with the tip of a finger, while also being careful to keep the sky area wet with an occasional spray of water from a spray bottle.

RAGING SEAS
60 x 60cm (23½ x 23½in)
Acrylic on canvas.

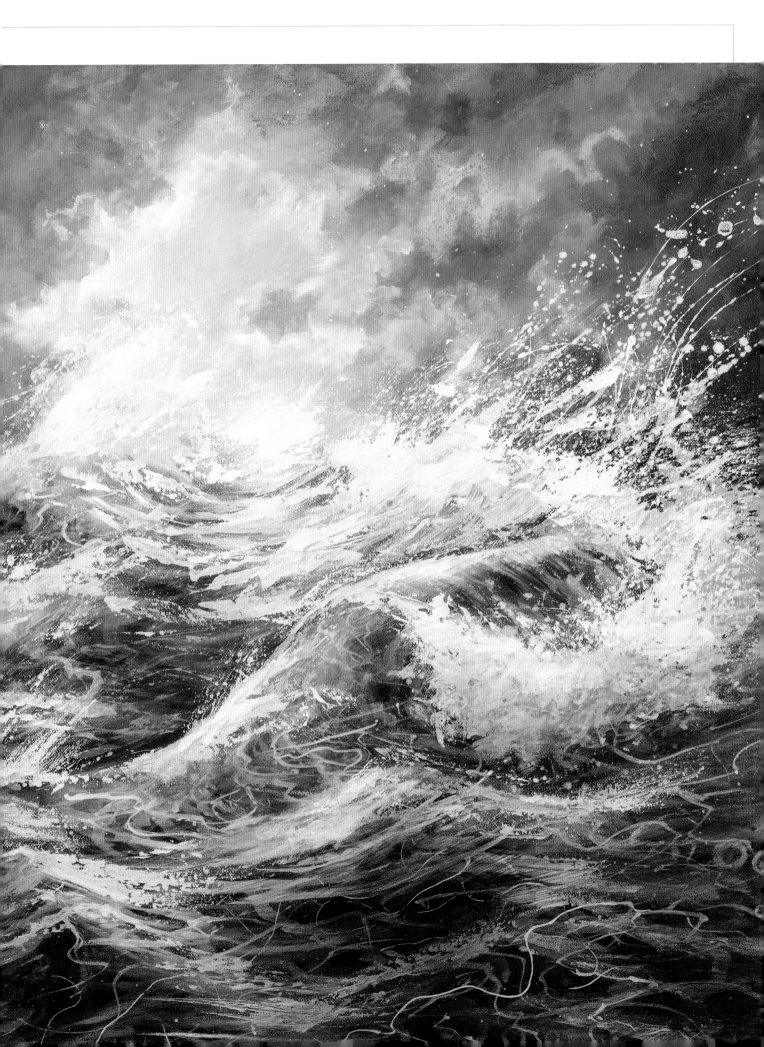

PAINTING *SURGING WAVES*

I am intrigued by the layers visible within water and constantly trying to find new methods to replicate these in paint. In this painting, I moved in close to the subject to fill the entire space with a single wave, in order to concentrate on the subtleties of translucent water.

I used mount board for the surface. This can be used without additional preparation, but on this occasion I added a thin layer of gesso in areas where breaking water and foam would appear before I began. This created some light texture, which I developed by pressing the flat side of a palette knife into the gesso and lifting it quickly upwards to leave small peaks. These shapes would later help make the splashes and foam more convincing. In order to suggest the edges of small waves, I made thin arching shapes in the foreground with the edge of the palette knife dipped in the gesso. Once this was dry, I applied a watercolour ground over the entire surface and again left this to dry completely.

To obtain a sombre, murky feel, rather than a bright Mediterranean clarity, I used several watercolour washes within the multi-toned areas of water. These gradually become darker in the shadows beneath the foam, with loose mixes of indanthrene blue, Hooker's green, yellow ochre and burnt sienna.

The splashes of foam were applied with titanium white acrylic paint mixed with a small amount of yellow ochre on areas to suggest sunlight hitting the water droplets. I flicked a loaded 25mm (1in) short flat brush a short distance – about 30cm (1ft) – away from the surface to add splattered marks. I repeated this with varying consistencies of white paint to create slightly different effects across the work, both in size of splashes and in opacity of paint. I enjoy the effect of the translucent and opaque sitting together: the variety of marks helps to create a more believable illusion.

The smaller choppy waves in the foreground were created with the sharp edge of a flat brush loaded with white paint. Also, a semi-dry palette knife was scraped horizontally over the textured surface to pick up on the raised areas, which had previously been applied in a sideways wave motion.

I emphasized the shadows with an acrylic glaze of raw sienna, Hooker's green and burnt umber, layering up gently until the right tone was achieved. To finish, a further layer of yellow ochre was washed over areas to give a golden glow.

SURGING WAVES
40 x 40cm (15¾ x 15¾in)
Watercolour and acrylic on mount board.

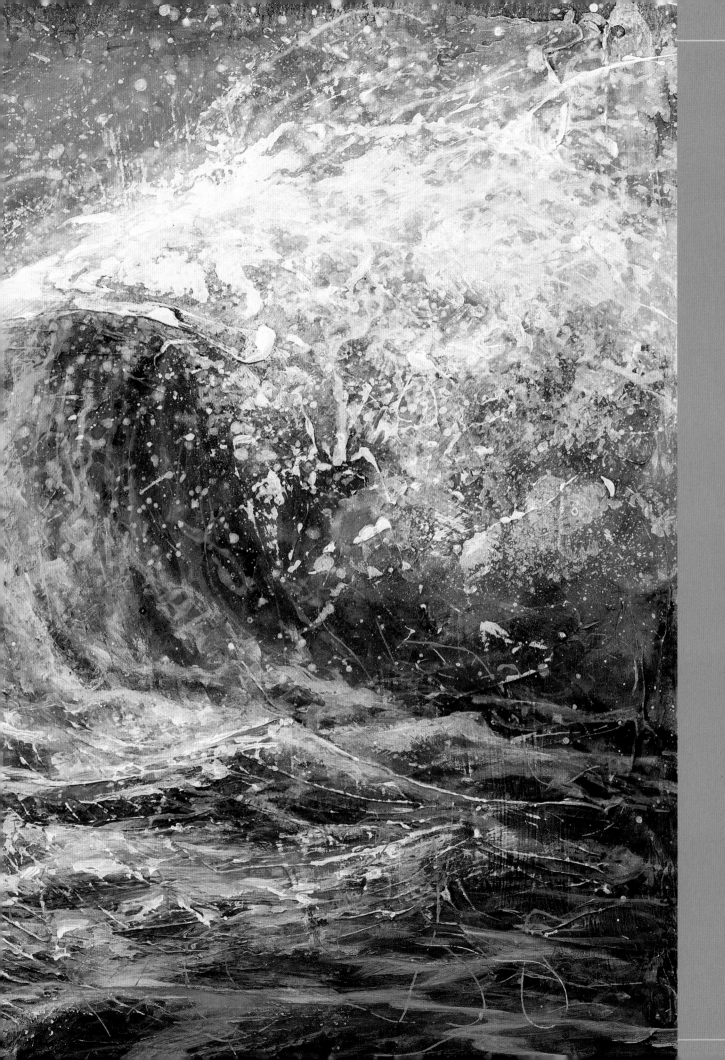

SHIMMERING MIST

I am drawn to the mellow colours and atmospheric mists that form along the coast in the autumn. The subdued colours and light effects are amazingly beautiful and provide inspiration for my work.

This painting is dominated by strong contrasts. The work demonstrates how the cool, blue tones used in the sea contrast perfectly with the dark browns of the rocks and the warm ochres of beach. I have also contrasted the thick impasto texture of the beach with softly blended tones in the sea and sky.

Using this approach, you will discover that you can suggest natural forms through texture and layering of colour, while simultaneously building detail and interest.

In this painting I also demonstrate how interest can be built up slowly using layers of texture alongside glazes and the use of flat colour. As you work through the steps, you will explore several techniques in one image; techniques that will provide a range of possibilities in your own paintings.

You will need

BRUSHES: 25mm (1in) flat, 17mm (¾in) flat, 37mm (1½in) flat, fan brush, size 2 rigger, 5mm (¼in) flat

ACRYLIC PAINTS: Titanium white, ivory black, dioxazine purple, cadmium yellow light, yellow ochre, raw sienna, burnt sienna, burnt umber, ultramarine blue, cobalt blue, and phthalo blue

ACRYLIC INKS: Sepia, indigo

SURFACE: MDF board, 60 x 60cm (23½ x 23½in)

Gesso

HB pencil

Texture paste

Palette knife

Granulation medium and pipette

1 Prepare the board with thin gesso, allow to dry, then use an HB pencil to mark the main shapes. Use the palette knife to apply texture paste to the beach, aiming to create the texture of sand. Use the flat of the knife to create a smoother texture in the distance, and make the texture more raised and dense in the foreground.

Tip
When drawing the main shapes, I recommend using a ruler to ensure a straight line for the horizon.

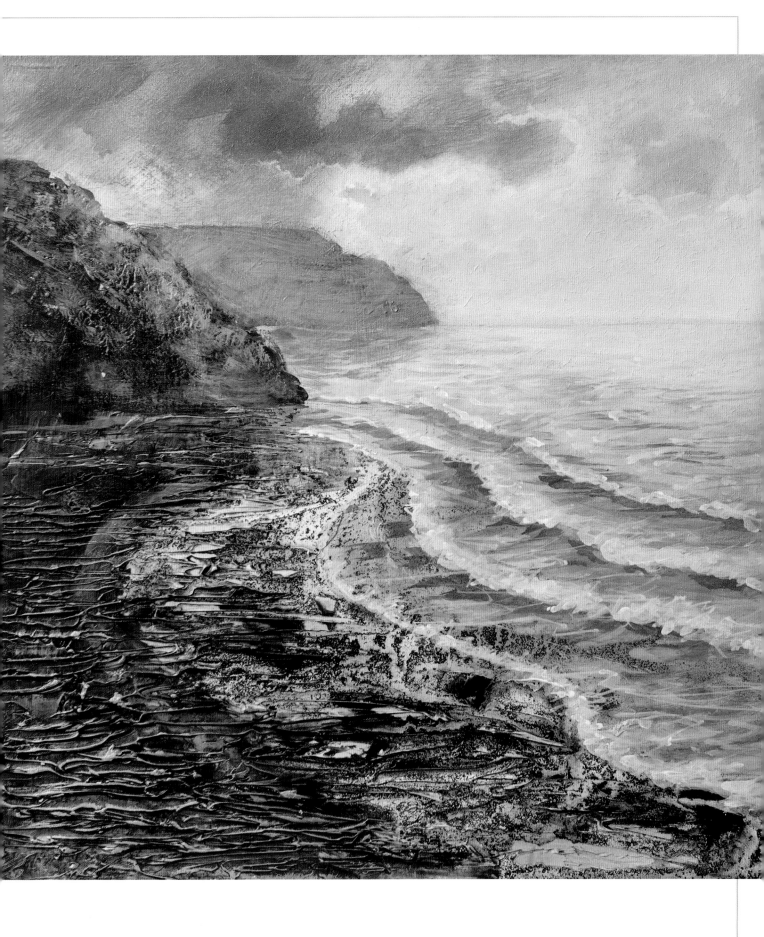

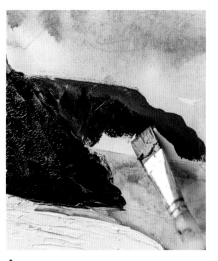

2 Using a dilute mix of titanium white, ultramarine blue and dioxazine purple with a touch of burnt umber, establish a base tone in the sky and sea with the 25mm (1in) flat brush.

3 Create a very dark mix of ivory black and burnt umber. Still using the 25mm (1in) flat brush, paint the midground cliff, applying the paint quite thickly.

4 Paint the distant headland with the same mix, but use it slightly more diluted in order to avoid creating an excess of texture. This helps the area to recede into the background.

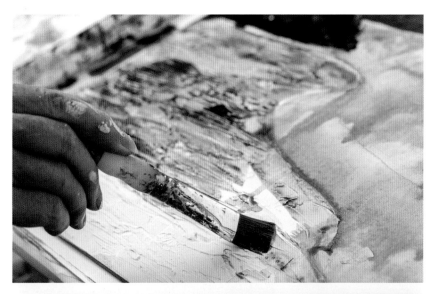

5 Starting in the distance, paint the sand with a very dilute mix of raw sienna and burnt sienna. Add burnt umber into the mix as you advance.

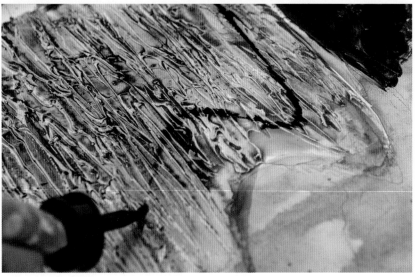

6 Add a trailing line of sepia ink, using the dropper to draw the ink down parallel to the shoreline.

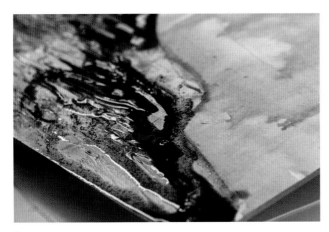

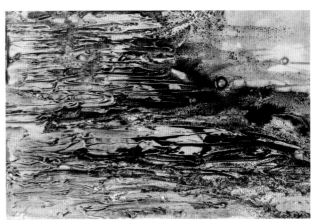

7 Use the pipette to pick up some granulation medium and work it into the line of wet ink.

8 Add indigo ink to the right of the sepia, allowing it to blend and spread, and add more granulation medium, too. Encourage the wet ink into the sea with the tip of the pipette.

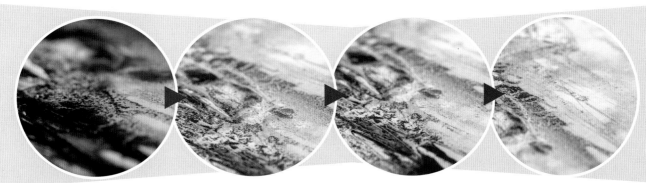

The granulation effect appears over time, as the paint dries.

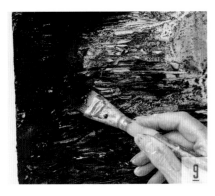

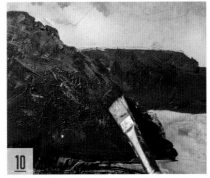

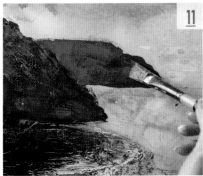

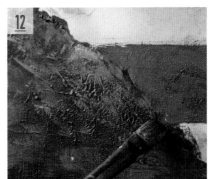

9 Allow the painting to dry completely, then set it back up on your easel. Darken the left-hand side of the sandbar using the 37mm (1½in) flat brush and a mix of ivory black and burnt umber. Rinse the brush, and use it still damp to soften the edge of the dark paint. This prevents a hard edge forming.

10 Create a sandy grey-purple mix from yellow ochre, dioxazine purple, ultramarine blue and titanium white. Draw the 17mm (¾in) flat lightly over the rocks to pick out the existing texture.

11 Using the same colour, lightly paint over the headland. There's no change to the mix: you're just applying slightly more paint. With less surface texture, you'll get a flatter result, helping the headland to recede further.

12 Add a hint more yellow ochre to the mix and add highlights to the left-hand side of the midground rocks. Use different parts of the brush – side, face, blade – to develop the texture.

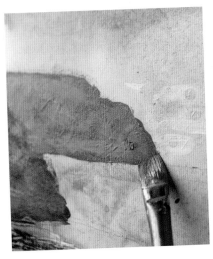

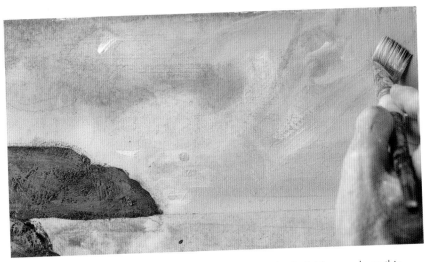

13 Knock back the headland slightly more with the sandy grey-purple mix of yellow ochre, dioxazine purple, ultramarine blue and white.

14 Mix titanium white, yellow ochre and a tiny touch of cobalt blue, and use this with the 37mm (1½in) flat to overlay the sky with quick, broad, choppy marks, starting on the right-hand side.

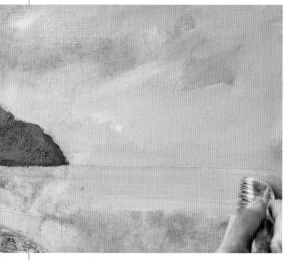

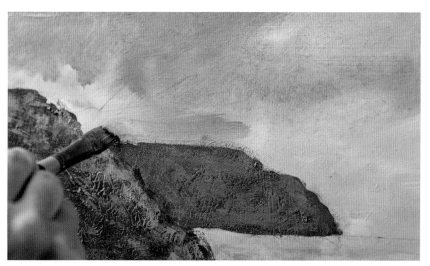

15 Leaving a line for the horizon, continue applying this colour down into the sea, changing the shapes of the strokes you are making to shorter, flicking curves.

16 Change back to the 25mm (1in) flat brush and create a brooding cloud with a brown-grey mix of cobalt blue, titanium white and touches of dioxazine purple and raw sienna. Apply this lightly over the clouds on the top left, like a semi-opaque glaze.

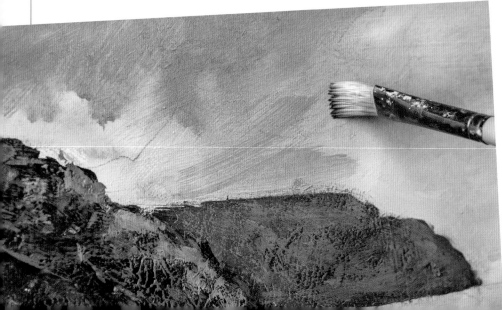

17 Work towards the right. As you run out of paint on the brush, soften the marks in with the dry brush.

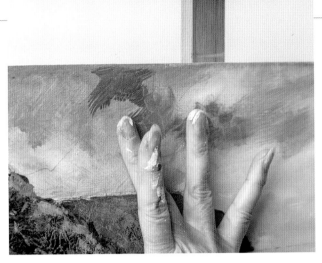

18 Combine the brown-grey mix with the dark mix of ivory black and burnt umber. Use this to develop the clouds on the left-hand side, knocking the marks back with your finger.

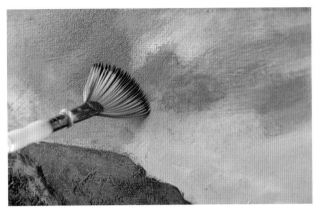

19 Very lightly flick a clean, dry fan brush over the paint to soften the effect and create the impression of distant rain.

20 Combine titanum white and raw sienna and build up the sky just above the horizon, applying the paint with the 25mm (1in) flat brush and horizontal strokes.

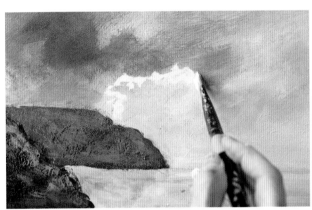

21 Work the mix upwards into the sky.

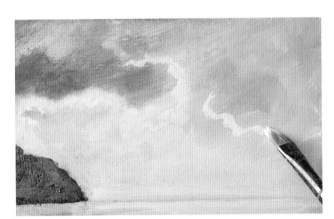

22 Add more titanium white to the mix and add some silvery highlights to the clouds. Don't overdo these marks – a few well-placed highlights are more effective than too many.

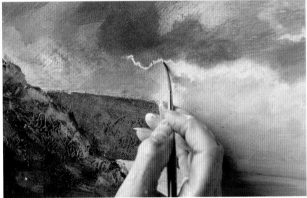

23 Switch to the rigger if you want to add some really tight details. Resolving just one or two tiny marks in this way makes it clear that the rest is intentionally unresolved – it creates a point of focus; and to be effective, this needs to be contrasted with the more impressionistic, loose mass of the clouds. Resolving too many of these details tightens the painting, and strangles it of movement.

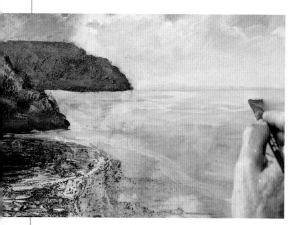
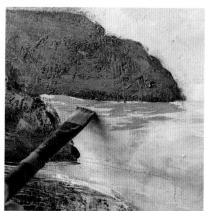
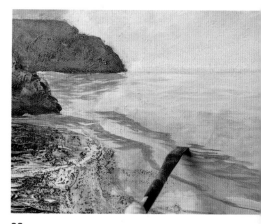

24 Use the 25mm (1in) flat to add some highlights on distant waves just below the horizon, using the same mix of titanium white and raw sienna.

25 Use a mix of titanium white, dioxazine purple, burnt umber and cobalt blue with a tiny hint of ivory black to make a rich blue-grey. Use the 25mm (1in) flat brush to develop the shadow and reflection of the headland on the sea.

26 Develop the shadow below the midground rocks, then draw the colour down to suggest the lines of shadow of the breakers in the foreground.

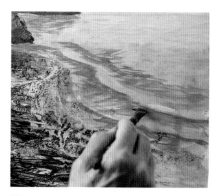
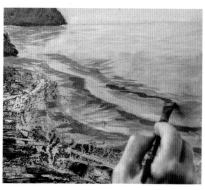
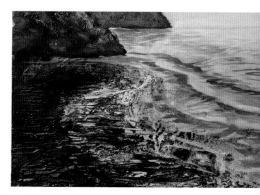

27 Use light, flicking back-and-forth marks to draw the colour from the shadow lines out towards the shore, to help give form and sense to the waves.

28 Develop the tone here with slightly darker mixes, produced by adding more hints of cobalt blue and ivory black.

29 Extend a few select hints of the same blue-grey mixes into the midground and distance.

30 Glaze phthalo blue over the foreground sea to ensure the colours blend smoothly from dull, distant cool-grey to more vibrant blues in the foreground.

31 Add more titanium white to the blue-grey mix and use the 5mm (¼in) flat brush to add dibs and dabs of foam of the breakers. Don't make these regular marks; aim to create a loose, tumbling feel.

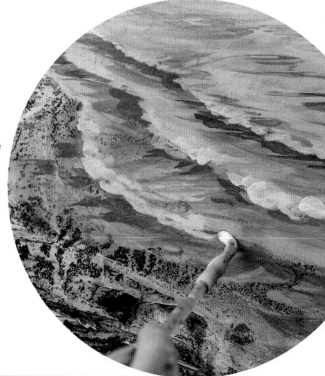

32 Change to the size 2 rigger and pure titanium white for the extreme highlights.

33 Using the rich blue-grey mix (see step 24) and a 25mm (1in) flat brush, run a dry brush very lightly down the transition between light and dark sand. Hold the brush almost flat, so that the face of the brush just catches the raised texture. Be careful to work downwards only – don't move the brush upwards, or the highlights will be caught on the wrong side of the ridges.

34 Repeat the process with a sandy mix of burnt sienna, yellow ochre, raw sienna and titanium white, applying the paint with the 37mm (1½in) flat brush.

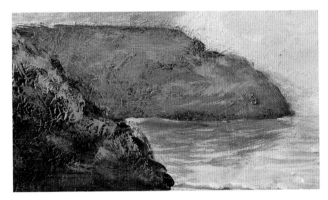

35 Still using the 37mm (1½in) flat brush, use a dilute mix of cobalt blue and titanium white to knock back the distant headland with a glaze.

36 In the bottom-left corner, use a palette knife to add further highlights with the sandy mix (see step 34), loading it very lightly, and just skimming it over the surface.

37 Once the painting has dried completely, use the 37mm (1½in) flat brush to lay a white glaze over the whole distance – sky, distant sea and the headland. This knocks the colours and tone back, softening the effect and suggesting haze and distance.

THE FINISHED PAINTING
A larger picture can be seen on pages 83–84.

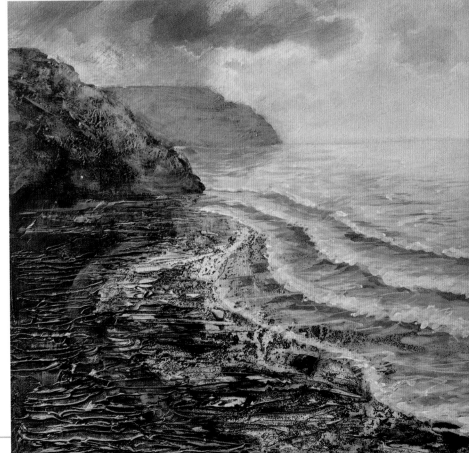

PAINTING *THE INLET*

I regularly visit the coast of North Wales, I find the weather conditions in the summer and winter months equally compelling. As for the lighting, the moodier the better!

In the previous step-by-step project, *Shimmering Mist*, I used various layers of acrylic paint along with heavy texture to gradually build up the light effects on the water and hard rock forms. In contrast, *The Inlet* was created almost entirely using a single layer with a few small additions once dry. In this work I aimed to capture the mysterious, hazy effects seen in a shallow inlet, the low brooding clouds and autumn mists highlighted with silver patches of sunlight, a feature so often seen on this coastline.

Using the wet-on-wet technique, I enabled the inherent blending qualities of watercolour to describe the atmosphere by allowing the colours to flow and merge together gently. Watercolours create their own subtleties – along with unplanned surprises that can be happily incorporated into the painting.

Using thoroughly wet paper, I painted very loose washes of French ultramarine, sepia, Vandyke brown and Payne's gray to form the sky and clouds. By dropping a loaded brush onto the wet paper, I encouraged the colours to run and merge naturally to form cloud shapes, simply adding more paint in chosen areas to form darker clouds.

Whilst still wet, I lifted the pigment through the central area. This left a strip of light suggesting sunlight breaking through the cloud. I sprayed the paper with water from a spray bottle whilst tipping the work, encouraging the pigment to slowly merge and drip towards the base. To suggest light on water near the bottom third of the work I used a dry paper towel to lift the pigment from the still-wet paint, leaving a lighter area that I planned to work into later. I dropped a few salt crystals on the left-hand side and left the work to dry flat.

Once everything was dry, I loosely added greys and blues to the water echoing the colours above, I used a water spray very close to the surface to wet these and allow drips to run downwards suggesting reflections.

To indicate sunlight gleaming behind the clouds. I added white gouache around some of the cloud edges. These final highlights bring more light into the work.

In certain areas, to create a softer transition from light to dark, I wet the edges of the clouds and merged the white into the background with a size 6 round watercolour brush. I added the same white to the water, in sweeps of dry brush to suggest the light reflected on the surface.

Finally an opaque mix of titanium white gouache, ultramarine blue and manganese blue watercolour was painted in a sweeping movement with a rigger brush from the foreground to draw the eye into the painting towards the light source.

THE INLET
33 x 26cm (13 x 10¼in)
Watercolour on 640gsm (300lb) Saunders Waterford watercolour paper.

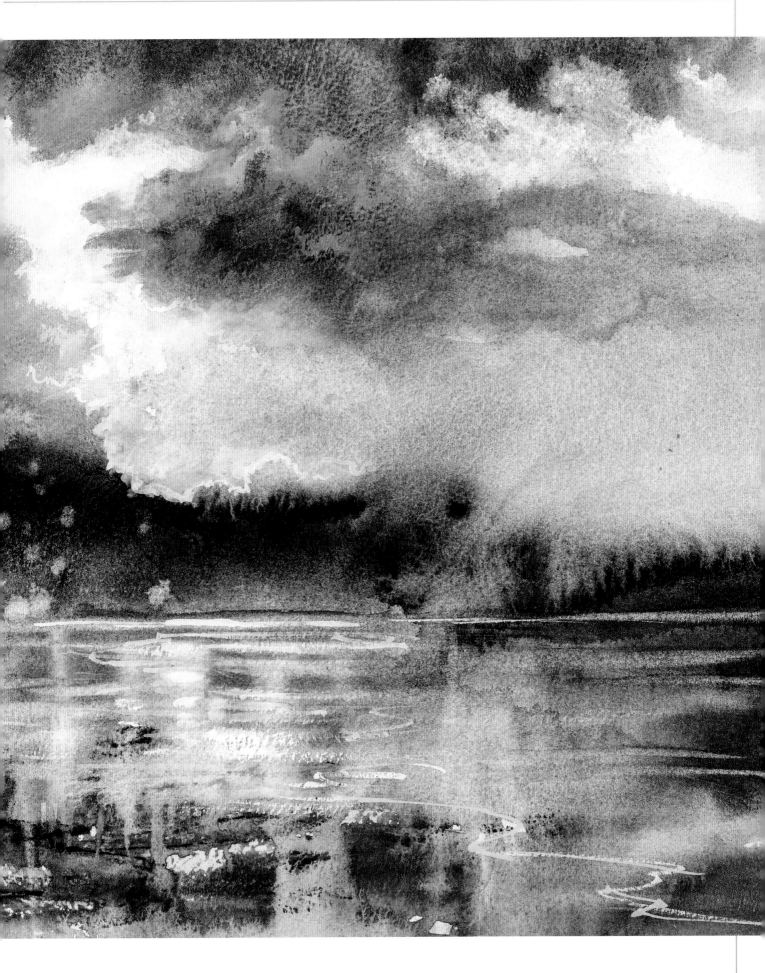

PAINTING *SUNLIT DEPTHS*

One of the great joys of visiting the coast in summer is walking along the shoreline as the sun goes down. It can be tricky to capture the light of a setting sun without the result becoming clichéd. Here, I wanted to capture the marvellous light effects I witnessed one summer in Cornwall. The sea was ablaze with flickering light, reflected in the wet sand and waves. Instead of a stereotypical sunset scene, I focussed solely on the effects of the light.

I did not want to be too literal with this version, so to avoid this I concentrated on the soft hazy glow and light playing on the varying textures and shimmering surfaces. In particular, I decided to give the marks and the surface of the paint as much importance as the illusion. I therefore did not resolve them too much: keeping them very obvious and loose avoided adding too much realism.

In terms of materials, I used acrylics on a square, ready-primed canvas. To begin, I created texture towards the foreground with medium-textured paste. I mimicked the trails and shapes within the sand by dragging the tip of a palette knife through the textured paste in wriggly shapes, representing water ripples on the beach and creating long sweeps of texture to draw the eye into the image. I knew that I could pick up on these textures at the end of the work and use them to add the final flashes of light along with adding interest to the surface.

As I often choose to do with acrylics, I worked from dark to light. I started by painting the darkest base colours over the entire background in thick opaque paint, from the dark-toned purples in the sky to the deep black and dioxazine purple mix towards the front. The work always looks odd and disturbingly flat when it is first covered with these dark tones, and there is a temptation to make it look impressive immediately. Resist this: as the painting progresses it will slowly and subtly come to life as colours are laid on top. I worked from the dark tones through the subtle mid-tones. These were followed in turn by the lighter colours which, worked on top, make the work pop!

The highlights and lowlights were applied with thick brush strokes of paint along with smears created with a palette knife to keep everything loose. Splashes and sweeps of paint were added with a mix of cobalt turquoise and titanium white to represent the direction of the waves, I also produced tracks with a similar directional movement using my favourite antique pastry cutter (see page 16), which was dipped in paint and rolled across the surface to the bottom left. All these highlights were applied in a speedy fashion to generate energy. Adopting strong, clean, bright colours projects the marks forwards and attracts the eye; as well as suggesting reflected light. These sweeps of colour lead the eye into the image.

For an atmospheric effect, glazes were loosely worked over each other a number of times. Due to the build-up of paint, they leave an interesting layered effect.

A loaded palette knife was dragged horizontally over the surface to depict the bright central glow of the sun in a mix of titanium white and cadmium yellow, becoming brighter towards the centre.

The highlights on the foreground ripples were painted with a mix of titanium white, yellow ochre and cadmium yellow. A flat dry brush was swept carefully at an angle over the heavy underlying texture, so that the paint only touched the highest areas, drawing attention to the texture made previously. I dragged the brush downwards to create a subtle suggestion of the sunlight reflecting on the wet sand.

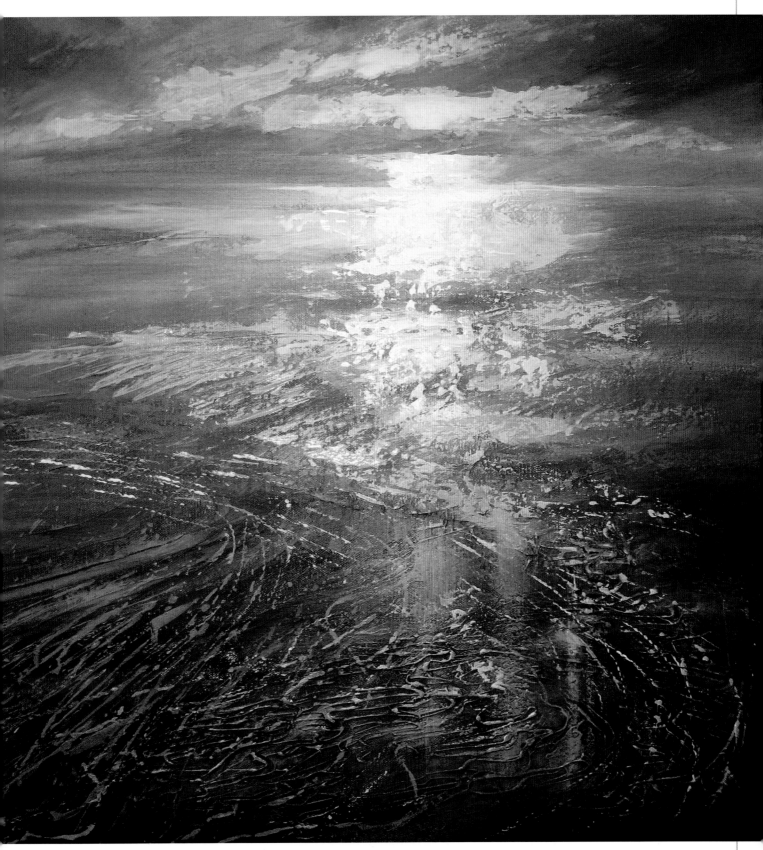

SUNLIT DEPTHS
60 x 60cm (23½ x 23½in)
Acrylic on canvas.

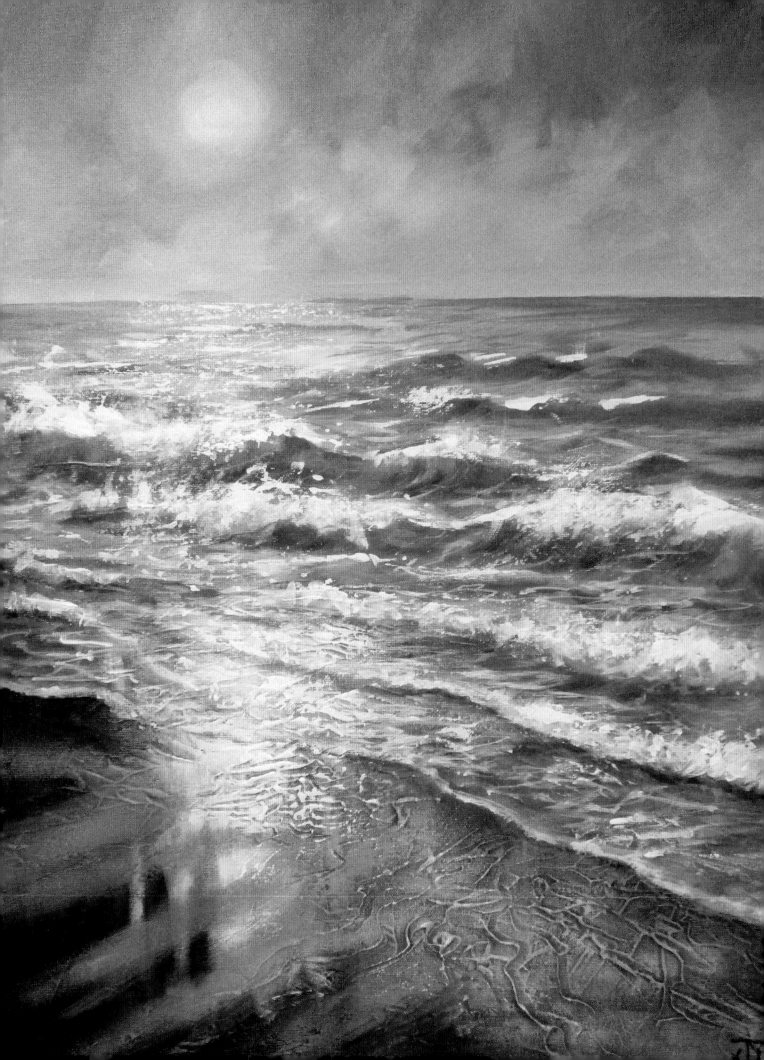

COMPOSITION

A strong composition is an important aspect in every painting. It can make or break a piece of work. Badly-placed elements cause a jarring distraction, whereas well-placed elements ensure a harmonious effect, pleasing to the eye.

Tempting though it is to launch into the painting straight away, spending a few minutes trying out alternative compositions will pay dividends. It is much more challenging and time-consuming to have to change the structure of the work mid-painting.

Even if you only have a few simple elements to arrange within the artwork – for example sea, sky and sun – it is always a good idea to try out several ideas using thumbnail sketches made with a pencil, pen or paint.

These do not need to be detailed. Simple loose sketches are enough to give you a indication of which option will make the best composition. To support this, a basic suggestion of tones, loosely applied, will help to define the main shapes within the work. It is at this early stage when decisions can be made and elements can be moved around with ease.

You are never 'locked in' to a composition. As the painting progresses, utilizing a strong main structure, you are at liberty to become more intuitive with mark-making and with the addition of tones, colours and texture.

On the following pages, I have shared a few paintings and explain the decisions that I have made within the compositions.

Opposite
MERGING BLUES
46 x 79cm (18 x 31½in)

Acrylic on canvas. In this simple composition, I wanted to lead the eye up and through the area of reflected light towards the focal point – the sun. I made some preliminary sketches for this painting to help me develop the composition. You can see these overleaf.

COMPOSITIONAL BASICS

There are many elements to think about when composing a painting. Here are a few of the basics that you will need to consider:

Shape of the painting The format of the painting space is fundamental. Are you going to paint a portrait (narrower than it is tall), landscape (broader than it is tall) or square artwork – or perhaps something more unusual, like a very tall and narrow format?

Point of view Where are you going to situate the viewer in relation to your image?

Cropping Will you stand back from the image or zoom in tight for details?

Leading lines and movement Consider the marks, shapes and movement you will use to create pathways through the image. These do not have to be too obvious, you can use simple 'paths' of light, broken lines, subtle marks or dabs of colour to lead the eye through the painting.

Focal point Work out how you will guide the viewer to the main focal point in the work. You may choose to include secondary areas of interest, but keep these to a minimum as they can cause confusion.

Rule of thirds Dividing the image into even thirds is the traditional, tried-and-tested method of composition (see right). Fit the sea or sky into a third or two thirds of the painting, and place the subject or focal point at one of the intersections of the horizontal and vertical dividing lines. Flouting this set formula can, on occasion, create something exciting and individual. For this reason, it is worth playing with alternative options through the painting.

Shapes Patches of colour and variations of tone generate strong shapes and interest within the composition. Texture, applied loosely within those shapes, will direct the eye to these areas of interest. Look for the main shapes in your inspiration and the relationship between them, to work out how to place them in the painting.

Perspective Use this to create an illusion of space and depth. Even seascapes with no strong, linear form still need to follow the rules of perspective.

THUMBNAIL SKETCHES

Even simple thumbnail sketches will give you a good indication as to which composition works best for the subject. These helped me to identify some potential problems to avoid.

The horizontal lines of the waves in the first thumbnail (left) could have formed a barrier, which would have led the eye from left to right. To avoid this, I gave them a slight diagonal tilt. I also emphasized the soft, blue marks on the wet sand, which point to the sea (see thumbnail 2, centre). After this, I painted a strongly contrasting area of wet sand. This allowed me to place reflections at the bottom left to attract the viewer's eye to the highlighted area; and then upwards towards the sun. The result is the third thumbnail, which was used as the basis for the painting on the page 96, *Merging Blues*.

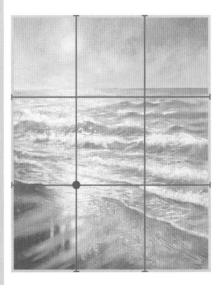

THE RULE OF THIRDS

This method will always create a strong composition. Here the sky occupies the top third; the sea the central third (and extending into the bottom); and the bright focal reflection sits on the lower-left intersection, marked with a blue circle.

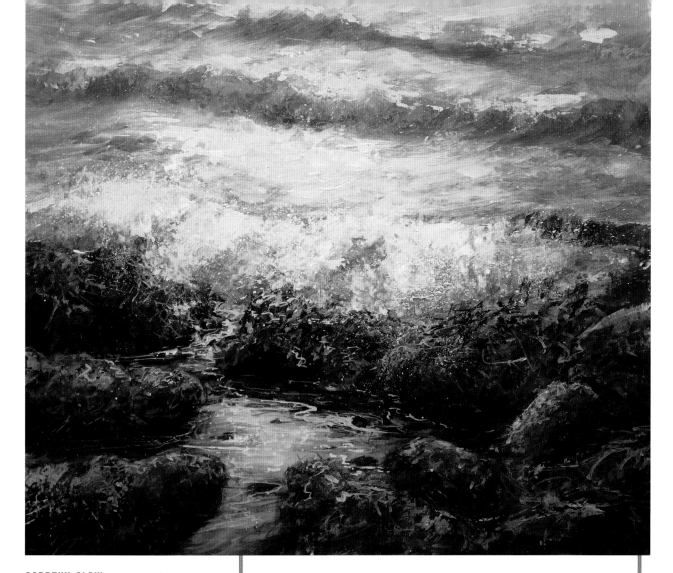

GODREVY GLOW

50 x 44cm (19¾ x 17½in)

Acrylic on mount board. To emphasize the layers of texture and light in this near-square format painting, I cropped the image fairly tight to the subject. This avoids other visual distractions and creates a simple, contemporary viewpoint.

The detail of the seaweed-covered rocks takes up more than the traditional 'Golden Section' third of the composition. Towards the front, the eye moves to the strong contrasts between the seaweed and the dark rock, followed by the layers of bright water. To enable the background light on the water to recede into the distance, the paint was applied with much less movement and softer brush strokes.

A few problems to avoid

- Try to avoid leading the eye out of the painting. Lines travelling nowhere tend to make the work look awkward and uncomfortable.

- Two subjects just touching each other can appear awkward. If you make them overlap a little, it is much easier on the eye.

- Try not to repeat shapes: instead, look for variation throughout the painting.

- Change the scale of objects within the artwork. This will add to both the interest and realism of the painting. This also applies to elements such as waves, clouds and rocks – repeating the same shape looks unnatural.

- Don't pair things up: objects look better in off numbers. Try groups of three rather than two.

- Avoid placing your main point of interest in the centre of the painting. Instead, apply the rule of thirds system and position it one- or two-thirds to the side. It does work!

- Always allow breathing spaces within the painting, incorporating quieter areas against the busier patches. The eye needs to rest at intervals – a cluttered work makes for uncomfortable viewing.

VIEWPOINT

When starting your composition, you will need to consider your point of view. This simply refers to the position of the observer in relation to the objects in the painting. Many artists, myself included, enjoy placing the viewer in the middle of the action, amongst the waves. This viewpoint enables the energy of the sea to be felt at close range. For practical reasons, it requires creating the majority of the artwork from the imagination, combining information from a variety of reference material.

Another effective viewpoint with a dramatic outlook is overlooking the coastline from a cliff edge. Alternatively, a bird's-eye view soaring over the water from directly overhead would create an impressive vantage point. For something a little different, you could try a very low-level viewpoint – a near worm's-eye view, peering through grasses on the coastline with the sea beyond.

Another option would be to move in very close to your subject so that it becomes almost abstract, filled with movement, details and reflections. The choice is yours, but varying the viewpoint will help to keep your work interesting.

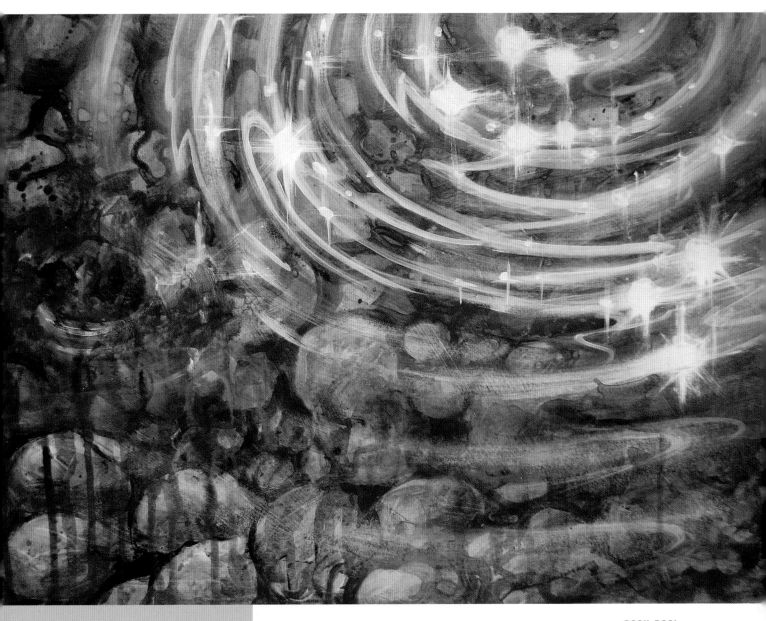

ROCK POOL

52 x 38cm (20½ x 15in)

Watercolour and acrylic on mount board. For this painting depicting ripples on water, I chose an aerial view and moved in very close to the subject. I cropped the image, leaving a semicircle of ripples that lead the eye down to the underwater details in the foreground. The sparkling light leads the viewer to stop at each one before moving to the next. Even though the drips of paint over the left-hand side of the painting flatten the perspective a little, I enjoy the feeling of wetness they provide and the slight move towards the abstract.

Opposite

LIGHT ON NANJIZAL

40 x 35cm (15¾ x 13¾in)

Watercolour on 300gsm (140lb) Arches Aquarelle Rough surface paper. The traditional viewpoint for this watercolour was selected from a number of photographs taken from the coastal path near Land's End, UK. The rocks and grasses wind their way round the bottom right of the composition, creating a border of interest around one side, I emphasized this by adding extra foliage. Two-thirds of the image is filled with the rocky coastline and dappled water, leaving one third of the image for a simple sky. This provides some breathing space against the more detailed area of rock and seawater.

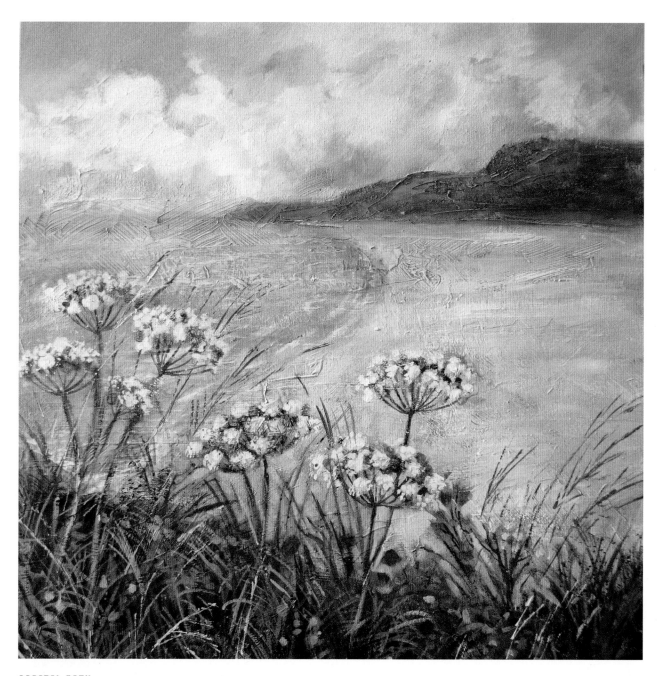

COASTAL PATH

60 x 60cm (23½ x 23½in)

Acrylic on canvas. In this beach view from a coastal path, I used a low viewpoint peering through wild flowers. The foliage and flowers add interest to the foreground. I used brisk speedy marks, strong contrasts and bright pops of colour to attract the eye. The sweep of the water, beach and rocks were kept very indistinct and the colours faded to give the illusion of distance.

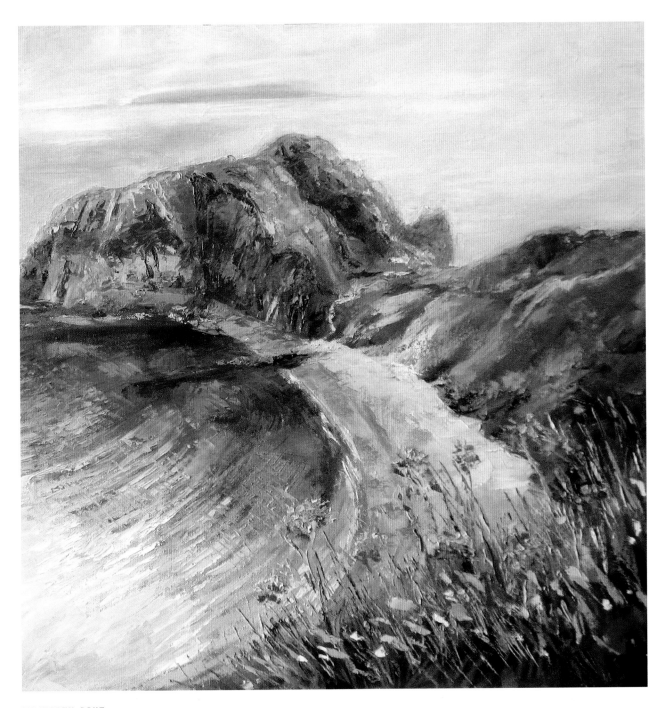

LULWORTH COVE

60 x 60cm (23½ x 23½in)

Acrylic on canvas. The main points of interest in this work are the unusual rock forms along with the reflections on the rippled water. My viewpoint is from high on a cliff, overlooking the scene. To concentrate on this area of interest, I filled approximately two-thirds of the work with the rock and reflections, and cropped the end point off the rock to the left-hand side. This contains the most compelling area and encourages the eye to return to the dark-toned reflections in the semi-circular sweep of seawater.

The background sky and water gently merge into one mass of subtle, pale colour, making them barely distinguishable as they recede into the distance.

CREATING DRAMA

Many artists enjoy adding a touch of drama to their paintings, which attracts the viewer's attention and makes the artwork 'pop'. Certain dramatic elements can be planned ahead – but more painterly and experimental techniques often demand a looser, more intuitive approach, where the work is allowed to develop naturally.

During the painting process, we can often lose the impact that we originally intended: the resulting painting lacks drama, a consequence of the colours becoming too mid-toned and the marks too uniform. To avoid this, we need to stand back from the work and analyse the results, both throughout the painting process and at the final stage.

You will quickly learn to use your own critical judgement, and learn where brush strokes need emphasizing, colours and tones adjusting and finally where to apply those small highlights to make the painting sing. Here are a few techniques that will add drama to your work.

- **Strong contrasts** Areas of strong contrast between light and dark add drama and create a focal point, pulling the viewer's eye to that location.

- **Directional lines** Strong directional lines and shapes within the work create drama and tension.

- **Dynamic marks** Creating dynamic and energetic marks adds movement and interest. Quieter areas within the work will act as a foil to these busier patches.

- **Small details** Small details can add drama by stopping the viewer's eye at strategic points. For example, a small bright patch of colour in an otherwise loose atmospheric work will create unexpected punctuation.

- **Texture** An area of texture will add an interesting dimension, attracting attention in amongst the flatter areas.

Tip

To help you see if your painting is balanced, view the work in reverse by looking through a mirror. Alternatively, turn the work upside-down. Both of these techniques enable you to judge the work more detachedly through its shapes, marks, tones and colour.

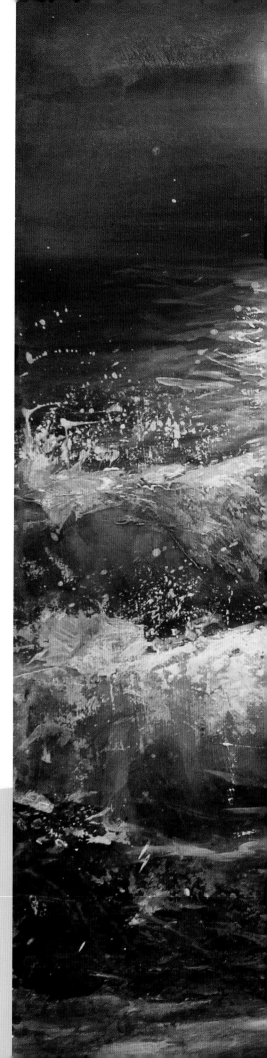

BURNISHED SUN
50 x 50cm (19¾ x 19¾in)

Mixed media on gessoed MDF. Sunsets possess natural, built-in drama as a result of the strong contrast between the dark tones and the bright sunlight.

To create additional drama, I included an abundance of movement. Using vigorous brush strokes, I swept the main two waves into an angled, arched shape that runs in an upwards direction from one side of the painting to the other. To add to the dynamic sense of movement, I included splashes of foam to attract the eye.

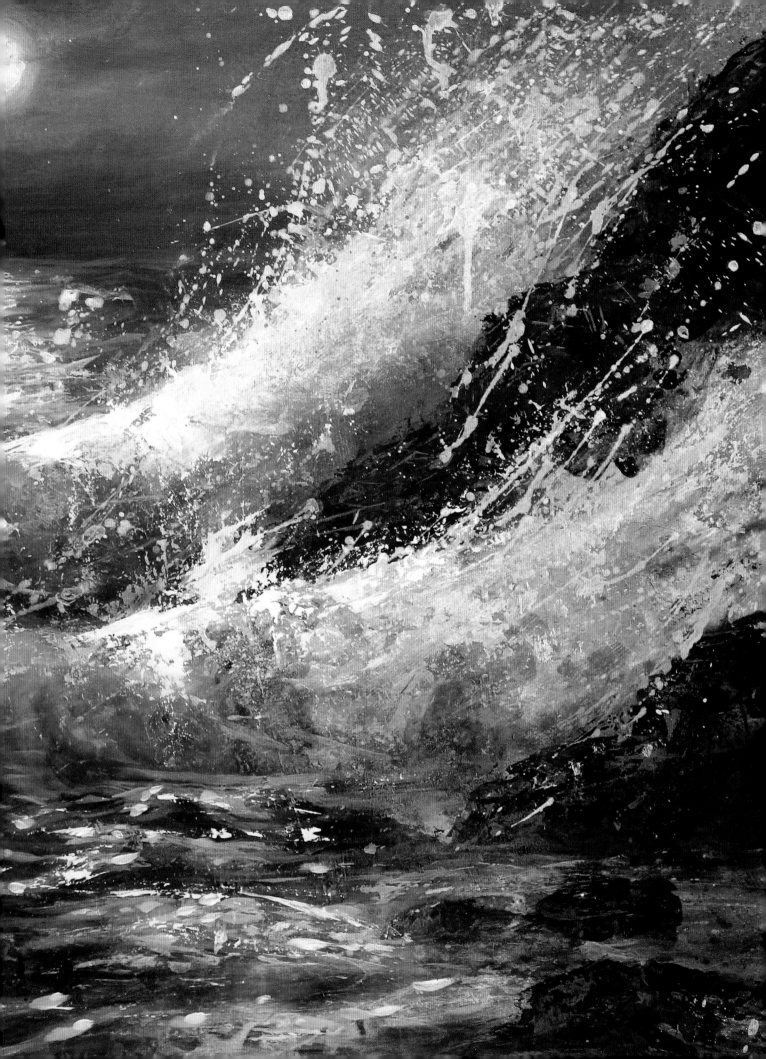

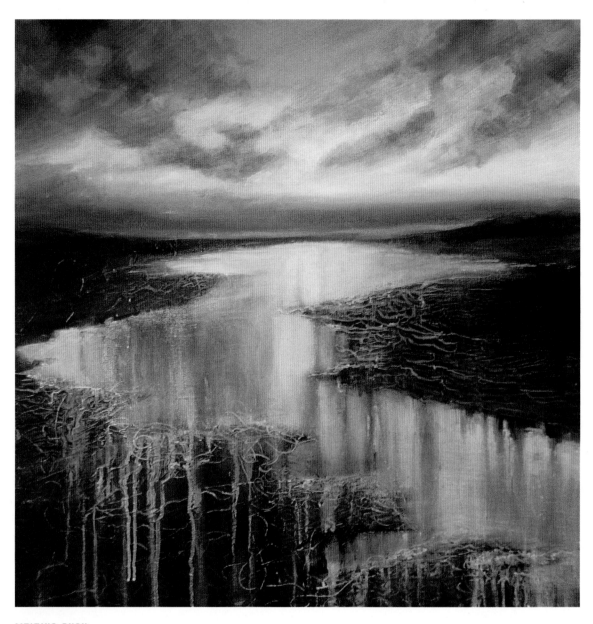

MELTING DUSK

60 x 60cm (23½ x 23½in)

Acrylic on canvas. It is an extremely enjoyable activity to paint from memory and imagination: I tried this process on a whimsical seascape. This approach will give you the freedom to invent without feeling tied to your reference material. I also wanted to have fun with the image and draw attention to both the illusion and the painted surface.

To add drama to the painting, I used a very strong contrast between the bright, reflective surface of the water and the darker land. For suggested detail, I added a heavy texture to the dark areas, before highlighting the edges with the warm pink. I created the impression of a melting surface by allowing drips of paint to run directly down from the water. These marks could easily flatten the image, so to counteract this I used a strong, convincing perspective in the cloud forms and the water. Following the lines of perspective, this leads them towards the vanishing point on the horizon.

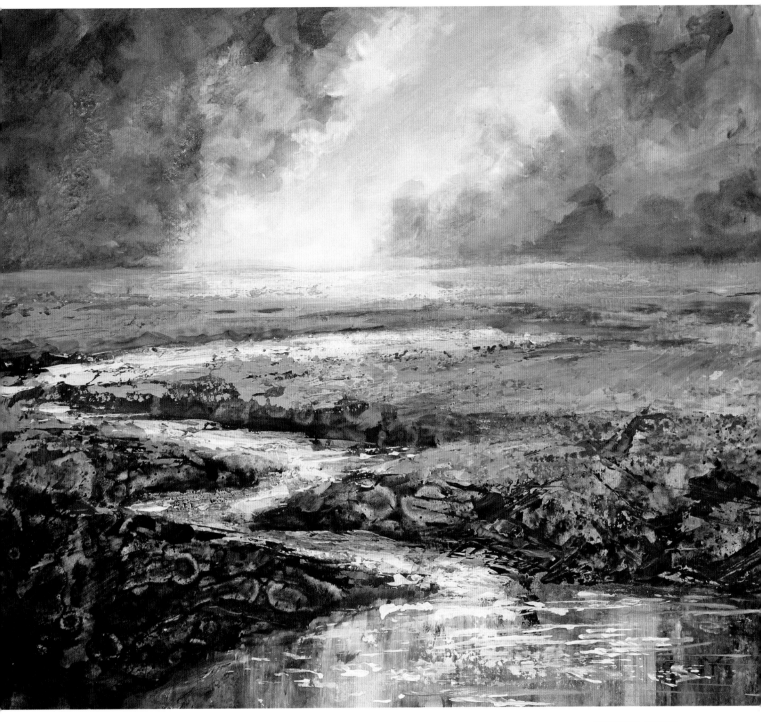

JURASSIC COAST

35 x 25cm (14 x 9¾in)

Watercolour and acrylic on mount board. I used a strong zigzagging path of light for the strip of water to draw the eye through the painting towards the distance. Once again, the bold contrasts between light and shadow create a dramatic quality. To add interest in the foreground, I used busy, multi-textured layers and glimpses of underlying detail.

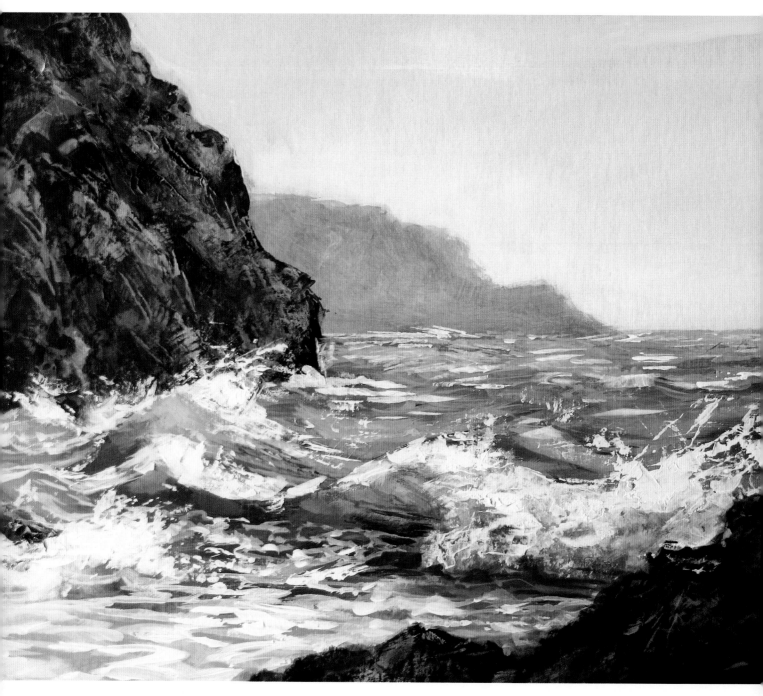

SEA FOAM SPLASH

44 x 30cm (17¼ x 11¾in)

Acrylic on mount board. In this traditional seascape composition, the contrast between the dark, heavy cliff and the dynamic, bright marks of the waves adds drama. The shape of the strong, dark rock cuts downwards into the water, producing an imposing, looming appearance. All this energy is balanced by the calm, subtle colours in the background, which also add to the tonal perspective.

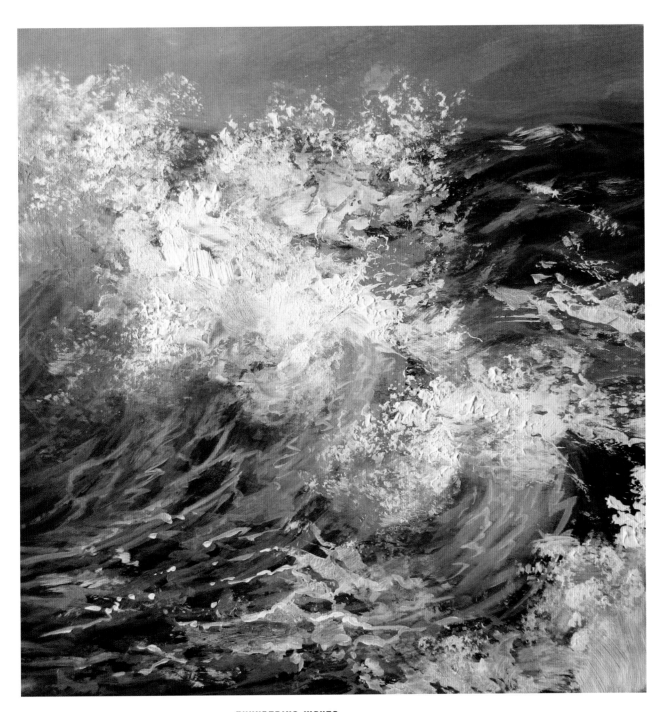

THUNDERING WAVES

20 x 20cm (8 x 8in)

Acrylic and watercolour on mount board. For this
small painting, I moved in close to the action. It is a
very simple composition, where most of the drama
is created through the use of dynamic brushwork to
suggest energetic movement. The sweeping marks
describe the curve of the wave, drawing the eye up
and around the shape.

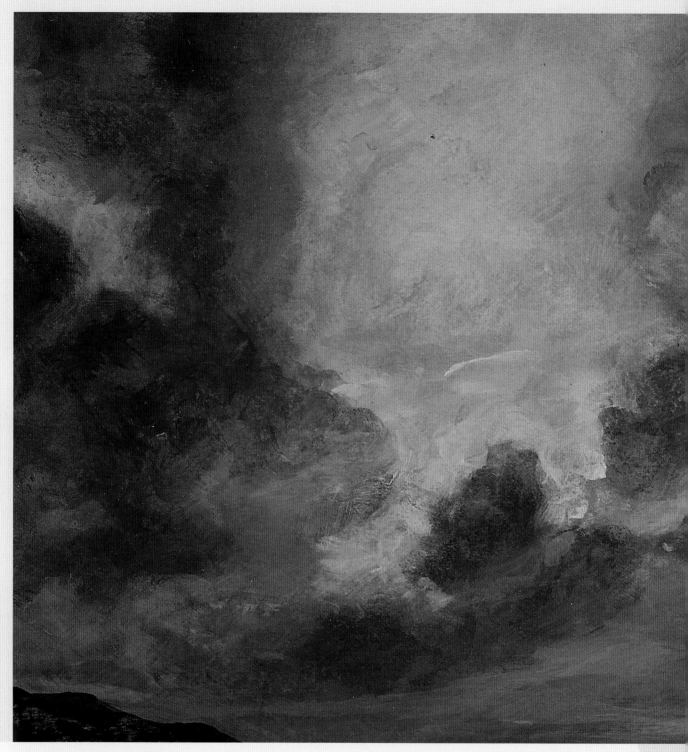

SKIES AND LIGHT

I usually start any seascape painting with the sky. As well as providing the source of light, skies create endless moods and atmospheres, which can be represented through a range of painting techniques.

Painting a sky rewards using the paint in a loose, free-flowing manner, leaving hard and soft edges that help to suggest the the light and variety of tones within the clouds forms.

The sky also interacts with the water below, casting shadows and reflections onto its surface. All these shapes and paths of light help to create a strong composition. Adding an impression of perspective to the sky will create a strong sense of depth to the work.

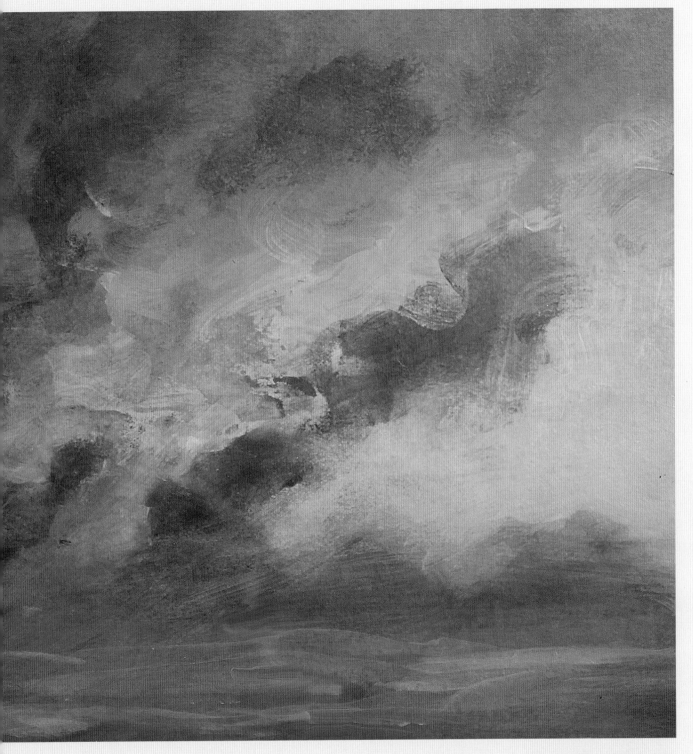

DETAIL FROM LUMINOUS SEAS

55 x 49cm (21¾ x 19¼in)

Acrylics on board. Here the contrast between the dark clouds and the blue of the sky creates interesting V-shapes within the composition. These shapes help to create a sense of depth by following the rules of perspective and projecting towards a vanishing point on the horizon. I made the marks using multiple layers of wet paint, making no attempt to hide the brush strokes. Often, keeping the marks visible can add considerable interest and movement to an area.

Inventing weather

One of the advantages of painting seascapes is that you are free to invent any weather conditions. If your reference material has a monotonous, lifeless sky, you are free to create your own sensational sky to enhance the painting.

I often combine seas and skies from several photographs. Providing that you ensure that the light on the sea reflects the colours in the sky, you will be able to create a convincingly realistic scene.

Try creating brooding skies by adding billowing clouds, exaggerating the light effects and heightening the contrasts. The decisions are yours to make – there are no rules!

DETAIL FROM BRIGHT BREAKING THROUGH

32 x 25cm (12½ x 9¾in)

These brooding clouds were painted in watercolour on heavy textured paper. To encourage the colours to merge in the base layers, I used a wet-on-wet technique. In order to form the very dark clouds, once the underpainting was dry, I scumbled on a thicker mix of lamp black, indigo and violet, the colours becoming softer and more indistinct as they move towards the horizon.

The shafts of light breaking through the cloud were painted with a wet mix of titanium white gouache dragged in a downwards direction.

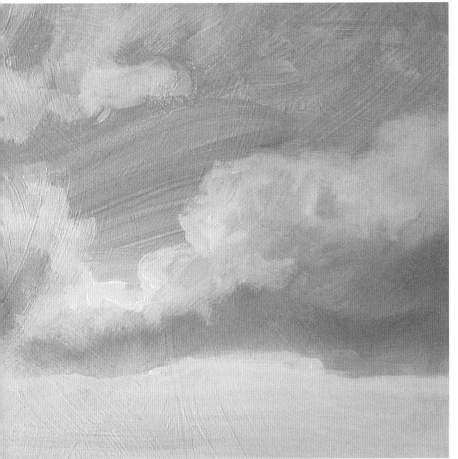

DETAIL FROM DANCING LIGHT

40 x 40cm (15¾ x 15¾in)

Watercolour and acrylic. The sky in this painting represents clouds sunlit from behind on a bright, breezy day. The lightly textured brushwork – created beforehand in the base layer of gesso – breaks up the surface, producing an overall shimmering effect. To emphasize the breezy feeling, I started with brisk, loose brush strokes in watercolour. To form hazy, blurred edges within the clouds, I switched to acrylic paint using a mix of titanium white and indigo. While the paint was still wet, I used a finger to merge the paint in several areas developing a soft blend.

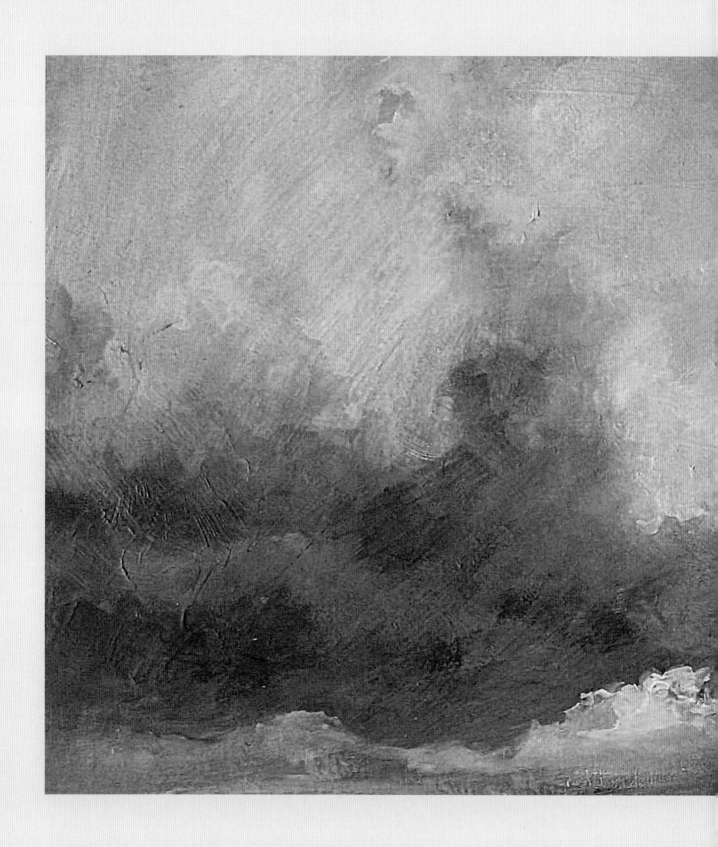

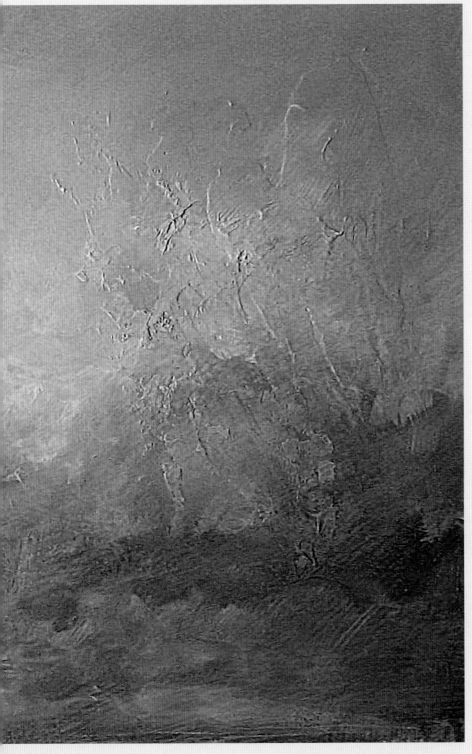

DETAIL FROM SWATHES OF LIGHT
60 x 60cm (23½ x 23½in)

The sky was loosely painted in acrylics on an MDF board undercoated with gesso. To achieve a shimmering, broken effect, I used multiple layers of paint, keeping the brush strokes brisk and lively. To soften the surface marks, I kept the paint slightly damp by spraying the surface with a water spray and sweeping in every direction over the whole sky, with a large, soft, dry brush. I also used a fingertip to blend the edges in order to create a soft misty halo of cloud.

I incorporated a mix of titanium white, permanent rose, ultramarine blue and gold ochre to form the clouds. Finally, to unify the painting, I glazed over large areas with soft washes of a permanent rose mixed with yellow ochre.

FOREGROUND: ADDED ELEMENTS

I will often focus on painting the sea on its own. However, I am also drawn to other natural forms and organic elements such as seaweed, flotsam, coastal grasses and wild flowers, any or all of which make interesting additions to a painting. These elements also capture my strong memories of the coast.

Man-made objects also rekindle memories of the coast for me. Including these elements in a painting often helps to create a sense of narrative. For example, the use of small boats provides a sense of scale – especially when placed amongst huge waves, where they also reminds us of how small and insignificant we are.

The inclusion of buildings into a seascape provides a recognizable sense of place and suggests lives with strong connections to the sea.

PATH TO NANJIZAL
60 x 60cm (23½ x 23½in)

Occasionally a reference shot gives you just what you require, leaving little to alter or adjust. The photograph of the South West Coast Path, UK, is a perfect example. The sun overhead created dramatic dark shadows which needed little changing. The main area of interest was the small, rickety stile which appeared to lead to nowhere. I cropped in close to the stile, so that the slant of the path made an interesting diagonal across the image. The eye is drawn to the details and strongly contrasting elements in the foreground, before moving towards the gate and beyond. The background sea and cliffs are left misty and vague to create a sense of distance.

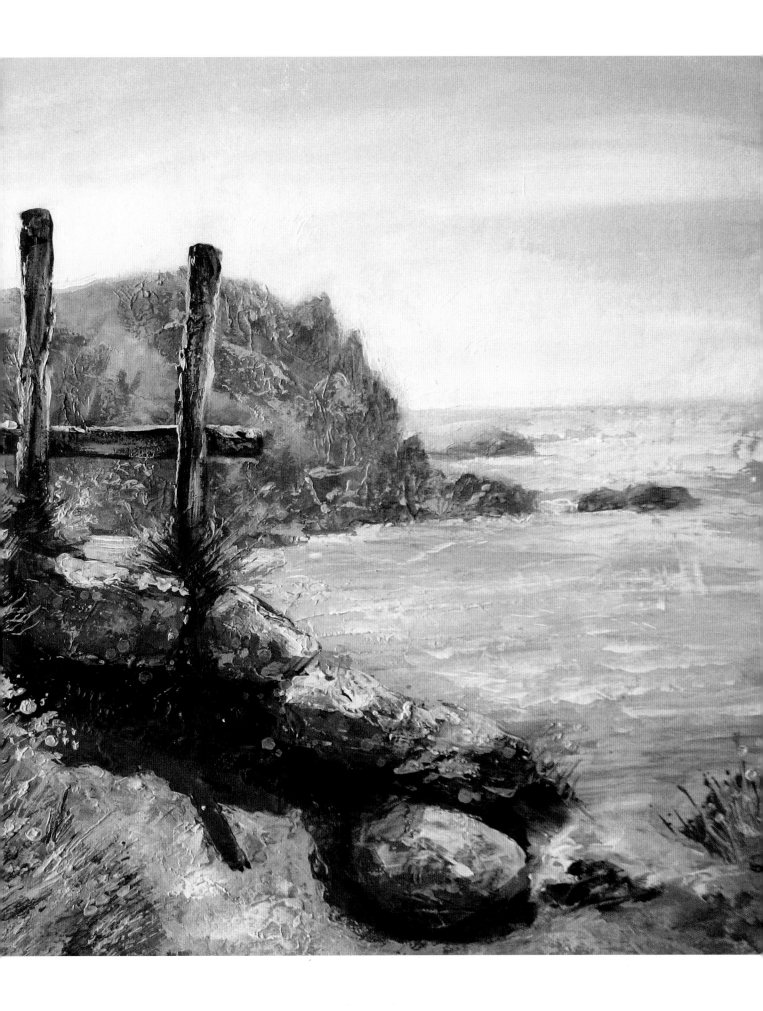

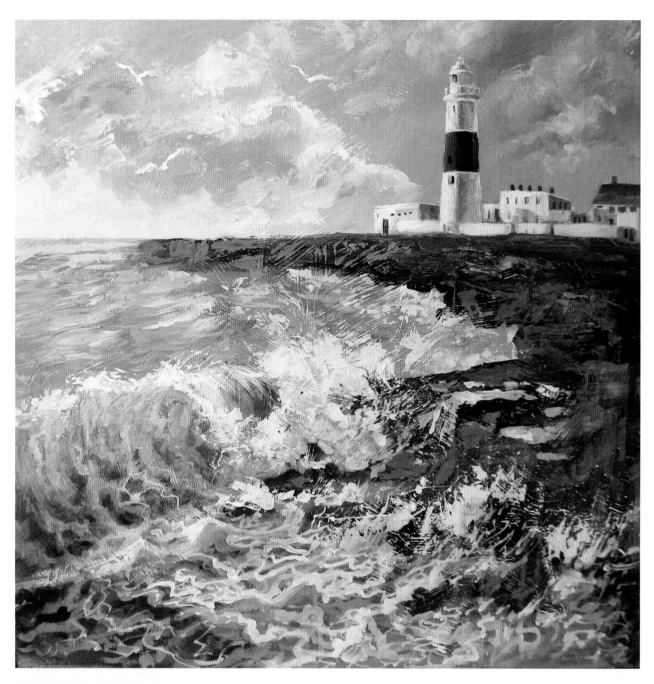

SEA SPRAY AT PORTLAND BILL

50 x 50cm (19¾ x 19¾in)

Acrylic on gessoed hardboard. The focal point in this painting is the lighthouse, which is placed off-centre, following the rule of thirds (see page 98). I used vigorous marks and textures within the water to draw the eye to the foreground and to contrast with the flat, clean surface of the lighthouse. Likewise the flash of red painted on the lighthouse adds punctuation, contrasting with the organic forms and blues tones of the main body of the painting.

Opposite

WEATHERING STORMS

50 x 60cm (19¾ x 23½in)

Acrylic on gessoed MDF. The careful positioning of elements within the composition provides considerable drama to a painting. The image space here is completely dominated by the large and foreboding cliff face. I had fun painting this little house perched on the edge. To suggest it was clinging to the cliff top, battling not to be blown away, I painted it at a tilt, echoing the tree.

To suggest grasses, I used thick, heavy, palette knife marks on the cliff. These are angled in the same direction, further emphasizing the strong wind. Vigorous splashes, achieved with wet paint flicked off the end of a loaded brush, create an upwards motion and draw the eye to the house.

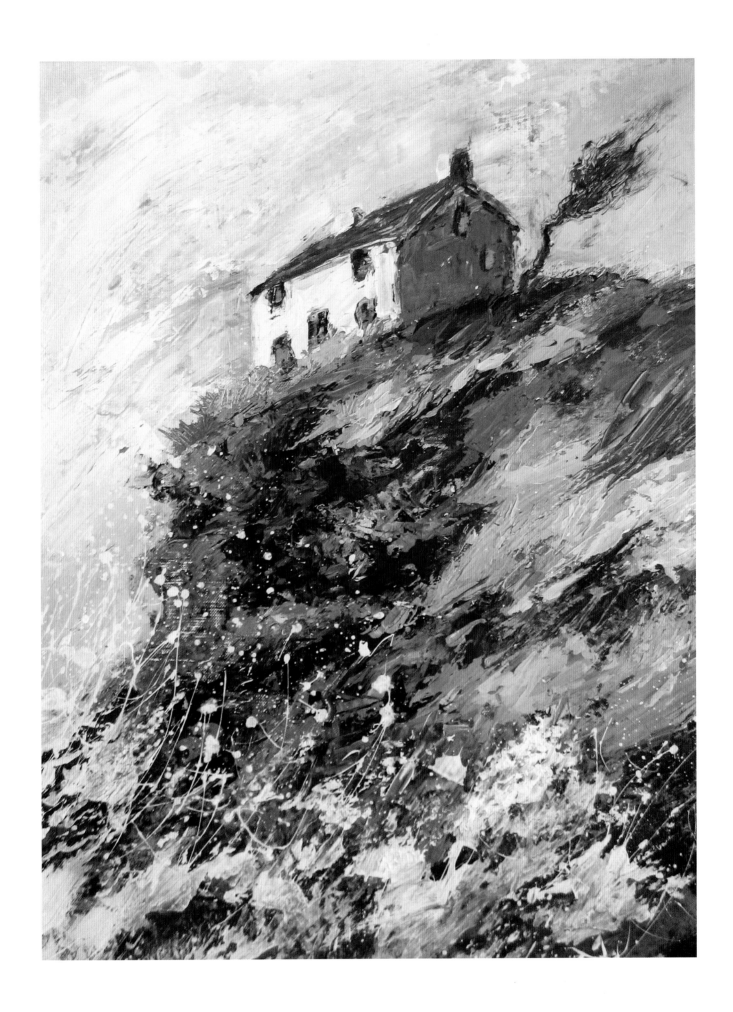

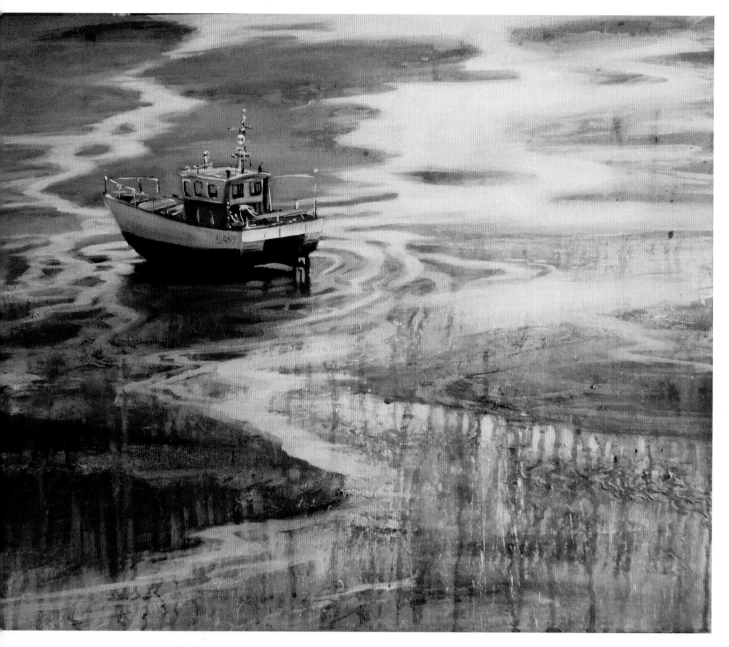

TIDES TURN

56 x 46cm (22 x 18in)

Acrylic on canvas. This lone boat attracted my attention as it sat stranded, waiting for the tide to turn.
So often seascapes become a metaphor and certainly this small boat struck me as a perfect example.
I positioned the vessel in a comfortable position, just off-centre, to establish the boat as the focal point.
The rivulets of water on wet sand sweep towards the boat, then beyond into the distance. They become
smaller and narrower as they recede, helping to provide a sense of depth. I have accentuated the
contrast between shadows and the highlights on the boat, underlining the three-dimensional illusion.

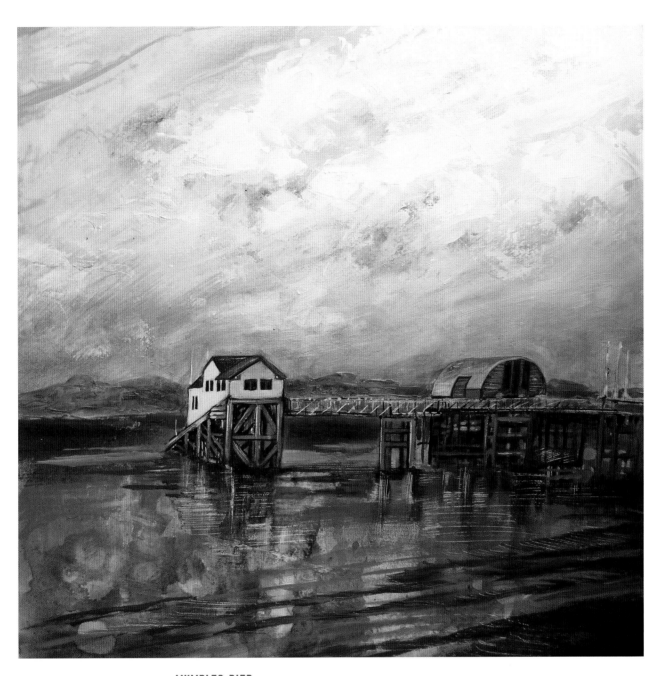

MUMBLES PIER

40 x 40cm (15¾ x 15¾in)

Watercolour and acrylic on board. I recorded many photographs of the tiny Mumbles Pier in Swansea, Wales, but unfortunately the sky was too bright and sunny in all of my reference shots. I felt a contrast was required to highlight the small, bright building. To achieve this variation, I painted a large, stormy sky that fills two-thirds of the work. Consequently I was able to concentrate on the bright reflections on the darker water, using strong contrasts to add drama.

To suggest a slightly worn, faded appearance, I completed the work by sanding the surface with fine sandpaper, establishing small areas of scratches within the paint.

TEXTURE, TRICKS AND ILLUSIONS

Textures

I constantly look for ways to incorporate textures into my artwork, as they add interest in a number of ways. As with strong contrasts, texture attracts and leads the eye through a painting, pausing at strategic points. In a similar way to an impressionist painting, texture leaves plenty to the imagination – and the brain has an amazing ability to make sense out of a jumble of loose and indistinct marks.

Texture can also be used to suggest distance. It is possible to use textural elements within your work and still retain a sense of three-dimensional space; using heavier textures in the foreground, while rationing texture in the distance will help the sense of recession.

A word of warning about the overuse of texture: it can overwhelm and flatten the painting if used in excess.

Perspective

The use of perspective is necessary when we strive to obtain an illusion of three-dimensional depth and space in our artwork. You can achieve a believable image by understanding a few key areas of the subject. I suggest concentrating on one or two of these points from the notes below, in order to attain a sense of space and realism.

- **Vanishing points** Even without obvious symmetrical parallel lines, all objects follow the rules of linear perspective: they converge towards a single vanishing point on the composition's horizon line. A vanishing point is not always obvious within a loose seascape, but it is worth keeping in mind to avoid unintentionally flattening the image.

- **Scale** The simplest and most obvious method of suggesting perspective is to reduce the size of objects and the distance between them as they recede. Often this is all you require in a seascape to obtain a sense or realism. For example, if you emphasize that the clouds and waves reduce in scale until they disappear towards the horizon, you will quickly achieve a sense of perspective.

- **Colours** Using colour carefully and effectively will add a sense of perspective. The colours in the foreground should be brighter, contain stronger contrasts and more saturated, than those in the distance. As a consequence of the layers of atmosphere, the tones in the distance are cooler, bluer and paler. This creates a visual distance, also know as atmospheric perspective.

- **Foreground detail** Adding detail in the foreground will help to achieve a convincing sense of perspective. Details become blurred as they recede into the background, softening and merging into one indistinct tonal mass.

SAND RIVERS
20 x 28cm (8 x 11in)

Acrylic on canvas. I used very heavy texture over the entire surface of this beach scene. I enjoyed the thick bold marks and smears of colour, so I decided to allow it to flatten the perspective somewhat. The finished painting retains a certain illusion of depth due to the rivulet of water leading into the distance.

Sometimes you just have to let things happen and put the rulebook away in the end I decided I liked the effect and I ended up painting an entire series in a similar manner.

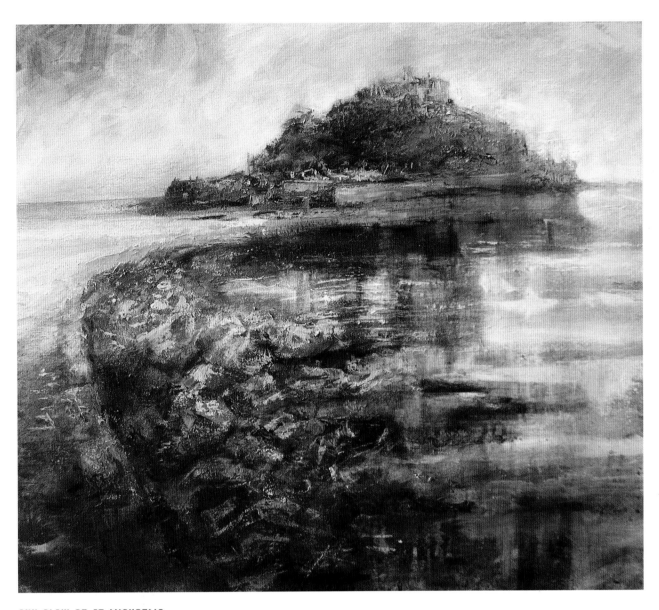

SUN GLOW AT ST MICHAEL'S

70 x 55cm (27½ x 21½in)

Acrylic on canvas. For this atmospheric image of St Michael's Mount in the south-west of the UK, I started with a light random texture. This was achieved by applying gesso over the whole canvas with a stiff bristled brush. As well as infusing the work with a shimmering quality, the top layer of paint is partially broken. As a consequence, it picks up the underlying texture. In the foreground, thicker textures were used to suggest the rough surfaces of rock, seaweed and other natural forms.

Once the gesso was dry, a dark base colour was applied to suggest the shadows. Warm yellow and ochre tones were painted over the base colour by dragging a brush at an angle over the textured ground. This process accentuates the detail on the raised surface, implying light interacting with the subject. The tones and contrasts become increasingly subtle along the horizon line, causing them to recede into the background and creating atmospheric perspective.

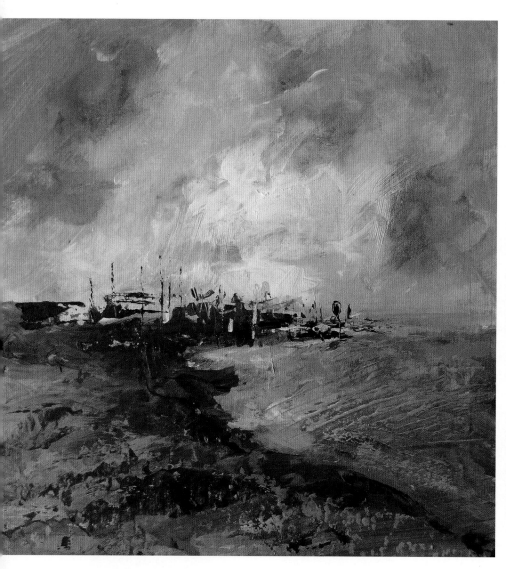

BEYOND OLD BOATYARDS

20 x 20cm (8 x 8in)

Acrylic on mount board. This atmospheric painting focuses on the textures and colours of a coastal scene in winter. I used an impressionistic approach, keeping everything vague and suggestive. I applied loose texture using a palette knife over the contrasting base colours in the foreground, and scraped away the surface whilst wet to reveal the underlying colours. To convey the distance, I utilized the sweep of the coastline to incorporate softer ochres and hints of grey.

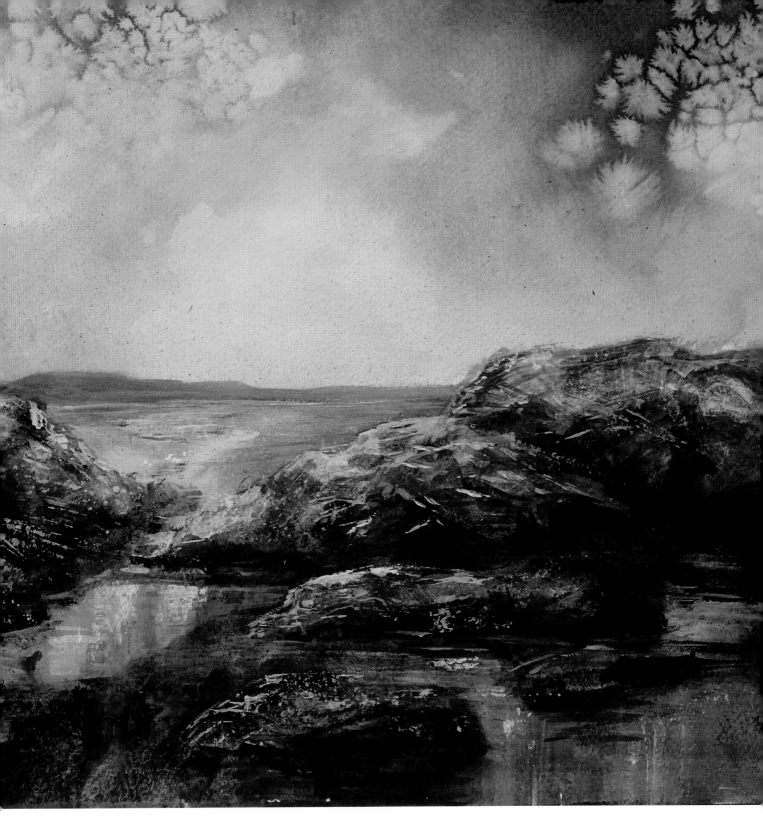

EVENING FELL

37 x 30cm (14½ x 11¾in)

Watercolour and acrylic on mount board. In the foreground, to enhance the sense of depth, I painted dark, heavily textured rocks that contrast with the shimmering water reflections. In the top section of the sky I used the texture of the salt technique (see page 53), which projects the area forward in contrast to the calmness of the horizon, obtained by using a flat painting technique. The distant land is painted as a strip of pale grey.

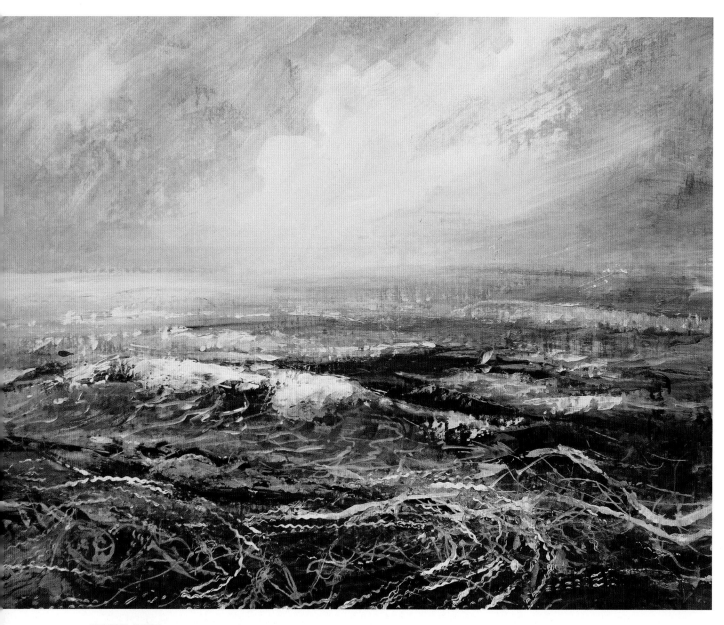

JETSAM DAWN

40 x 33cm (15¾ x 13in)

Acrylic on mount board. I really enjoyed drawing attention to the different layers of texture in this painting. I used a pastry cutter dipped in acrylic paint to suggest ropes and tangled weeds along the shoreline.

Large obvious marks always appear to be closer than smaller gentler brush strokes. The sea was loosely painted with a vague suggestion of movement. Resting on the skyline, the colours fade and merge together to form a soft, atmospheric effect.

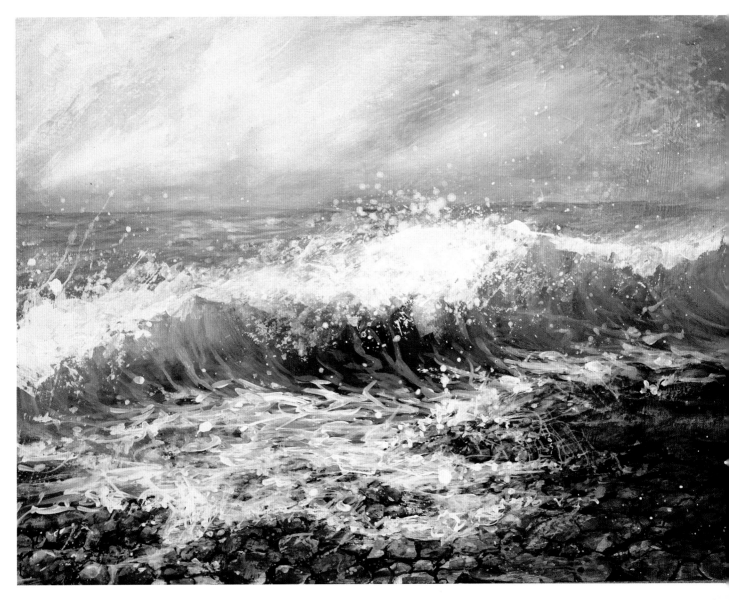

SHIFTING TIDE

45m x 30cm (17¾ x 11¾in)

Watercolour and acrylic on MDF board. In this painting, the busy detail and energetic brush strokes grab the viewer's attention! The rocks in the foreground were painted with vigorous marks and strong contrasts. Similarly, the wave and foam splashes were all created using speedy, energetic brushwork. The eye is naturally drawn to all this action, which is reinforced by and contrasts with the soft haze of the horizon.

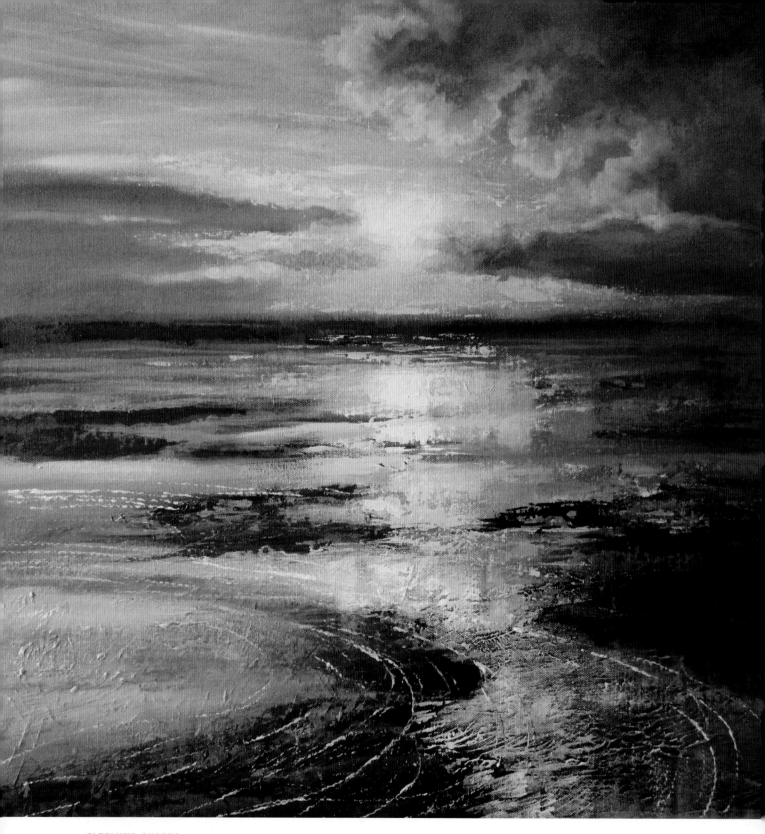

GLEAMING SHORES

60 x 60cm (23½ x 23½in)

Acrylic on canvas. To create a sense of calm and tranquillity in this sunset, I employed a restricted palette of complementary colours, using various tones of black-browns, ochres and grey-blues, mixed mainly from ultramarine blue, doixadoine purple, raw umber, burnt umber, yellow ochre and burnt sienna along with titanium white.

To emphasize the feeling of serenity, I avoided using energetic marks. To form soft edges in the flat, reflective water and the sky, I blended the colour using a fingertip in the wet paint, to create a gradual merging of tones. The dramatic lighting was captured with light flat marks of the darkest tones made with a palette knife in a mix of ivory black, burnt umber and dioxazine purple. This contrasts with the searing bright highlights of titanium white with a touch of cadmium yellow. To finish, I added a few sweeps of reflected light in the foreground, using my favourite old pastry cutter loaded with a warmer mix of cadmium yellow and titanium white.

CREATING MOOD AND ATMOSPHERE

The 'abstract' elements of mood and atmosphere, and my quest to achieve both qualities, form the cornerstone of my painting. I am constantly aware of the light effects cutting through water, casting long shadows, or shining through mists. My objective is to capture my response to the combination of colours, light effects and weather conditions. By combining the following methods, you can experiment with the moods and atmospheres you wish to achieve in your work.

ELEMENTS OF ATMOSPHERE

Colour

The viewer has an automatic and profound response towards colour in a painting. Consequently, the use of colour is one of the most exciting aspects of a painting. It is also one of the most effective ways of changing the mood in your work.

 Blues, for example, tend to look rather tranquil and trigger a calming effect. Black often evokes mystery, whilst reds and yellows generate work with drama, passion and excitement – this may explain why so many of us are drawn to sunsets!

 In order to intensify the mood of a painting, yet keep the work convincing, you may simply decide to exaggerate the colours that occur in nature. To heighten the atmosphere, you might choose a muted, monochrome palette, resulting in a calm, serene atmosphere, or alternatively select clashing colours to produce an agitated, edgy result.

Light

The quality of light is a crucial element in the mood of a painting. It generates a strong response, attracting us to a scene. Good control of light also allows you to emphasize the contrasts within a painting, and builds a dramatic atmosphere. Strong side-lighting will form very bright highlights and deep shadows, for example, creating drama and excitement. Conversely, diffused lighting and manipulating colours closer in tone will produce a harmonious effect and tranquil painting.

Marks

Using an assortment of marks enables you to create a range of moods within a painting. Juxtaposing dynamic brush marks with thicker smears of colour made with a palette knife will produce a tense, exciting mood, perfect to express the highly charged atmosphere of a storm.

 Gentle marks, used in partnership with subtle blends and merging tones, appear soothing and tranquil. This combination will enable you to create an ethereal sense of calm; or can suggest mists and hazy lighting effects.

Heavy texture applied in the gesso base layer creates a suggestion of waves whilst adding a three-dimensional element. The effect of the texture was heightened when a dry brush, filled with white paint, was dragged horizontally over the surface.

STORMY RAGING SEAS

In order to produce a painting full of movement, I created a multi-directional, textured base by applying gesso with a thick bristled brush. This underlying texture breaks up the subsequent marks to build a feeling of energy throughout the entire image.

Additional heavy texture was applied to the base layer of gesso to suggest both the choppy sea and the swell of the waves. Once the gesso had dried, I applied a layer of watercolour medium and left it to dry for at least three hours. To create the base layer of the sea, I used watercolour washes of Prussian blue, Winsor green and sap green to provide a translucent layer of colour. This gleams through the subsequent layers, providing the illusion of depth.

For increased drama, very dark shadows were painted with acrylic washes, using a mix of phthalo blue, indanthrene blue and Hooker's green.

To represent the sea foam, I added energetic brush marks in an acrylic mix of titanium white with a touch of cobalt blue. Finally for extra energy, I applied a variety of splashes in the same white acrylic mix, representing spray flying from the top of the breaking waves.

The underlying dynamic marks created in the gesso provide another layer of energy, breaking up the surface and diffusing all the subsequent layers into one mass of movement.

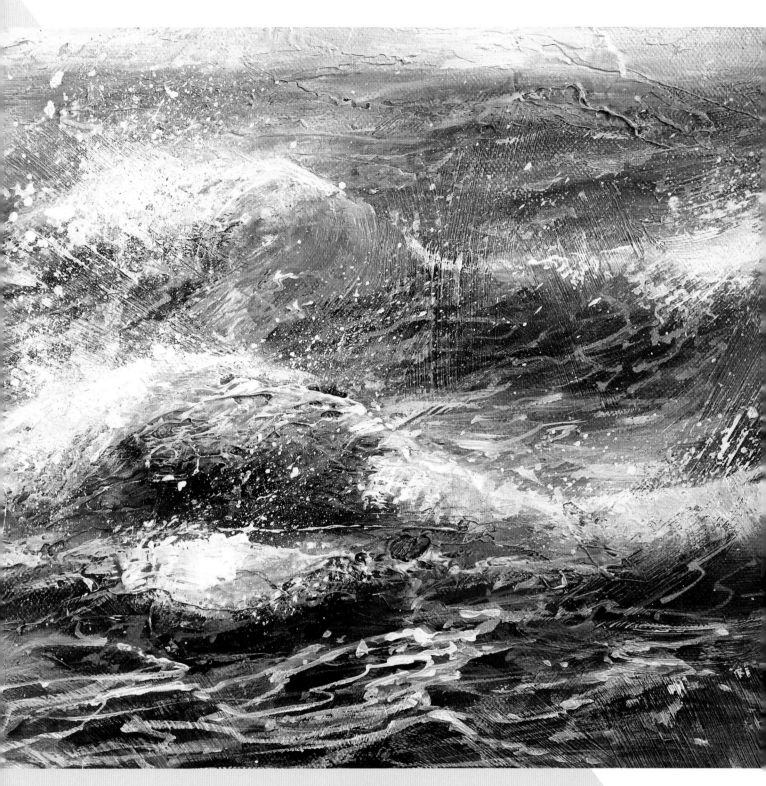

SEA SPRAY
40 x 40cm (15¾ x 15¾in)
Watercolour and acrylic on canvas.

MISTY, ETHEREAL ATMOSPHERE

I created the texture in the foreground rocks by loosely placing plastic food wrap onto a wet, watercolour wash of sepia, Vandyke brown, burnt sienna, cobalt turquoise and lamp black. After the paint had totally dried, the food wrap was removed and the resulting shapes were emphasized by applying darker overlaying details with a fine brush to suggest deep crevices within the rock.

I painted a calm, misty sea and sky to provide a contrast against the hard rock forms. To obtain a feeling of tranquillity, I thoroughly wetted the board to allow the tones of cobalt blue and cobalt turquoise light to merge together. Watercolour is ideal for these gently melding, blends of colour.

I added a subtle suggestion of small waves using a few broken lines in a soft mid-toned blue. To further enhance the misty, ethereal atmosphere, I merged the sea and sky together on the horizon by slowly building up layers of a wet acrylic glaze. For this, I used titanium white acrylic mixed with plenty of water.

Food wrap is ideal for creating rock textures, leaving subtle, intriguing marks, which mimic a variety of weathered surfaces without being too literal. For the technique, see page 60.

Once dry, the resulting texture can be enhanced with the addition of painted details and deep shadows glazed across specific areas to build depth.

Building up thin washes of white acrylic paint creates a soft haze. It also provides a dreamy tranquil mood by softly merging underlying tones together for an ethereal effect.

To apply washes, it is best to use a large soft brush using a gentle sweeping motion in order to avoid leaving marks. This action can be repeated a number of times to obtain the desired opacity.

Opposite
GODREVEY MISTS
40 x 33cm (15¾ x 13in)
Watercolour and acrylic on mount board.

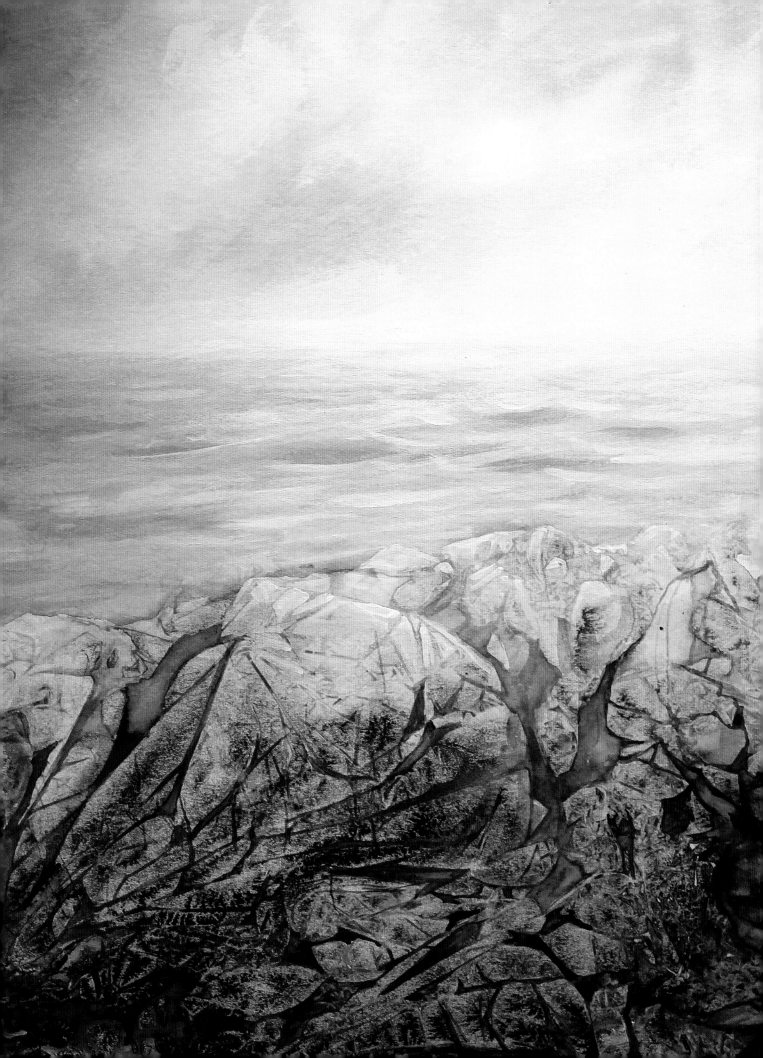

In order to keep a restful feel to the sky, the clouds were blended to create soft edges and merging tones, leaving a few harder edges to suggest cloud forms silhouetted against the bright light.

Finally, a soft glaze of titanium white was painted over the large areas of cloud to subdue and merge the tones.

CALM, SHIMMERING WATERS

In this painting, I wanted simply to replicate the restful tranquillity of the scene. I also tried to capture the strong contrasts between the dark clouds and intense sunlight. To add a slightly whimsical air, I over-emphasized the naturally occurring colours of the sunset, incorporating slightly exaggerated pinkish-purple hues.

In order to present a feeling of calm, I avoided using dynamic marks, instead creating the work using a combination of blends utilizing soft gradations of colour, multiple glazes, and I also allowed the paint to run and merge together.

To create the cloud forms, I used glazes made with various quantities of quinacridone magenta, cobalt blue, dioxadine purple, raw umber and titanium white, all blended with a fingertip and a soft dry brush. I added small hints of cadmium yellow light and yellow ochre to the recipe to suggest sunlight illuminating the clouds.

To represent ripples on the sand, I started by using the tip of a palette knife to create a heavy textured surface of wavy, horizontal marks in a base layer of gesso. These create a curving arc that sweeps towards the distance. All this texture is contrasted against the calm, flat area of bright reflective water.

The beam of bright sunlight through the centre is intensified by the surrounding deep shadows. The effect was created by smearing pure titanium white down the central area with a loaded palette knife. The thickness of the paint creates a bright opaque colour.

To unify the painting and achieve a warm glow, I swept a very thin wash of translucent gold ochre over all but the sky. Using glazes in this fashion is an effective method of subtly changing tones and merging colours. If you use this approach I suggest applying long sweeping gestures with a large brush, together with very wet paint. A last word of advice: remember to keep a wet rag handy to wipe off any patches that have become too vibrant.

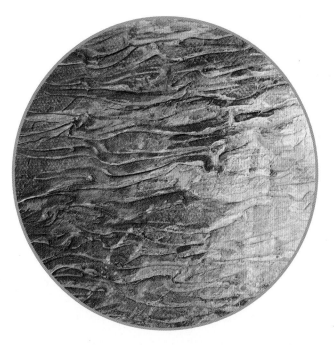

Heavy texture used strategically creates a contrast with the quieter areas. It adds interest, suggests a variety of natural textures, and attracts the eye.

The dark base colour can easily be overlaid with brighter highlights: here I used a subtle, pinkish, yellow tone over a mid-purple/brown base. Applied quickly with a brush or palette knife, held parallel to the surface, the contrasting yellow-pink highlights the raised areas, bringing out the surface texture and suggesting the light falling on the sand.

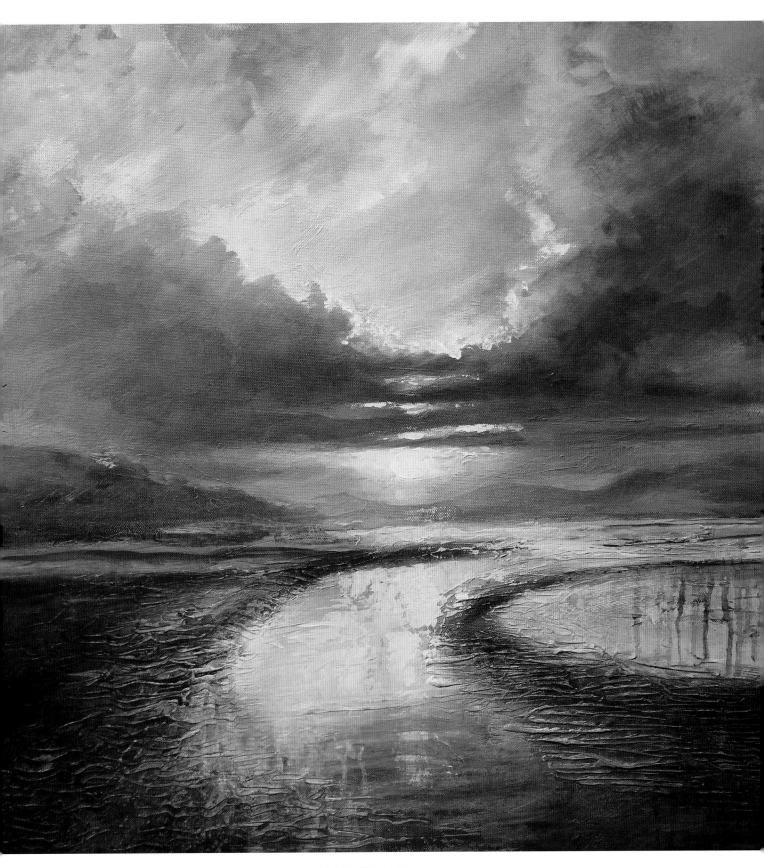

BARMOUTH LIGHT
60 x 60cm (23½ x 23½in)
Acrylic on canvas.

DREAMY ATMOSPHERE

To create a harmonious feeling in this seascape, I used a restricted colour palette of soothing, cool blues and complementary sand tones. The sky was painted with soft blends of similar restful blue-grey hues, all adding to the dreamy feel.

The hazy sunlight was suggested using a pale, surrounding glow, created with a dry brush technique using titanium white mixed with a small amount of yellow ochre. I used several dashes of the mid blue in the texture of the rocks to merge the colours and consolidate the work. Incorporating fragments of colour from the main body of the work into the smaller details produces a unifying effect.

To suggest the light shining on wet sand, I used a series of gentle, sweeping, brush strokes applied with a rigger brush loaded with a wet mix of titanium white over a pinkish-grey sand-coloured base. I created a variety of soft, curving marks down towards the front of the painting, mixing heavier marks directly below the sun, to represent the gleam of reflected sunlight.

A variety of gentle, loose sweeping marks were made in soft tones to suggest the reflections on the wet sand. The underpainting showing through helps to give an impression of layers and shadows flowing through the water.

In order to suggest the bright strip of light reflecting on the sand, I applied the titanium white paint with a palette knife in a downwards motion. The shadows of the rocks were created using a range of dark brown-purplish glazes, dragged downwards over the sand. Overlaying glazes produces an interesting layered effect revealing the previous marks and history of the process.

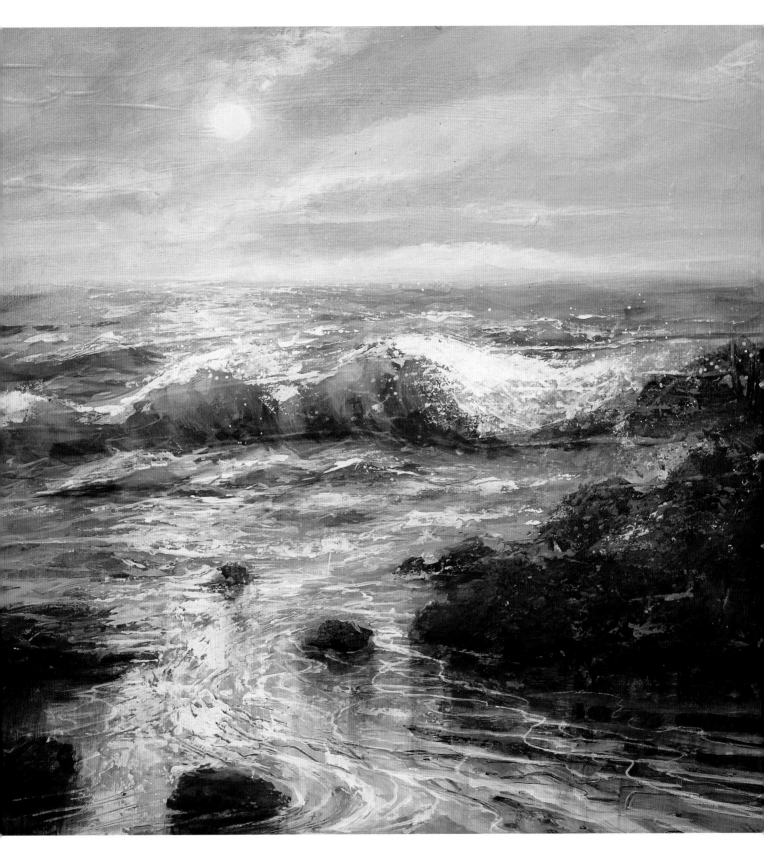

BRANDY BAY
50 x 50cm (19¾ x 19¾in)
Acrylic on MDF board.

BROODING MYSTERY

Many of the most eerily beautiful effects I have witnessed have been created by the image of the moon over a calm sea. In this example, the light reflecting on the flat surface of water created an appearance similar to liquid mercury. Such effects are often surrounded by intense black shadows, creating an air of mystery to the whole scene.

I used faded lighting to subdue this seascape, narrowing the range of tones and allowing them to merge together in a haze. The result is that everything in the mid-ground and beyond is indistinct and intriguing.

The colours used in the scene were indanthrene blue, cobalt turquoise, raw sienna, burnt sienna, burnt umber, and ivory black; all mixed with titanium white. To achieve subtlety, the colours were also mixed with small touches of brown and black.

I painted the watery moonlight with the addition of surrounding white glazes to merge the edges into the clouds. To create a sense of calm within the sea, I made use of restful, serene colours, using understated pale blues, leaving subtle underlying glazes of burnt sienna to shimmer through.

In the foreground, I allowed very deep shadows to merge together for a melancholy feel. I felt the mix of ivory back and burnt umber mixed with indanthrene blue created the desired depth of tone needed to achieve sense of brooding mystery. This combination gave the painting an eerie edge.

In the foreground the deep shadows were overlaid with sweeps of brighter toned track marks produced with my pastry cutter, fully loaded with paint then rolled over the surface.

To create additional surface impressions, I pressed a 30cm (12in) piece of thread, saturated in paint, repeatedly onto the canvas.

The softly merging tones of the sky pick up on the underlying texture of the canvas, complementing the small marks which were created in the first layer of gesso. Consequently the subtle texture breaks up the surface to good effect.

To achieve a smooth blend of these subtle tones, I used a 17mm (¾in) brush to make repeated dry-brush applications. As each coat of colour is added, it merges into the previous layer, helping to create a soft haze.

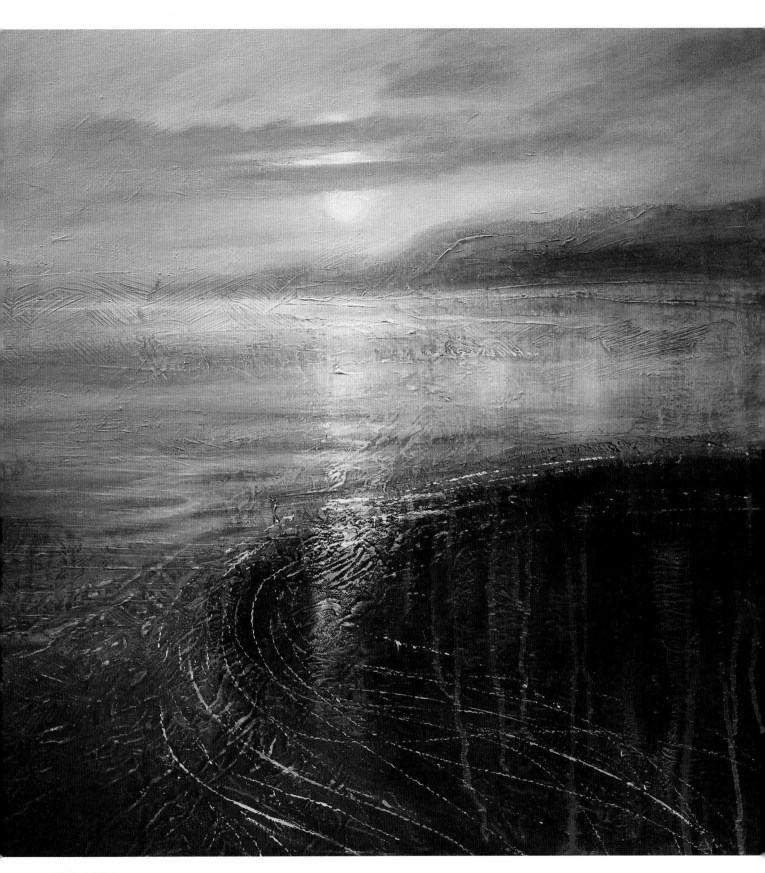

INDIGO SEAS

60 x 60cm (23½ x 23½in)

Acrylic on canvas.

DREAMY NOSTALGIA

The warm tones of the early evening, with the sun hanging low, its light cutting through the water, always gives me a nostalgic feeling. Mellow directional light often creates a warm glow that results in a dreamy, restful atmosphere. I love the way the sinking sun shines through the tops of waves, forming a beautiful translucent effect.

The low side lighting at this time of day forms many sharp tonal contrasts, with deep saturated colours and dark shadows contrasting with sparks of bright light across the surface of the sea.

Painting the saturated colours within the sea, I used a mix of phthalo blue and cobalt turquoise in the darker areas, adding a touch of ivory black to the very deep shadows.

To depict the small bright sparks of sunlight hitting the surface of the water, I painted using a small brush loaded with white paint in a fast dabbing motion. This effect requires tiny, sporadic, fast touches in selected patches, to suggest the shimmering flashes of light.

I created a hazy sky with soft washes of subtle blue-green tones that mirrored the colours used in the sea. This was supplemented with a generous quantity of titanium white, and all were mixed with ochre in the clouds to obtain a warm glow over the entire sky.

To give the illusion of the ripples on the sand, I used my favourite method of suggesting detail, which involves creating a subtle texture in the base layer of the gesso, by forming thin, wavy overlapping marks using the tip of a palette knife. This is accentuated by all the soft overpainting. Building underlying texture is my way of avoiding the obvious. Describing elements too literally can result in leaving little or nothing to the imagination.

To paint the translucent water, I mixed titanium white, yellow ochre and gold ochre with cobalt turquoise. This was used alongside a mix of titanium white and yellow ochre for the warm highlights, which become whiter and brighter on the edges of the waves as the sunlight strikes them at an angle.

DRIFTING IN DETAIL
60 x 60cm (23½ x 23½in)
Acrylic on canvas.

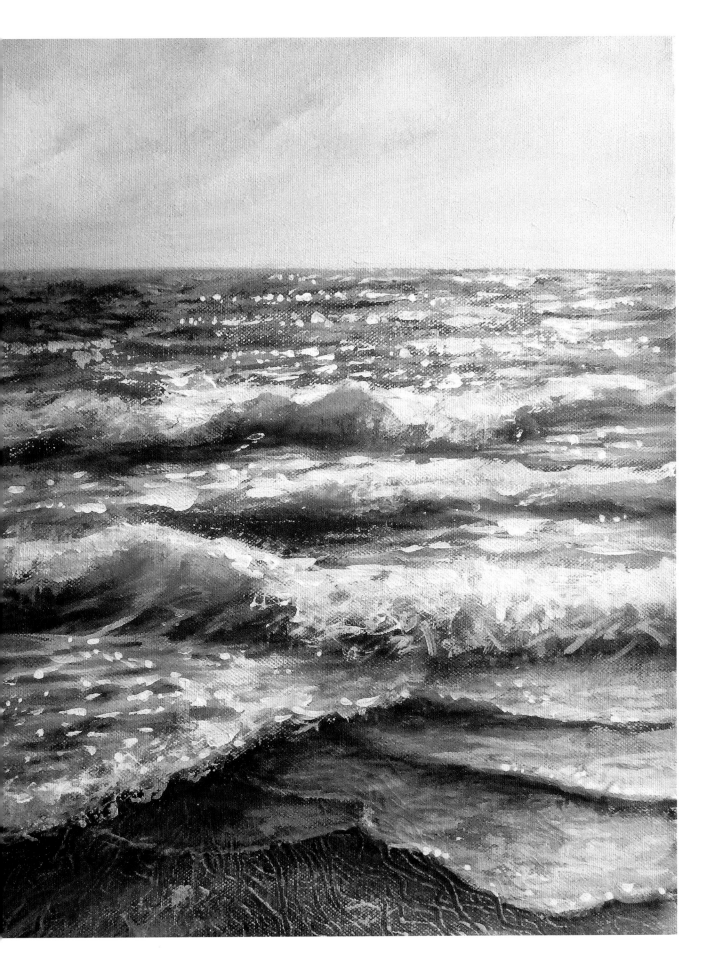

AFTERWORD

I do hope that after studying this book, you are raring to go and are looking forward to creating your own artwork with enthusiasm and optimism. Yes, it's an artistic cliché, but rules are meant to be broken; there are no rights or wrongs. In other words, you should play with different approaches to develop your own personal interpretation. I encourage you to hone your craft and continue to discover new expressive techniques, which will create your own unique style.

Please ignore the commonly-held belief that the process of painting is straightforward. It is not – painting takes a considerable effort. It can, on occasion, also feel like a daunting challenge, especially when work doesn't go to plan and feels like a struggle. At such times, it is also worth remembering that working through these tricky patches often produces the best results. Out of disadvantage comes advantage!

From my experience I can confidently predict that the best ideas will be generated through the process of painting, so crack on. Be creative, be productive and be absorbed by the wonderful activity that is painting.

SOFT SAND SHIMMER

40 x 40cm (15¾ x 15¾in)

Acrylic on canvas. This impression of a rainy day by the coast was created by allowing drips of wet paint to run over the heavy underlying texture.

INDEX

abstract 60, 100, 101, 129
acrylics 6, 12, 14, 16, 18, 19, 20, 22, 24, 26, 32, 38, 42, 45, 50, 51, 53, 54, 55, 57, 60, 61, 62, 68, 80, 82, 92, 94, 101, 107, 113, 115, 121, 125, 126, 127, 130, 131, 132
atmosphere 6, 8, 10, 12, 19, 45, 51, 65, 84, 92, 94, 104, 122, 123, 124, 126, 129, 132, 136, 140

background 24, 30, 37, 38, 57, 62, 74, 75, 80, 86, 92, 94, 99, 103, 108, 116, 122, 123
balance 30, 104, 108
beach 35, 84, 94, 102, 122
blend(ing) 16, 20, 37, 38, 45, 51, 68, 73, 80, 84, 87, 90, 92, 113, 115, 128, 129, 132, 134, 136, 138
board 18, 19, 22, 52, 57, 60, 61, 70, 72, 82, 84, 99, 101, 107, 108, 109, 111, 115, 121, 124, 125, 126, 127, 132, 137
boat(s) 116, 120, 124

calm 108, 128, 129, 132, 134, 138
canvas 12, 18, 20, 32, 35, 38, 43, 46, 48, 61, 80, 94, 95, 97, 102, 103, 106, 120, 122, 123, 128, 131, 135, 138, 139, 140, 143
cliff 86, 100, 103, 108, 118
cloud(s) 27, 38, 51, 62, 65, 73, 80, 88, 89, 92, 99, 106, 110, 111, 112, 113, 115, 122, 134, 138, 140
coast 6, 8, 10, 12, 24, 38, 51, 57, 62, 84, 92, 94, 100, 101, 102, 116, 124, 143
colour 9, 16, 24, 25, 26, 27, 28, 30, 31, 32, 34, 35, 36, 37, 42, 45, 47, 50, 52, 53, 55, 57, 58, 59, 61, 62, 65, 73, 74, 80, 84, 87, 88, 90, 94, 98, 102, 103, 104, 122, 123, 128, 129, 130, 132, 134, 136, 138
colour palette 24, 25, 28, 136
 evening 27
 Mediterranean 26
 sunset 29
 winter 28
cropping 98

depth 14, 30, 31, 35, 53, 65, 68, 76, 77, 98, 110, 111, 120, 122, 125, 130, 132, 138
depth of tone 68, 138
diagonal 98, 116
drama 8, 12, 19, 20, 24, 31, 35, 38, 47, 51, 54, 60, 61, 64, 100, 104, 106, 107, 108, 109, 116, 118, 121, 128, 129, 130
dreamy 132, 136, 140
dripping 64, 101, 106
dry brush 20, 32, 34, 42, 44, 51, 57, 58, 65, 74, 88, 91, 92, 94, 115, 130, 134, 136, 138

energy 10, 12, 32, 35, 38, 41, 70, 80, 94, 100, 108, 130
evening 25, 27, 62, 140
experiment 14, 41, 51, 129

fan brush 16, 84, 89
flat brush 37, 38, 42, 43, 46, 58, 72, 73, 74, 75, 77, 80, 82, 86, 88, 89, 90, 91
flicking 75, 82, 118
foam 24, 26, 30, 32, 34, 35, 38, 44, 48, 67, 78, 79, 80, 82, 90, 104, 108, 127, 130
focal point 89, 97, 98, 104, 118, 120
foreground 25, 30, 32, 57, 68, 72, 74, 75, 76, 77, 78, 82, 84, 90, 92, 94, 101, 102, 107, 116, 118, 122, 123, 124, 125, 127, 128, 132, 138
format 98, 99

gesso 18, 20, 50, 51, 60, 61, 70, 72, 77, 82, 84, 104, 113, 115, 118, 123, 130, 134, 138, 140
glaze(-ing) 24, 25, 29, 32, 34, 37, 52, 53, 55, 57, 61, 62, 68, 70, 74, 76, 79, 80, 82, 84, 88, 91, 94, 115, 132, 134, 136, 138
glue 20, 50, 51, 55, 57
granulation medium 6, 20, 50, 51, 54, 68, 84, 87
grasses 100, 101, 116, 118

harmony 97, 129, 136
haze 19, 28, 91, 92, 94, 113, 127, 129, 132, 136, 138, 140
headland 86, 87, 88, 90, 91
highlight(s) 20, 25, 27, 30, 32, 34, 36, 37, 48, 53, 58, 75, 77, 87, 89, 90, 91, 92, 94, 104, 120, 121, 128, 129, 134, 140
horizon 30, 32, 84, 88, 89, 90, 106, 111, 113, 122, 123, 125, 127, 132

imagination 100, 106, 122, 140
ink(s) 14, 20, 54, 64, 68, 84, 86, 87

juddering 44

knocking back 65, 74, 89, 91

light effects 8, 10, 84, 92, 94, 112, 129
lighting 92, 128, 129, 138, 140

mark-making 20, 46, 48, 58, 97, 129
 dynamic 38, 130, 134
 expressive 43
 gestural 43, 134
memory 8, 10, 106
merging 122, 128, 129, 132, 134, 138
methylated spirits 20, 48, 51, 61, 62, 70, 72, 80
mist 28, 34, 38, 65, 78, 84, 91, 92, 115, 116, 129, 132
mixing colours 31
mood 25, 92, 129, 132
moon 138
motion 34, 38, 43, 44, 48, 67, 78, 79, 80, 82, 118, 132, 136, 140

movement 10, 32, 38, 43, 44, 46, 68, 70, 77, 80, 89, 92, 94, 98, 99, 100, 104, 109, 111, 126, 130

narrative 116
nostalgia 140

palette knife(-ves) 16, 20, 22, 38, 46, 47, 50, 55, 57, 58, 59, 70, 77, 78, 80, 82, 84, 91, 94, 118, 124, 128, 129, 134, 136, 140
 scraping 20, 38, 42, 47, 50, 55, 57, 80, 82, 124
 smearing 47, 134
pastry cutter 16, 94, 126, 128, 138
perspective 30, 32, 98, 101, 106, 108, 110, 111, 122, 123
photographs 8, 10, 12, 101, 112, 121
plastic food wrap 60, 61, 132
point of view 98
printing 59

realism 24, 35, 70, 80, 94, 99, 112, 122
reference 6, 8, 9, 10, 12, 24, 38, 100, 106, 112, 116, 121
reflected light 34, 35, 94, 97, 128
reflections 32, 37, 62, 76, 77, 92, 98, 100, 103, 110, 121, 125, 136
refraction 35
rigger brush(es) 16, 32, 38, 44, 48, 70, 75, 76, 77, 80, 84, 89, 91, 92, 136
ripples 94, 101, 134, 140
rock(s) 20, 26, 27, 28, 35, 47, 48, 57, 58, 84, 87, 90, 92, 99, 101, 102, 103, 108, 123, 125, 132, 136
rule of thirds 98, 99, 118

salt 20, 50, 53, 62, 68, 92, 125
sand 8, 12, 20, 32, 35, 47, 68, 84, 86, 91, 94, 98, 120, 134, 136, 140
scale 122
scumbling 65
sea bed 35
sea spray 16, 30, 32, 34, 35, 38, 45, 50, 62, 65, 66, 67, 70, 72, 80, 92, 115, 118, 130, 131
seaweed 35, 48, 57, 58, 99, 116, 123
shadow(s) 24, 26, 27, 29, 32, 34, 35, 37, 75, 79, 80, 82, 90, 107, 110, 116, 120, 123, 129, 130, 132, 134, 136, 138, 140
shoreline 48, 86, 94, 126, 128
side-lighting 129
sketching 9, 10, 38, 97, 98
sky 8, 24, 26, 28, 29, 34, 37, 62, 68, 72, 73, 75, 80, 84, 86, 88, 89, 91, 92, 94, 97, 98, 101, 103, 110, 111, 112, 113, 115, 121, 125, 128, 132, 134, 136, 138, 140
speckling 16, 66, 70
speckling brush 16, 66, 70, 78
splattering 35, 42, 66, 67
stippling 35, 67
stormy 32, 38, 80, 121

sunlight 26, 29, 32, 35, 36, 37, 38, 59, 73, 82, 92, 94, 95, 104, 113, 134, 136, 140
sunset 12, 25, 29, 62, 94, 128, 134
surface of the water 34, 37, 48, 80, 106, 140

texture(s) 10, 18, 19, 20, 43, 44, 46, 47, 50, 51, 54, 55, 57, 58, 59, 60, 64, 68, 77, 82, 84, 86, 87, 91, 92, 94, 97, 98, 99, 104, 106, 118, 122, 123, 124, 125, 126, 130, 132, 134, 136, 138, 140, 143
texture paste 84
thread 16, 59, 138
thumbnail (sketch) 97, 98
tonal contrasts 140
tone(s) 12, 24, 26, 27, 28, 29, 30, 31, 34, 36, 37, 38, 47, 62, 79, 80, 84, 94, 97, 104, 110, 118, 122, 123, 128, 129, 132, 134, 136, 138, 140
toothbrush 32, 35, 67, 70, 78
tranquillity 129, 132
translucent 6, 24, 32, 36, 37, 53, 61, 70, 79, 80, 82, 130, 134, 140

underpainting 42, 47, 53, 65, 70, 74, 113, 136
unify 37, 68, 115, 134

vanishing point 106, 111, 122
viewpoint 99, 100, 101, 102, 103

wash(es) 16, 20, 32, 34, 38, 42, 45, 48, 50, 51, 53, 54, 57, 60, 61, 62, 68, 72, 74, 80, 82, 92, 115, 130, 132, 134, 140
watercolour 9, 14, 16, 18, 19, 20, 22, 24, 26, 27, 45, 50, 51, 53, 54, 55, 60, 61, 62, 68, 82, 92, 101, 107, 109, 113, 121, 127, 130, 131, 132
water spray 38, 45, 70, 72, 92, 115
wave(s) 8, 10, 12, 26, 30, 32, 34, 35, 36, 37, 38, 51, 59, 70, 72, 74, 75, 77, 78, 80, 82, 90, 94, 98, 99, 100, 104, 108, 109, 116, 122, 127, 130, 132, 140
 interior 34
weather 24, 32, 34, 38, 92, 112, 129
wet-on-wet 45, 92, 113
workspace 22